# *Home* Is Where the *Bus* Is

# *Home*
# Is Where
# the *Bus* Is

**Anne Beckwith Johnson**

*Good wishes —*
*Anne Johnson*

2001 · JOHN DANIEL & COMPANY, SANTA BARBARA, CALIFORNIA

Cover illustration by V. Courtlandt Johnson

Published by John Daniel & Company
A division of Daniel and Daniel, Publishers, Inc.
Post Office Box 21922
Santa Barbara, CA 93121
www.danielpublishing.com

LIBRARY OF CONGRESS CATALOGING-IN-PUBLICATION DATA
Johnson, Anne Beckwith, (date)
    Home is where the bus is / by Anne Beckwith Johnson
        p.   cm.
        ISBN 1-880284-47-2 (pbk. : alk. paper)
    1. Johnson, Anne Beckwith, (date)—Journeys.   2. Voyages around the
world.     I. Title
    G440.J64 J64 2001
    910.4'1—dc21
                            00-012886

*In memory of my husband, Vernon,*
*and his improbable but possible dreams.*
*And to our children,*
*Christie, Jill, Court, Jenda, Jeff,*
*Vicki, Kara, and Andy*

Home Is Where the Bus Is

# *Preface*

IN ANOTHER HOUR we would be home where friends were waiting to help us celebrate our return. The word *home* echoed comfortably in my mind. Vernon kept our bus at a steady pace through the darkness, the headlights making cone-shaped patterns of light on the asphalt ahead. We had stopped for hamburgers and milkshakes in Paso Robles, eating as we traveled, the children thrilled to be again in the land of hamburgers. Vernon whistled softly as he steered the bus along Highway 101 toward the steep Cuesta Grade north of San Luis Obispo. He had done what he had promised the same group of friends two years ago: "If someone will rent my house, I will take our old bus and drive my family around the world."

The drive south from San Francisco had taken longer than expected. The vagaries of our old bus had taken us longer than planned on each day of travel for twenty months through fourteen different countries. We still entertained dreams of meeting a schedule. Without such foolish dreams, we would never have completed the trip.

Our third transmission was giving us trouble and I sat on a wooden crate in the aisle beside Vernon, my hand holding a sturdy string shopping bag looped tightly around the gear shift to keep it in third gear. If I let up, it would pop into neutral. Our eight children were talking softly and dropping off to sleep on the long seats at the rear of the bus.

"Do you think we should stop in San Luis and let them know at home we'll be late?" I asked Vernon.

"Never fear. They'll still be partying when we get there."

Although my husband marched to a different drummer than most men, he shared the universal dislike of stopping to phone or ask directions.

I switched the string bag to my left hand and pulled.

"You can let up for a few minutes," Vernon said. "I'll have to go up the grade in second gear. It'll hold."

"If high gear fails, could we get home in second?" I asked.

"Sure. And we haven't even begun on reverse."

As we approached the crest of the hill I was preparing to slip the bag back into place when there was a tremendous explosive clatter of metal. I'd heard that sound on the first trip we had taken in the old bus, a camping trip in the Mohave in 1959, one of those single experiences one never forgets. Vernon's grin was visible by the light of the instrument panel. "Well, there you have it," he said.

"We've thrown another rod, haven't we?" I said.

He nodded. "Looks like one more night in the bus. Might as well haul out the sleeping bags. We'll get help in the morning."

# *Chapter One*

"IF SOMEONE WILL RENT MY HOUSE, I'll take our old bus and drive my family around the world." My husband's voice rang through our remodeled carriage house/living room where a dozen friends had gathered for an evening of music and talk.

It was the first day of February 1960, and news regarding the state of the world had been disturbing Vernon more than usual. "Who the hell do you think this world belongs to?" he said. "People, that's who, people like us. Iron Curtains don't exist except for leaders who won't give us enough information to figure it out for ourselves."

After eight children and eighteen years of marriage I should have become accustomed to Vernon's sincere, if irrational, pronouncements.

As I leaned over to pick up a bowl of cheese dip, our friend Ruth said, "I'll rent your house. When can I move in?"

Maybe if I behaved normally and ignored Vernon, he'd return to reality. I moved among the circle of friends with the bowl of cheese dip.

"Let's see. It's February first," he said. I was impressed by his sense of location in time and space. All was not lost. Then he continued, "You can move in on the first of March."

The cheese dip hit the floor.

"Let's dance," I said as seductively as a mother of eight can say to the father of same. I had to divert him.

"I'm serious," he roared. "What this world needs is to see a typical American family instead of just a lot of diplomats and tourists. We can't just stand around while countries continue to threaten each other just to keep their economies going. When I met Khrushchev last September, I felt there was something I had to do. Now I know. We'll drive that bus right across Siberia. Our kids can meet the Russians and the Russians can meet us. We'll be able to communicate person-to-person."

Vernon took a sip of red wine. "Our children come home from school with papers for us to sign saying where they should go in case of nuclear attack. What sort of life is this? I want them to know the world and to feel safe in it."

The first of March, I mulled. Only twenty-eight days. He had probably selected the shortest month of the year so I would have no time to do anything but prepare. I brushed the thought aside. With a little luck, sanity would return by morning and Ruth could always find another house to rent.

I had always thought of myself as the anchorman in our marriage although Vernon often considered my cautious nature a drag. I was ready to drop that anchor at any moment to keep our ship from hitting the hidden reefs I anticipated. It sounded as though our ship was about to be cut adrift in whirlpools of international intrigue.

Eighteen years ago, in front of witnesses, I had promised to follow him anywhere. I had done just that during World War II when he was in pilot training. Vernon then spent two years in hospitals enduring the loss of a leg and months of surgery after crashing and burning in a B-17 bomber in Italy. When he recovered we moved to Arizona to study at the American Institute of Foreign Trade. By then we had four children. We lived for a year in Mexico while Vernon did graduate work in economics and history at the University of Guadalajara. We then returned to Santa Barbara, postponing our dreams of moving to Latin America. We bought an old carriage house and gardener's cottage and slowly converted the old buildings into a home while adding another four children to our brood.

I should have become accustomed to Vernon's impetuous decisions. I always hoped he would outgrow his inclination to find

an adventure at every turn of the road. These thoughts flashed through my mind as we sat there in our living room beside the adobe fireplace we had constructed with our own hands, enjoying its warmth in the company of good friends. Our eight children were asleep at the far end of the house.

The bus in question had been junked by the local bus system and converted for camping by an innovative friend before the days of recreational vehicles. Our friend took it on a trial run with his wife and children before deciding it was too small for a family with two children. We bought it and on our first test run we drove out to the Joshua Tree National Monument, where the engine threw a rod. The engine was replaced but we never quite got around to registering the change in engine numbers.

I hadn't heard anything like this evening's pronouncement since the time Vernon suggested a covered wagon trip through Korea. Or was it Afghanistan? That trip didn't come off because he couldn't locate the oxen. The bus, however, was right in our driveway.

After all, what can you do with someone who was always thinking of the *big picture* and world affairs instead of the price of a pair of children's shoes?

Before the party broke up our guests were caught up in the plot. They thought it was a terrific idea. As they walked down our driveway they were making plans for a glorious farewell party.

There was no point in my asking what we would do for money. What about school for the children? How do we get the bus to Europe? His answer would have been as always, "There's no such thing as a problem." Anyone who thought there was no such thing as a problem needed all the support he could get. I was obviously committed to this project.

# Chapter Two

ALTHOUGH VERNON WALKED with a slight limp, he still had the same jauntiness I had noticed when I first saw him sauntering across the college quad when he was twenty-one and I was seventeen. I was thrilled to find him in my Spanish classes later that day. His general philosophy and his confidence that great things are not only possible but also imminent were not acquired with age. He had them when we met. He also had a thirst for adventure and, as our romance developed, we planned great trips. He thought it would be wonderful to have a big family. We were each an only child and we talked blithely of having a half dozen.

Then World War II was declared and in a rush of youthful passion we eloped. Our travel plans were put on hold. Vernon joined the Air Force and became a B-17 Flying Fortress pilot. As he was transferred from base to base, I followed, an eighteen-year-old mother carrying our year-old baby daughter Christie on drafty, noisy trains to small-town military installations. When Vernon was shipped out to Italy, another baby was six months on the way.

His plane crashed a month after Jill was born, on Thanksgiving Day of 1944, as he was starting out on a double-credit night mission over Germany. Soon after takeoff an engine caught fire, then a second one. He crashed while attempting to land on a small emergency airfield. He lost his left leg soon after and, over the

next two years, went through repeated operations to save his right leg and to graft new skin over severe burns. Yet it was Vernon who began at once, even in his first letters, to build my confidence in the future. Because of his fierce determination, the only physical sign of all this was a slight, somewhat distinguished limp.

My husband believed in creating an atmosphere without tensions or preconceived ideas, and with such an attitude he believed great things were possible. He thought it was tantamount to crime to throw indiscriminate stress and fears into a situation. He was the right person with whom to be if a problem arose. Our friends joked about Vernon's bland statement, "There is no such thing as a problem." They treated the subject lightly, as he did. They called it "Thinking Johnson." They said it helped them find parking places.

His idea for our trip was in keeping with his old spirit of adventure. We were fully conscious of the tensions in a troubled world. He was quoted as saying, "We think people are more important than governments." We hoped to find what was important in the lives of people we met as we traveled. Aside from the practical necessity of transporting a family of ten, Vernon felt the bus would give a simple picture of American family life.

When we left home in early March of 1960 Vernon was thirty-nine, over six feet tall, with early graying hair and a full beard. He looked the proper patriarch of such a clan.

Our trip would never have been possible without my husband's dreams and his ability to convince the rest of us that great and important things are really possible. He believed in setting an example rather than being a disciplinarian, and our children always strove to reach the "carrots" with which their father baited life. Our bus trip would have been just another long camping trip without that spirit he generated so strongly in his family and in everyone he met. "Always keep the big picture in mind," he would say when the path was rough. It wasn't always easy to do.

I was thirty-five, a tall woman with long, darkening blond hair pinned in a practical chignon. I saw my role as mother, lover, cook, budget-balancer, and champion of the current underdog. I was alternately loving and despairing with my children and my husband.

The two "older girls" (we tended to group the children in

such terms) were seventeen and fifteen. Christie, the elder, had just turned seventeen. She was tall and slim with long silver-blonde hair, and a fragile, self-conscious poise. She was an honor student and before we left was awarded an early graduation certificate from her high school.

Jill, with curly gold-brown curls and greenish eyes, was the energetic one, always willing to take care of the children when we went out, a great help with the housekeeping. She looked much like her father.

The two girls were just beginning to discover "men." Their eccentric and/or crazy parents and immature and/or bratty brothers and sisters consistently embarrassed Christie and Jill.

Court, our twelve-year-old first son, was a quiet boy with a quirky sense of humor—always able to make me laugh, even at times when I desperately wanted to scold him for some infraction of family law. Once when he ate a banana from a decorative fruit bowl he had stuffed the peel with paper towels, stitched the peel together with sturdy black thread and returned it to its place. He had a rare artistic gift and spent his free time with his drawing pad and pencils.

Jenda (Court had been unable to say Jennifer when she was born) was tall with shoulder-length blonde hair. She was unaware of her good looks as she coped with the awkwardness of being eleven. Both Jenda and Jeff, as middle children in a big family, had to use their wits to establish any supremacy as they were set upon by older siblings and tattled on by the younger.

Jeff was nine years old with a cherubic face topped by tawny curls. He was a tremendous tease, although he couldn't tolerate being the recipient and hence was consistently victimized by his brothers and sisters when life seemed dull and they wanted diversion.

Vicki, age six, with tight blonde curls like a halo, was seldom given to silence and adored attention. She knew how everything should be done. Vicki, whose middle name is Alexis, was a small version of all that is female, and Christie called her "Sexy Lexy."

Kara at four, a quiet child with long, silver-blonde hair, was given to impenetrable silences and to long private interviews with her adored rag doll. She hated to be the focus of attention.

Anders (known as Andy-Bo by an adoring bunch of siblings), who had just turned three, was an adaptable, contented, happy little towhead.

That is the list of characters, except for The Bus. It had spent its youth carrying passengers along the staid and quiet streets of Santa Barbara, seldom accelerating to more than twenty-five miles per hour, before it was retired. It was purchased and remodeled by a friend who installed comfortable long padded benches on either side of the aisle, plus a tiny kitchen and almost-bath to accommodate his family of four. It was a precursor of the modern motor home. We bought it for weekend camping trips that consistently included a mechanical breakdown. One tow truck driver said, "It really tows well."

# *Chapter Three*

VERNON'S URGE TO TRAVEL around the world acceler-
ated following a chance meeting with the Soviet Union's Premier
Khrushchev.* Vernon regarded the meeting as a personal message.
He had been looking for a way to express his feelings about the
Cold War and the Iron Curtain, a term used for the political
boundary between the so-called Free World and the Communist
Bloc countries. My husband believed that individuals not only
could make a difference but also had an obligation to do so.

Khrushchev came through Santa Barbara on his way to San
Francisco in September of 1959 following a promising meeting
with President Eisenhower. Shortly after he arrived in Los Ange-
les he was told he could not visit Disneyland because security
officers felt his safety could not be ensured. He was angry and re-
porters predicted he would not get off the train in Santa Barbara.

At the time there was strong anti-Communist talk but Vernon
felt it was a historic moment and wanted his family to honor the

---

* After the death of Stalin in 1953, Nikita Khrushchev won the position of
first secretary of the Communist party. In 1958 he took over the post of
chairman of the Council of Ministers (while remaining first secretary). He
was soon known as a leader of great shrewdness. He began to threaten the
West with destruction if it did not end the "cold war" on his terms. This led
President Dwight D. Eisenhower to invite Khrushchev to the United States.
They met at Camp David in September of 1959 and agreed to a summit con-
ference the following May.

Soviet head of state. There was a large crowd at the station when the train pulled into Santa Barbara. The Premier sat stolidly in his seat in the observation car with no apparent intention of moving. We were standing close to his car when, according to Vernon, their eyes met. Khrushchev smiled, stood up, went to the front of the car, stepped off the train and spent a moment shaking hands with our city's mayor. Then he strode purposefully back down the platform to Vernon, reaching out to shake hands. Through his interpreter, there was a brief exchange.

"Welcome to Santa Barbara," Vernon said.

"Thank you. Tell me, why do you wear a beard?" asked Khrushchev. Beards were unusual in those days.

"My wife thinks men with beards are interesting," said Vernon.

"She's right," said Khrushchev. "I like your face. You have good eyes."

"So do you," answered Vernon. "I hope you'll enjoy the rest of your visit in the United States. I would like to bring my family to your country some day."

"You have a beautiful family," the Premier said. "We would welcome you." He patted a few young heads, grinned at everyone around him, and climbed back on the train.

That was the extent of the exchange. However, Vernon insisted there had been a special communication and that the meeting signaled his destiny, particularly when the next day's headlines appeared, as far away as London, saying "All Things Change in Santa Barbara."

Khrushchev's mood *had* changed, and the rest of his visit in California was peaceful. Who could have predicted this was to change the pattern of our lives? The next time Vernon spoke to Khrushchev would be under very different circumstances.

# Chapter Four

WHEN VERNON ANNOUNCED the grand plan, the children reacted calmly. After all, they had never known another father. As usual I argued and rejected Vernon's wild ideas but, once I'd expressed every opposition I could muster, threw myself completely into the project. By the end of the day I was geared up to face the obstacles that might stand in our way.

High on the list of things to be done before the trip was the installation of a heater in the bus. We decided to settle for long underwear. It would be cold on the East Coast but it was so sunny and warm in Santa Barbara it was impossible to come to grips with this fact. I phoned the Sears catalog department and an obliging woman unearthed a catalog from their North Dakota or maybe Alaska division. I proceeded with my order. "I need two sets of men's extra large, six sets of women's medium, four sets of boy's size 14...."

The woman sputtered, "I know this is none of my business, but would you mind telling me just what you plan to do with all these?"

I explained.

"A lot of people think I have a dull job," she said.

Our passport applications contained the tantalizing question, "Is this an organized tour?" Not by a long shot, I thought.

Someone who knew more than we about traveling suggested we inquire into passage on a ship. In 1960 one traveled by ship.

They were not just for cruises. We hadn't decided on a destination. Spain would be nice. We spoke the language and it might be warm in April. England would be wonderful and we spoke a reasonable dialect, but England would not be warm in April. The experienced traveler suggested Italy.

A travel agent told us the Italian Line's *Vulcania* had space for us somewhere on a lower deck for a reasonable price, two hundred dollars per person for the ten-day trip with no charge for the three youngest children. Appropriately, we were to sail from New York to Naples on April Fool's Day. The *Vulcania* could not take the bus on board. It was suggested we contact freight lines when we reached New York.

On February 15 we remembered that the Internal Revenue Service would soon be expecting our returns. Vernon always claimed he couldn't earn money if he knew how much it cost to feed, house, and clothe ten people, so I always paid the bills. I went to work on the tax returns.

On February 16 Vernon discovered a broken piston in the bus. He stripped the motor. Fortunately, he had put himself through college by running a little Santa Barbara garage called Limp In and Leap Out. He also discovered that someone had put the oil dip-stick in the wrong hole and it had been chewed to a fine pulp.

We couldn't find the pink slip that proved vehicle ownership. Nor did the engine numbers on the registration slip match the new engine we had installed following the thrown rod on our test run. Insurance companies had never insured a project of this nature and hesitated to set a precedent. We couldn't find a shipping company willing to take our old bus across the Atlantic.

Money that was to have come from a property sale did not materialize.

Somewhere during those few weeks Vernon decided our bathroom should be remodeled for the new tenant. We were doing the work ourselves, of course.

One by one, these obstacles were overcome. Vernon said, "You take care of the little things and I'll take care of the big ones." I was unable to separate them.

Four days before we were to leave, he was taking the motor

apart for the third time, trying to find out why it smoked while climbing small hills.

The children stayed in school until the last few days. It was hardest on Christie, who would miss her high school graduation in June. The younger ones felt the air of a continual picnic and bedtime found them sleeping in odd places. There was a night when six-year-old Vicki put two pillows behind the newly installed bathroom door and slept there. Kara set up housekeeping in a long, twelve-inch-wide cupboard and slept with her big rag doll. Andy-Bo, the two-year-old, slept on a mattress *under* his crib, which had broken the preceding day after years of repair with tape and wire. Court, Jenda, and Jeff slept under the avocado tree in the back yard. By then Vernon and I could have slept standing up in the center of the room.

A group of friends rented a local hall and potlucked an incredible feast of enchiladas, fried beans, rice, and salads. There was a barrel of home-stomped wine and kegs of beer. Seeing some 150 friends assembled, enjoying another wonderful time together, made me even more reluctant to leave. They had all chipped in to present us with a set of luggage. We were really committed!

The fact that the bus wouldn't start had little to do with our not leaving on time. There were several other last minute details. My March 2 journal notes read, "Should have gone yesterday noon. More bus trouble. Vernon sick with severe stomach pains last night. Doctor thinks it's nerves but gave him a shot of morphine. Hope to leave tomorrow. Tenants moved in last night. Our family slept in one room on mattresses spread on the floor. I laid linoleum tile in bathroom. Friends moved stove and refrigerator. Rains came and storeroom roof leaked. All boxes had to be removed and contents dried. Vernon says he will patch the roof before we leave."

Another couple of days and the urgent tasks were complete. Vernon had recovered.

In midmorning of March 6 (we had been sharing the house with our tenants for six days), Vernon tightened the remaining loose bolts on the bus, loaded the family aboard, mounted the driver's

seat, and stepped on the starter. It wouldn't turn over. Deciding it was only a low battery, we pushed it out of the driveway onto the road that sloped steeply from our house for two miles down toward the ocean. About a half-mile from the house the motor caught. Vernon later pointed out that if the motor hadn't started, the brake system wouldn't have functioned. But if a man is going to insist there is no such thing as a problem...well....

# Chapter Five

A CELEBRATION WAS CALLED FOR on our last night in America. After three weeks of driving, sightseeing, breakdowns, and camping across the country, we were enjoying the civilized comforts of a new motel in New York City.

The troubles we'd had crossing the country were behind us. In retrospect they became what Christie and Jill approvingly called "blasts." We'd left broken fan belts strewn over the southwestern desert. Our homemade brake system was an ongoing challenge and we'd had a small engine fire.

We crossed the border into Mexico at Juarez, where Vernon bought a broad charro hat and two bottles of tequila. In San Antonio we saw the Alamo bathed in moonlight and the soft air whispered old stories to us.

Our most memorable breakdown occurred in the town of Junction City, Texas. We were there for three days and nights, during which we sent plaintive telegrams to the Ford Company and its agencies around the country asking for a new rear axle. The bus had been towed to a spot beside the local garage. We were allowed to use their bathroom and plug in an extension light. When the mechanics left for home at night, I set up our camp stove on the grease racks and cooked dinner. In the daytime we roamed the tiny town, watched the children swim in the March-cold Llano River, and checked the telegraph office for incoming messages.

The chief mechanic said, "The problem is these here axles are so strong they usually last longer 'n the bus. Ford probably don't make 'em no more." He turned his head and shot a stream of tobacco juice into a bush.

"Maybe we could weld it," said Vernon.

"Nope," said the mechanic. "That wouldn't get you over the next hill."

I stared out at the vast flatness. That would be far enough, I thought.

Finally the strain imposed by kids who left odd shoes and peanut butter sandwiches in toolboxes and torn-down engines took its toll. The axle was welded. So well, in fact that it would not only get us over the next hill, but over the Alps and through the Apennines before it snapped, but by then Vernon would have a spare axle on hand and the voluptuous Swedish actress Anita Ekberg would be seated next to him on the front seat.

We sometimes camped in even less convenient places than garages, often beside the road. In Mississippi we stayed in a migrant workers' camp. The amenities were few but it had hot showers.

As Vernon parked the bus, three small boys watched him, fascinated by his bearded face. The most daring finally asked, "Is y'all God?"

Vernon's answer was a joking, "Yes." He was viewed with awe during our brief stay.

In New Orleans we celebrated our eighteenth wedding anniversary with a dinner at The Court of the Three Sisters in the French quarter featuring a platter of red snapper impaled with flaming sparklers. Near our table a caged mountain lion roared and a chartreuse parrot made even more noise than our kids.

Driving north along the East Coast we ran into snow and had a chance to use our new long underwear. At Valley Forge we trudged through deep snow lending a sense of reality to history. We saw the sights in Washington D.C. and Philadelphia and stayed on Long Island for several days with supremely tolerant and hospitable old friends.

While I spent the afternoon unpacking the bus and repacking for the voyage, Vernon made arrangements to ship the bus to

Europe. The cheapest way was for the bus to go to Antwerp even though we would land in Naples. Vernon assured us we would then be able to board a train for Belgium to reconnect with our home on wheels.

We were down to our last hours in the USA. "Now the trip is really starting, isn't it?" asked Court.

# Chapter Six

OUR LAST MORNING IN NEW YORK could only be reproduced with stage sets by Dali, dialogue by Gertrude Stein, and action by the Marx Brothers. We had gone to bed the night before with the happy sensation that all was organized. The bus was in Brooklyn, ready to be shipped to Antwerp, Belgium.

Vernon dressed and left the hotel early. "I'll go to the bank and pick up our money and meet you in the lobby in half an hour."

I dressed the small children and turned to other last-minute tasks. While we had traveled in the bus we had shelves and places beneath the seats to store things. Now everything had to be transferred to suitcases and duffel bags. Suddenly there was an appalling number of items that didn't fit into purses or bags. Loose items multiplied. Each of us carried an armful of leftovers as we moved our luggage to the lobby to wait for Vernon.

Stories had begun to appear in various newspapers, sparked by an Associated Press report from the Santa Barbara paper. When we reached the hotel lobby, reporters and a photographer from the *Herald Tribune* materialized. They preferred to have the head of the family in the picture. Children, paper bags, and coats were scattered on couches. One guest was so amused that he took home movies of the melee.

The clock crept toward eleven. We were to sail at noon. Still no Vernon. As I stalled the reporters and reassured the children,

Vernon phoned. "There's a bit of confusion here at the bank. I'll meet you at the ship."

"There's a bit of confusion here and you damned well better!"

With reporters following, I loaded the children into a pair of taxis. At the dock porters snatched at our luggage. "If you want to take this ship, lady, you'd better let us load your bags."

"Is Daddy lost?" Vicki asked.

"Are we lost?" It was Court's idea of humor.

With only minutes to go, Vernon arrived. We released our bags to the porters and made a dash for the gangway.

"What took you so long?" I asked.

"The damned money wasn't there. It took all that time to find out that Bob never made the deposit for us. So I called him and all he could say was that it had slipped his mind."

"But you got the money?" I nodded to the porters to take our luggage.

"Well, not really." Vernon picked up his accordion case and Mexican hat and started toward the gangway. "But don't worry, they'll forward the money to Naples."

Worry? Vernon had written a thousand-dollar check for shipping the bus. We had little more than $200 in our pockets and no credit cards. Fortunately we didn't know this was to be the pattern of our financial status for the next twenty months.

I followed Vernon, carrying Andy and an assortment of coats and jackets. The other children carried the typewriter, small bags, and a large paper sack with the intact two bottles of tequila. Kara trudged stolidly along in the rear with her rag doll snagging itself on posts, revolving gates, and other people's baggage. Christie and Jill pretended they didn't know us.

We were headed for the tourist gangplank when the publicity man for the Italian Line found us. "There is a press conference for you in the first class lounge," he said.

Then Jenda, who was temporarily in charge of the tequila, bumped into a post and the pungent liquid began to drip through the sack, leaving a Hansel and Gretel trail. I vowed then I would some day board a ship in a stylish basic black dress, carrying nothing but a simple purse, and with a mink stole clinging to my shoulders, in lieu of a squirming two-year-old.

Our clutter was deposited near the entrance of the main salon and we were ushered in, trying to look worldly and accustomed to such attention. All-ashore whistles were sounding. A dozen reporters descended on us. Drinks were offered and Vernon and I clutched glasses of cognac, while answering questions. In truth there were no very solid plans beyond landing in Naples and getting together with the bus but, fortified by the cognac, Vernon made firm pronouncements. "We plan to drive our bus across the Soviet Union."

With a dozen people firing questions at once, the only other answer I can remember was Andy's. When asked his name, he answered brightly, "I'm Andy-Bo Johnson, Oh My Darling Clementine." In my mind he made as much sense as his father.

There was a rush for pictures, hurried farewells to the reporters, and in a final burst of whistles, we found ourselves standing near the band. Streamers were flying. The ship was under way. We told the children to watch for the Statue of Liberty.

There was little time for sentimentality, and fame had been fleeting. Stewards urged us to gather our assorted luggage and directed us to our deck.

As soon as we waved goodbye to the Statue of Liberty we were ushered below to the tourist deck—a fancy word for steerage. It was a long descent. We passed three lounges, ranging in elegance from first class red velvet Victorian to steerage gray plastic functional. Down more steps, across a narrow catwalk above the engines, down more steps below the engines, through a dark corridor and we were home.

Luggage that was to have been delivered to our cabin was found to have been stored in the hold by mistake. We would untangle that some other time.

As we returned to the deck, Jill said, "The trip is really starting, isn't it?"

Our three dark, utilitarian, ironclad cabins were below-decks, across a narrow trestle over the noisy engine room, and down a narrow passageway. I thought nervously of where we were in relation to the water line. Bolts on the portholes were rusted shut, our only proof that we had outside cabins.

On the positive side, our fellow third-class passengers, joyous Italians returning to their country, were prepared for a ten-day, ocean-going party.

Many of the crew members had served on the *Andrea Doria*, the ill-fated jewel of the Italian Line, which had sunk like a rock a few years before, following a collision with a Swedish ship. Members of our crew told daring stories of that night but no one mentioned the reports that the crew of the *Andrea Doria* had preceded passengers to the lifeboats. We faced the possibility that the excellent service might have limitations. Bumbling lifeboat drills on the *Vulcania* were a laugh. "We'd be better off just staying out of the way," Vernon said.

Our waiter, Luigi, was a splendid example of tender loving Italian care. When he first met us at our long table in the dining room, he carefully counted each blond head. Then, turning his head from right to left, shaking his right hand limply, and pursing his lips slightly he said, *"Mama mia, otto bambini!"* It was a routine that would be repeated often by Italians who also conferred instant sainthood on a mother of many children.

During the first three days, as the unnerving sight of soup and wine rising and falling caused several of our children to make more-or-less successful exits from the dining room, Luigi would lean over me and murmur, "Don' worry, Signora. Itsa okay." When a glass was spilled, an automatic, "Don' worry" accompanied the mop-up.

Luigi was wonderful. After escaping a sinking ship, it would take more than a vomiting child to upset him. His reassuring, "Don' worry" became a mantra and we all continue to use it at appropriate moments.

Luigi was a wisp of a man who appeared to take nourishment only from the fumes of the rich food. Yet he was afraid we might fade away if we didn't finish our seven-course dinners. He brought extra helpings of dessert and wrapped small bundles of tidbits to tide us over between the huge meals. He even smuggled special delicacies from the first class dining room to our cabins if a family member failed to appear for a meal. Large decanters of wine sat in the center of the table and for our ten-day trip to Naples, Luigi

urged me to give the children small splashes of wine in their water. "Justa like tonic," he explained.

We had originally purchased passage as far as Naples, where most of the passengers disembarked, but Pietro, the captain of our deck, urged us to stay aboard and continue on to Venice for no extra charge. We were, however, unable to separate luggage (including our camping gear) which had been stored in the hold. We were assured it would be safe in the Naples customs storage and we would be able to retrieve it on a return trip in the bus.

We accepted the captain's offer and enjoyed an additional five days, landing in Venice during Easter week with no reservations, little money, and all hotel rooms booked.

# Chapter Seven

TRAVEL IS BROADENING. Geography is brought into focus. History lives again. When I ask my children if they remember Venice, they say, "Sure, that's the place with the camels."

We planned to stay in Venice a week while Vernon took a train to Antwerp to retrieve the bus, but we had no reservations, it was Easter Week, and Venice was the Palm Springs and Fort Lauderdale of Europe.

First class passengers told us they knew a delightful little hotel on the Lido.

Our tourist class friends said, "Do you have any idea how expensive that would be?"

They suggested hotels near the wharves.

The first class passengers responded, "My dear! Think of the children!"

Pietro said, "I have a friend who runs a little *pensione*. She will take good care of you."

Luigi murmured, "Don' worry!"

We approached Venice in mid-morning, passed small outer islands, and entered wide canals. From the high decks of the ship we looked down on aged, tiled roofs, balconies bright with flowering plants and drying laundry, and we had glimpses of narrow streets. Our ship moved ponderously from wide canals into narrower ones and pulled up next to customs in the very heart of the city. The towers of Piazza San Marco rose above the rooftops to our left.

The high, white customhouse was just a few steps from the

gangplank. As we waited for our luggage, we sat beneath a brightly colored umbrella at a small restaurant by the water's edge. Pietro and Luigi joined us and we opened bottles of champagne, sent by the chief purser. "Here's to future trips together," we echoed.

The children were fascinated by the water and the small water taxis and gondolas tied up to the dock. I sent Christie and Jill to restrain the little ones, who seemed determined to hurl themselves into the canal. Friendly gondoliers caught tiny crabs that scurried along the canal walls and handed them to the children.

While I waited with the children, Vernon walked around the corner and over a bridge to find the *pensione* of Pietro's friend. "She doesn't speak English," said Vernon when he returned, "But she understood my Italian and there is plenty of room for us whenever we are ready."

I suggested taking our bags over immediately, but the children opted to ride in a gondola. "You'll have plenty of time for that after we're settled," I pointed out.

"We're in Venice!" Vernon proclaimed. "And it's not yet noon. Let's enjoy ourselves."

I hauled Andy away from the canal's edge. Teenagers, Christie and Jill were held spellbound by a gondolier's impassioned sales pitch. Jeff and Court had climbed into a water taxi and its skipper sold Vernon on the fact that his boat held more people, was more comfortable, faster, and cheaper than a gondola. We would eventually wise up to persuasive Italian salesmen.

For two hours we toured up and down narrow canals, around small bays and little islands. Our skipper pointed to an occasional *palazzo* and the island of the glassblowers. We watched a watery funeral procession to the Cemetery Island. The motion of the boat relieved my usual land-sickness after a voyage, but Christie was getting seasick again. With brotherly good will, Court encouraged her by rocking the boat.

As we sailed down the Grand Canal toward the customhouse, we saw the camels—three of them—kneeling on a large raft that was being towed slowly up the canal. It was the high point of the tour for the younger children.

Returning to the customhouse, we paid the ridiculous price

asked by the skipper, promising ourselves, "Next time we *will* ask the price in advance."

I suggested we take our baggage to the *pensione* but Vernon repeated, "This is Venice and everyone's hungry! Right, kids?" We ate lunch.

After lunch I repeated my plaintive request to move our baggage but Jeff and Vicki were telling their father of the terrible hunger of the plump pigeons in the Piazza San Marco. To hear them tell it, the pigeons hadn't had a decent meal in years.

As if it were his own idea, Vernon said, "Let's go to our *pensione*. We'll get the baggage later."

Having become a repository for heavy winter jackets and sweaters and Andy, who was tired of walking and pigeon feeding, I suggested another water taxi.

"The *pensione* is just around the corner," said Vernon.

It seemed to me that a man with a game leg should have a better sense of distance. Up those pretty little arched bridges and down more of them, around several corners and we found ourselves at the *pensione*. The landlady met us at the door with an expression of horror. She was not really inhospitable. It was more a misunderstanding of Vernon's newly evolving Italian. She thought he had said "a child of eight," not "eight children." There was no way she could accommodate us.

Trying to look on the bright side, we decided that Venice wasn't a safe place for children. We collected our baggage at the customhouse, piled it into a water taxi and headed for the railroad station. We had eighteen pieces of luggage (not bad for ten people) and the usual assortment of paper bags, dolls, and heavy coats.

Court said, "I've got a headache."

Christie answered, "Who doesn't?"

Italy had begun to lose its charm. Austria wasn't far away. Maybe we should go to the inn in Innsbruck someone recommended. That would cost money that was hopefully en route to Italy. It was tentatively decided I should stay in Italy with the children and Vernon would go alone to Antwerp to retrieve the bus.

"It will be easier if you stay in Italy with the kids," said Vernon. "I'll make a quick trip north and bring the bus back."

We were almost out of money. We had to choose somewhere

34

in the immediate area.

At the station Vernon stood in line for tickets. The clerk asked, "*Dove?* Where to?"

"Is there a nearby town where we could find an inexpensive hotel?" asked Vernon. "Not too far."

"Verona," said the clerk. "It is *bella*. You will like Verona."

"I'll take tickets for four adults and six children, please."

We stuffed most of our luggage into our compartment. The rest flowed out into the corridors, making stumbling blocks for passengers. Others in our compartment warned us we would have to move quickly when the train stopped in Verona. Italian trains are punctual to a fault.

For the two-hour trip I worried about our future while the rest of the family dozed. When the train pulled into Verona our compartment mates went into action. They threw open the windows, seized bags indiscriminately, and tossed them out on the platform. Others helped shuttle the children down the steps. We returned bags that didn't belong to us and waved goodbye.

It was nearly nine in the evening. We had been on the go since dawn. Court's headache was worse. He lay on a baggage cart on top of our luggage. He was glassy-eyed and burning with fever.

As always, when things were at their very worst (our situation seemed qualified for that status), Vernon proved there was no such thing as a problem. He found a man waiting at the station, apparently eager to help someone and enormously pleased to help ten at one time. Vernon and he disappeared for fifteen minutes and returned to tell us all was arranged.

An hour later we were settled in a comfortable apartment a block from the station. Three women bustled about us, giving loving attention in voluble Italian to the children, making beds, fixing a late-evening snack, and pouring glasses of a sparkling, golden wine. Two of the women were moved into other apartments in the building and we had three rooms to call our own.

Over the wine, Vernon and I decided the man who had helped us did not usually make his living by finding homes for hapless children. Those women with hearts of gold followed an ancient profession, aided by our gallant guide, but they all shared the Italian virtue of loving children.

# *Chapter Eight*

I THINK OF PLACES IN COLORS. Verona was golden, not like the harsh gray stone of France or the clear blue-green of Sweden's countryside. To me all of Italy had a soft golden hue.

Vernon spent the first two days at the bank. Numerous telephone calls finally established that our money had arrived in Naples and more telephone calls and a few telegrams assured us it would be sent to our bank in Verona immediately.

*Immediately* may mean something else in Italian. Vernon decided he couldn't wait that long and saw no reason not to leave to get the bus. The bank manager helped draw up a document authorizing him to give me the money when it arrived. With assurance that in a day or two I could draw money and forward some to Vernon, he left for Antwerp, taking all but twenty of our remaining eighty dollars with him.

Verona is a beautiful old city. Ancient walls surround it and a river writhes gently around the walls. Our fifth-floor windows opened onto a balcony overlooking one of the ancient city gates and a broad avenue leading to the town center. The Montagues were just around the corner and the Capulets were on the other side of town. A coliseum, one of the best preserved in Italy, was in the very center of town.

Our landlady rented us three rooms, previously occupied by the obliging women who had moved into other quarters in the building. During our stay, she set up a bed for herself each night

in the kitchen. A pretty blond occupied the fourth bedroom. A man we never saw slept in the dining room on a couch. He came in after we went to bed and occasionally I heard him arguing with the Signora. He was gone when we got up in the morning.

The blond had a lot of dates. She spent much of the day standing on her balcony, next to my room, waiting for someone—always someone different, it turned out. She told me she had a very, very good friend who was an American officer at the United States Air Force base on the edge of town. She had *many* good friends in the American army.

Court recovered quickly from his illness and the day after Vernon left we were ready to start sightseeing. The Signora served our breakfast of coffee, hot milk, and crisp rolls with apricot marmalade. Our first destination was the bank, where we would be able to pick up our money.

We walked the few blocks, window-shopping along the way, and were fresh and enthusiastic when we came face to face with the gentlemen in the foreign exchange department. There had been a delay, he explained in his charming Italian fashion, but he was certain the money would arrive the very next day.

We stopped for *gelati* and coffee at a nearby ice cream shop and then walked some more.

We were ready for more adventure by dinnertime and returned to a nearby family-style restaurant. We were seated at a big table while Papa, Mama, and two sons hovered over us to help us order—veal Milanesa, spaghetti and salad. As dinner progressed, they petted the children, mopped up spilled glasses, and took turns showing us how to wind our spaghetti. A large decanter of wine was on the table and, as on the ship, even the small children were allowed a splash of wine mixed with water—a *lot* of water being the rule. We were surprised at how inexpensive such a good meal could be.

The following morning I went to the bank by myself. The foreign exchange manager was happy to say the money had arrived but it would be impossible for him to give me any of it. I was *not* the head of the family by his terms.

I referred to the paper Vernon had signed authorizing them to give me the money.

"I am so sorry," he said. "Possibly when my superior officer arrives, this could be managed. Unfortunately he is away from the city, but he will return tomorrow."

That afternoon I went to the American base on the outskirts of town and, with my military dependent's I.D. card, was allowed to cash a check for a hundred dollars. Cashing personal checks was not an accepted practice but the sergeant who authorized it was a sympathetic father of six. I gave the Signora fifty dollars and she agreed to wait for the rest of her rent money.

Each day I did our laundry in the bathtub using the Signora's method. I filled the bathtub with cold water (hot water was a sometime thing), soaked the clothes, then spread them on a smooth wooden plank and rubbed them with a cake of brown soap before scrubbing them with a stiff brush, removing both dirt and fabric. I hung the clothes to dry on lines strung from a small balcony that extended over an inner courtyard.

Luciana, a little girl who lived next door, visited us frequently and the children clustered together to jabber and laugh as they exchanged Italian and English lessons. Luciana was only nine, not quite as large as six-year-old Vicki, but she took her teacher's role seriously. Our children were soon confidently using their increasing Italian.

Our days were filled with washing and mending, shopping in the little market on the street floor of our apartment, and trips to the bank and to "our" restaurant each evening.

Firm economy measures were still needed. At dinner that night we decided to order only six of the very large portions of spaghetti. We went without the meat and salad. The family at the restaurant may have heard of our plight from the Signora. They supplied plenty of fresh rolls and a decanter of wine. The children had theirs with the usual dilution of water.

That night Jill pointed out that Kara had hardly touched her spaghetti. "Looks as though she has a fever, Mommy."

Kara didn't look well. Thinking she might have caught Court's bug, I took her temperature when we returned to the apartment. It was normal, not a matter for concern but something to be watched.

After dinner the foreign exchange man at the bank telephoned.

He asked after the children's health, then invited me to join him for dinner. I said I had just eaten but would look forward to our visit the next morning.

We took a few local bus rides but discovered a danger there, too. Italian buses, like their trains, move on a precise schedule. When the bus stopped there was time for five or six people to disembark—not nine. After chasing a bus for several blocks one day to retrieve Vicki and Jeff, who had not had a chance to alight with the rest of us, we abandoned buses. We bought a used baby carriage at the U.S. Air Force base, making sightseeing easier on little legs.

Our most pleasant hours were spent in a park across the street from the apartment. Luciana joined us there after school to play and chatter at us in Italian, expecting by her very exuberance to make us understand. Italian schoolboys played with Jeff and Court. Italian soldiers, in their exotic plumed headgear, flirted with Christie and Jill. Ancient guard posts became good hiding places for the children. We took simple lunches of bread and cheese and ate in the park, away from the eyes of the landlady, who was increasingly anxious about the rent.

Nevertheless, as the days passed she and I became friends. She was a middle-aged woman, trim and dark-haired. Her first reaction to us may have been one of intense warmth but it would take a saint to maintain that attitude in the face of eight exuberant youngsters.

I could hear her on the telephone telling, I fancied, of the plight and exploits of her American guests. I thought I detected something about a mother and *otto bambini* abandoned on her doorstep by a strange man late at night. But each evening she invited me into her kitchen for a talk and a glass of Pascua wine, a sparkling, fresh white wine that is available in Verona near Easter.

After several of these evenings in her kitchen we were able to communicate pretty well. My reasonably fluent Spanish, lightly laced with Italian, plus an Italian dictionary, made conversation possible. With Vernon away and our financial situation worsening, I was grateful for any sympathetic, adult companionship. As the days went by she became less resentful about the rent and increasingly resentful about my husband, who had left for God

knows where. I tried to explain about the bus that was to take us *everywhere* and about our careless friend who didn't think money important—for us. By the end, she even offered to lend me money.

If Kara wasn't going to eat her spaghetti, there was no point in ordering so much. That night we ordered five plates and again divided the portions. Again Kara seemed flushed and her eyes were bright but I could find nothing wrong with her. The rest of us were certainly in good health. It couldn't have been the food or the water.

As I was overtipping the waiter 1000 lira and while he was handing it all back to me, trying to explain the exchange rate, Vicki and Kara swung past, arm in arm, singing their version of "O Sole Mio." The waiter smiled broadly. Everyone in the restaurant found it charming. I, at last, realized what was wrong with Kara. No more could I let the children pour their own wine!

Vernon called one evening. "I'm still in Antwerp. The bus lost its transmission but I've found a replacement. I'll be a few more days. When are you sending the money? I've been writing checks but I doubt that there's any money in our account."

"I'm doing my best," I said. "I still hope the bankers will turn over our money. We'll just have to make do."

"No such thing as a problem" was *his* theory, after all, not mine.

Each morning I went to the bank. The superior officer arrived two days late. He had had a splendid vacation and enjoyed telling me about it. "It is good to get away from home and business cares for a while," he said. "Nothing could give me greater pleasure than to give you the money but it is out of the question. The name on the check distinctly says Vernon Johnson. You, Signora, are not Vernon Johnson, right?" His reasoning was impeccable.

My solo visits to the bank continued. First I would play the part of the charming woman and, when that failed, would switch to the part of the pathetic mother of eight hungry children. They preferred the first but I played the second role with greater skill. They continued to be charming and logical. "You should call your husband," they said.

"I am unable to call him, but he has called me begging me to send him money."

Their decision was unchanged. Yet the foreign exchange manager had called to ask me to dinner and his superior offered to show me the town.

Ingenuity was called for. Ten days had passed when I assembled the children and we went to the bank together. It was a Saturday and on Friday I had been told the bank would close at noon.

"On signal," I directed the children, "you are all to cry."

We walked into the bank. The children filled the available seats along one wall and I resumed negotiations. An hour went by. The little ones were restless. I scrambled the signal for tears and I began to cry. My banking buddies looked the other way in resolute silence. They were not going to be outwitted by a woman simply because she had a basketful of children.

When a vendor passed the bank windows with a bouquet of enormous, red, helium balloons the purchase price didn't seem to matter. Christie dashed out and bought four.

Andy let go of the long string on his balloon. He bellowed and Jill climbed on a chair to retrieve it from the ceiling. Kara was closer to the center of the room when she lost hers. She cried so mournfully that one of the clerks climbed onto his desk to reach the ribbon. Andy decided he didn't want his balloon tied to his wrist and howled. With a calculating look, Vicki let hers go, once again over the area where the clerks were working. Their ploy made more sense than my tears.

At noon a teller locked the front door of the bank. The clerks stayed to finish their work. We stayed, too. Balloons continued to search out the ceiling and the children continued to fuss and cry. I didn't think I could stand it for another minute, when my two admirers emerged together from the rear office. The superior said quietly, "Mrs. Johnson, we have agreed to give you one hundred dollars. We will send the balance to Mr. Johnson. Will that be satisfactory?"

I picked up the money, the children, and the red balloons and marched proudly out of the bank.

# Chapter Nine

TEN DAYS HAD PASSED. What would I do if Vernon never returned? The only thing that gave me reassurance, the bottom line, was my belief that the American Embassy would always lend me money to return to the United States. Who knows where I picked up that idea? (Yes, Virginia, there is a Santa Claus, and an Easter Bunny, and if I didn't step on cracks, I would be just fine.)

The phone rang one morning while the Signora was out shopping. I answered it, although the chance of it being someone who spoke only Italian was probable.

It was Vernon's voice. The relief I felt in hearing from him was enormous. "Why don't you look out the window?" he said. I called to the children and ran to the window. There he was, waving to me from the telephone kiosk across the street. The children were out of the apartment and clattering down the marble stairs before I could catch my breath. I had to wait my turn to hug him.

"Can we leave right away?" asked Jill.

"Of course, we will." I turned to Vernon. "What took you so long?" We had moved to the neighborhood ice cream shop to celebrate with gelati and café espresso.

"Well, first of all I arrived there on the first day of a three-day holiday and couldn't get the bus out of storage. When they did open it, I didn't have any of the right papers and, of course, I knew the engine numbers didn't match our papers."

"But after shuffling and explaining, the customs people de-

cided to let me go. That first day was just the tip of the iceberg."

The shipping agent said there was a sizable bill for heavy lifting, dockage, and storage. Vernon wrote a personal check, prayed his bank account had been replenished, and climbed into the bus. Some stevedores gave him a push to kick over the engine. It went a short distance, sputtered and stopped. For safety, the gas had been drained before the bus was put on the ship in New York. "I could only buy a few gallons as I was so broke and the money was still in the bank here in Verona. But I felt great! At last I was at the wheel, plunging down the cobblestone streets of Belgium, driving through a small village, windows wide open and full throttle. I was on a rousing chorus of *Il Trovatore* when the engine clattered as though going into reverse and second gear simultaneously."

That was the end of another transmission. Vernon found the European Ford assembly plant right there in Antwerp. The manager was cooperative but held out little hope. Vernon headed for the nearest bar, where he ran into a young Air Force pilot who had a friend who had a friend who was a mechanic on old buses. He knew where there was a bus like ours.

"The next thing I knew, we had a new transmission, the mechanic was ready to help me, and the money arrived. I had a slight setback in that I couldn't shift into low gear or reverse. I had to be on a hill when I started the bus and try to avoid dead-end streets. In Frankfort I found a mechanic who fixed that problem but second and third were slipping a little and I still had to get through the Alps."

Then the weather turned warm as he drove through Germany and it became apparent that although the gas tank had been properly drained before leaving New York, the portable toilet had not. He tried to find a filling station where he could empty the bucket. The Associated Press story had somehow caught people's interest and wherever he stopped there were people who had read the story. He found himself unable to ask them where he could empty the bucket.

He stopped in Munich for dinner. At midnight he was finally able to tear himself away from an impromptu party that had formed around him. In order to rest a while, he pulled off to the side of the alpine road, warmed only by a covering of maps and

newspapers. At dawn he drove out of the mountains and onto the sweeping Lombardy plains. There, in isolated splendor, beneath rows of fluttering banners, was a Shell service station.

"The bus had begun to warm up and I was a bit queasy from the previous night's celebration. I guided the bus carefully into the driveway of the station, turned off the ignition and slumped at the wheel. Then two men came out of the station and one of them rapped on the window and offered me a cold, dry martini."

Vernon left the bus as more people appeared. They shook his hand and a photographer took pictures. On the spotless grease rack were platters of cheese and cold meats. It seems he was the first customer in their new business. He couldn't possibly ruin the image by emptying a reeking potty.

When he arrived in Verona, the bucket still had not been emptied. I don't remember who finally took care of it. I suppose I did, but my mind has rejected the memory.

The next morning our friends up and down the street were there to wave to us as we drove away—the Signora, the restaurant family, the pretty blonde, the shopkeepers on the first floor, and Luciana.

This time we all agreed that the trip had really begun as we headed for Naples to collect our camping gear.

# Chapter Ten

IT WAS A SUNNY APRIL MORNING when we rode along the two-lane highway lined on both sides with towering poplars toward the northern Italian town of Iesi. As he drove Vernon was deep in his memories of an earlier time in Iesi. Even the children were quiet as we accompanied him on this pilgrimage.

"That's the house," he said as he pulled the bus to a stop near an ancient two-story stone farmhouse. "I wondered if I would recognize it but I know now that I could never forget it." He climbed out of the bus and walked with his faint limp slowly toward the house. I knew he was thinking back to 1944 when he had been a twenty-three-year-old pilot of a four-engine B-17 bomber, known as a Flying Fortress, on bombing missions from Italy to Germany, Austria, Hungary, and the Ploesti oil fields.

On Thanksgiving Day he had volunteered for a night bombing mission for which he would receive credit for two missions, bringing him closer to the twenty-five required to finish his tour of duty. He hadn't yet seen Jill, who was only six weeks old, and he was anxious to get home. All but one of his regular crew volunteered, too. There were fifty-percent losses on those night flights but the double credits and youthful optimism made it appealing. The Air Corps* didn't risk their best planes on those flights, only their strong young men.

---

* The term was the Army Air Corps at the time, becoming the Air Force later.

45

It took several hours to gain 20,000-feet altitude with a heavy bomb load on those long flights. Over the northern Adriatic, about an hour after take-off, the co-pilot warned of runaway number four engine. Feathering the engine didn't help; it was heating rapidly. They would have to return to their base.

There was no panic at this news. It was possible to land with three engines. They unloaded their bombs over the Adriatic but the engine was still heating and began to glow with a reddish color. The radioman sent an emergency Mayday call and received an answer from a nearby Canadian base at Ancona. They set their course and prepared to make their approach when the Ancona tower notified them of a crash on the runway. "There is a small emergency field at the town of Iesi just a few miles to the west," they said. "You will have to land there."

"There's still time to bail out," Vernon told his crew.

"Ah, you can do it, Skipper," was the answer. "We'll stay with you."

They were preparing for landing when number three engine began to burn. There was no choice but to keep going. As they made their approach only a faint string of lights guided them to what seemed to be the runway. There was no choice. Vernon lowered the wheels and in the plane's landing lights they could see a cleared field. Then, just as they touched down, a solid, two-story stone farmhouse appeared directly in front of the plane. Vernon pulled back on the stick, applied full power, and pulled the plane up. They cleared the house but crashed to the ground beyond it.

He sat in his seat, unable to move his legs, the sound of ammunition going off in the bomb bay behind him. "I knew I was dying," he told me later. "And I knew that was all right if only the men would stop screaming. Everyone was screaming." And then he passed out.

When he regained consciousness he was on the ground beneath a huge wing, and everything was on fire. He apparently had been blown through the side of the plane by the explosion of the oxygen tank beneath his seat. His bulky flight uniform was burning and he could not move his legs or his right arm. "But my left arm was moving almost without my will," he said. "It just kept pulling me away from that burning hulk." And he fainted again.

Vernon was taken to a monastery hospital that night and spent the next two years in a series of hospitals as his left leg was amputated, his right ankle fused with metal screws, and skin grafts transplanted to the deep burns. With the exception of the tail gunner and one waist gunner who walked away when the plane's tail fractured in the crash, he was the only survivor.

Sixteen years later, he stood and stared at that farmhouse that had been burned into his memory in the landing lights for those brief moments before the crash. Then he turned slowly, and we returned to the bus and drove in silence back toward the coast. He always believed he died on that wartime Thanksgiving night and was given a second life.

# Chapter Eleven

WE WERE CAMPED ON A BEACH on Italy's eastern coast
on the night of our visit to Iesi when we first heard Court tell bed-
time stories to his younger brothers and sisters. With the night
black outside our windows, the faint sound of waves splashing on
the shore, and whisper of wind in the pine trees overhead, Vicki
said, "Courtie, tell us a story."

Court's stories had been much in demand back home in San-
ta Barbara but I had never heard more than whispers, occasional
groans, and blanket-muffled laughter coming from their part of
our house. In those days Saturday nights often meant a pajama
party for friends. Some nights they camped out in the Pump
House, in the Play House, or even in the shed they called the
Monkey House—a bizarre assortment of outbuildings on our
two-acre parcel. Maybe they slept at "The End of the Lot," or in
the dark shelter of a huge avocado tree. But wherever they slept,
Court's blood-curdling stories were welcomed.

The younger children had repeated garbled versions of his
tales while I made Sunday morning pancakes but Vernon and I
never had a chance to hear them first-hand—until that night on
the Italian coast.

Softly he began a ghost story they had learned at school,
"Walking Through the Woods." It concerned the travails of a
young person who took a very long walk pursued constantly by a
large animal that repeatedly roared, *"Aarrgh"* and kept drawing

nearer and nearer. As Court said, "You see, this guy was running through the woods...*Aarrgh*...and he was all out of breath... *Aarrgh*...and he came to this river, see, and he splashed and he puffed and he turned around and he saw...*Aarrgh*."

At that point, three-year-old Andy whispered, "Mommy, where is you?" I cuddled him close to me as the story continued.

As we continued our journey, spending nights beneath the pines of Rome, the chestnuts of France, or the birches of Russia, we learned to wait with baited breath for the terrible beast who shouted *"Aarrgh."*

We should have known our clever eldest son could have told blood-tingling spook stories so creatively that a knife in the back dripped unexpected catsup and the death of a particularly gooshy worm brought murmurs of delight from young siblings. With the curve he could put on a story, Frankenstein became a kindly crank with whimsical motives and Dracula spiked drinks with mirth-provoking Mickeys. Horror was followed by laughter. In the silence following a story, eight-year old Jeff said, "Good old Courtie," and Andy again whispered, "Mommy, where is you?"

It was raining when we drove across the Apennines the following night. Flashes of jagged lightning fractured the blackness, followed by long rolling rumbles of thunder. While the children slept, I sat beside Vernon, willing our bus to make it over the next hill.

At a stop for fuel in a small village the attendant had pumped several liters of diesel into our tank before we noticed the error. Although it was topped off with gasoline, for the rest of the night the bus suffered a digestive upset, alternating genteel burps with unabashed flatulence.

Determined to reach Naples and retrieve our camping gear, we slogged on through the night. Every few miles the sudden glow of a small red light on the instrument panel reported the imminent failure of the air brake system. Vernon had to pull the bus to the side of the road. I hopped out and slammed a large block of wood behind a front tire. Vernon gathered the necessary tools and I followed him with flashlight and tarpaulin to cover both the engine and him while he again tightened the copper tubing that had vibrated loose on the rough road.

Just after midnight we were stopped at a police checkpoint and asked for passports and documents certifying the legitimacy of our quite illegitimate bus. We still had California plates and we knew the numbers on the replaced engine did not match the registration slip. I was anxious to be cooperative with my recently acquired Italian but Vernon, who loved to challenge authority in his unique, gentle way, knew better. "Let me handle this," he said.

Feigning stupidity with an intense sense of cooperation, he spoke English in a loud voice. He obligingly presented documents, one after another, none pertaining to a vehicle. He pulled out our marriage license. The officer shook his head and repeated his quite understandable request. Vernon continued in English and proceeded to offer vaccination records, birth certificates, and passports. He held up eight fingers. "Eight children," he said proudly.

The officer peered into the bus. *"Otto bambini!"* He shook a limp hand in characteristic Italian style. *"Mama mia!"* His approval was enormous. A father of eight, whose premature gray beard and smiling eyes made him look like a biblical prophet, was obviously an honorable man. The officer bowed to me, the sainted mother, climbed down from the bus and waved us on.

We slogged on through the darkness and downpour. At dawn we pulled up to the docks in Naples, parked in front of the customhouse gates, and slept.

# Chapter Twelve

WE WERE REUNITED WITH OUR BOX of camping gear in the customs office. The inspection of the box was performed by one of the officers, who poked through it with a long metal bar. I don't know what he expected to ram. Maybe the motley assortment convinced him it should only be touched with a ten-foot pole

We dragged ourselves out of customs, exhausted from lack of sleep. The bus fired on five of its eight cylinders, with a loose muffler that had jarred loose on one of the last bumps. A small crowd was standing at the gates waving and clapping as we entered the main street. We assumed the Associated Press story had somehow appeared in Italy.* It lifted our sagging spirits. We returned the waves and nods, assuming the gracious air of royalty in a gilt and crystal carriage.

It was Vicki, however, who figured out the applause, "They're clapping for my curly hair," she said modestly. It has since become a stock phrase in our family.

We drove on through Naples in search of a campground suggested by the customs men. It was located on one side of the crater of Solfatara volcano, near the Neapolitan suburb of Pozzuoli.

---

* In early April the *Rome Daily American* had published a story with the headline "$20,000 Windfall? Buy Old Bus, See The World." We were to find that each country had its own angle on our trip.

On arrival the overheated bus itself resembled a volcano, bubbling, breathing fire, and not quite dormant. By removing the side mirrors we were able to squeeze through the narrow entrance.

The camp was a dream, surrounded by lacy green trees, velvety turf, wild flowers, and a smattering of campers. There was an electric outlet for an extension cord and we were able to rent a small tent and two cots. Sinks and showers were clean and we hoped to get used to cold water. Mud pots on the far side of the crater bubbled ominously, rising like the tide each day to make a small lake on the far side of the crater floor. A small cave, accessed by crawling through a low entrance, furnished the steam baths noted in the camp's brochure.

There was a canteen on the grounds and a man came each morning with fresh milk and crisp rolls. Within walking distance were small shops that sold meat, wines, and pasta.

We returned to regular meals—regular in the sense of quantity and variety, on a very elastic schedule. The children were becoming Italian and felt they hadn't eaten if some form of pasta wasn't served. The local foods filled me with a wild sense of creativity and I produced sauces that would never have occurred to me at home. With string shopping bags in hand I gathered small plum tomatoes, tiny artichokes, bits of veal, big wedges of cheese, and olive oil. Fresh fruits and new wines were exciting.

We took a couple of days reorganizing the bus. Although a forty-five-passenger bus seems large, there was not much extra space after loading ten bodies of assorted sizes and a year's supply of clothing and basic necessities. The two doors were on the right side. Behind the driver was a petite kitchenette. Next came an impractical tiny bathroom. While we were in the United States we had found ways to empty the portable toilet (bucket) but European service stations and campgrounds offered no such convenience. The space was soon used as storage.

Our presentable clothes (one outfit per person) were hung in the two ten-inch-wide closets on either side of the tiny bathroom. Each person was allotted a section of the overhead bins for storing clothing.

Long seats with removable padded backs lined the sides around the rest of the bus. The backs could be laid on the floor

and used as beds. Sleeping arrangements were definitely toes to nose and we soon learned to roll over with our sleeping bags without falling off the edge. Court joked, "We're so close together that if you scratch your own back someone says, 'Thanks. Just a little higher and to the right, please.'"

Out-of-season clothing was packed in suitcases or duffel bags and stored in the luggage rack on the roof. This held a lot but was accessible only through a hatch from the inside of the bus. Removing a suitcase was like pulling an impacted wisdom tooth. The luggage rack was tall enough to create potential difficulty beneath some bridges, which always bore a sign noting clearance height. Only twice did we actually have to stop, remove everything from the rack, drive under the bridges and reload. Whenever Court found life dull, he would sit beside his father and call out, "Three meters and twenty-five centimeters" or a number just under the actual height of the bus. Vernon would hit the brakes. Court loved it.

Every inch of storage space was assigned to food, sleeping bags, pots and pans, typewriter, or shoes. A shelf beneath the rear windows held our books and our sewing, writing, and drawing supplies. We could have taught Einstein something about the relativity of space. One of the rear windows was covered with a new American flag, and the California Bear Flag was tied across the front of the bus beneath the windshield. The destination window that had once spelled out its Santa Barbara route now said "Around the World" in Italian.

Little did I know that we would eventually find space for two guitars, a trumpet, a mandolin, a folding ping-pong table, benches, two large Oriental rugs, a tent, ice skates, and a cast iron statue of Don Quixote.

At the end of the first week we had settled into a comfortable routine. Vernon, always abominably cheerful in the early hours when I preferred to mull over the day's problems, dressed first, singing noisily before announcing, "All out for PT!" This shred of acceptance of his military Physical Training in the Air Force had the proper ring of authority. Somehow he had the idea that we were all going to become soft on this leisurely tour and he was

determined to keep us in fighting trim. The rest of us scrambled for clothes amid complaints of being pushed and accusations of stolen socks and T-shirts. With the sleeping bags rolled and stored, Vernon assembled the group and put them through a series of pushups, jumping jacks, and deep knee bends.

At first I joined them, but the ferocity of appetites after the PT routine convinced me I should concentrate on preparing a hearty breakfast. It was a valid excuse.

# Chapter Thirteen

FROM THE HILL ABOVE OUR campground in the very crater of Solfatara volcano, on the outskirts of Naples, we could see across the bay to Vesuvius. With the help of garrulous Neapolitans we slowly learned our way around the city. *"Sempre direto,"* they always said. It meant straight ahead. The fact that few streets in Naples go straight for more than a block added to our adventure but slowly we found our way through the city and around the bay to the ruins of Pompeii.

For days we read the history of the ancient city, soaking ourselves in its lore. We arrived in Pompeii early in the morning, walking on streets that led us back almost two thousand years when the city had been buried in ash and left to sleep for centuries beneath an impenetrable blanket. Our visit was in April and there were so few tourists that our memories have convinced us we had the place to ourselves.

Court and Jeff were drawn to the underground rooms. The little children climbed to the top of each small hill and jumped along the center stones in the streets. Christie and Jill took off by themselves, determined to be teenage tourists without the handicap of elderly parents or younger siblings. I felt drawn into a bygone life as I walked slowly through the remains of homes and shops. I stepped into one and visualized fresh loaves of bread being taken from the deep ovens, golden brown loaves dappled with small chunks of grain that had escaped the crush of the stone

mills. Olive oil would have been dipped from a deep vat sunk into the red-tiled counter and I would have received it in a delicately wrought ewer. From yet another vat the vintner would have ladled a jar of dark red, heavily scented wine.

With a large bowl of figs and purple grapes with lusterware skins, my meal was complete. In my reverie I was properly gowned in a soft white toga that hung gracefully from my shoulders. The chatter of a pair of camera-toting tourists snapped me back to reality and I became aware of my practical, wash-and-wear dress and the camera hung on its leather strap around my neck.

I wandered on. My husband was talking with guides who were anxious to sell post cards. Always a sucker for a salesman, Vernon bought an assortment. "Our friends will enjoy these," he said.

I glanced briefly at the cards featuring unclothed men and women in timeless poses. "You bet they will," I said. "But these may keep the postman from his appointed rounds."

At the end of our first magic day in Pompeii, Vernon and I became the audience in a small stone amphitheater while the children climbed onto the stage to sing their new Italian songs.

I shopped for dinner that evening, lost in my dreams of the past, as though in a time warp, walking from our campground along a cobbled path, with a view across the bay. The swarthy woman in the dark recesses of the oil and wine shop down the road from the camp lent me a bottle for my olive oil. I remembered the graceful jug of my earlier visions. I left her shop and picked my way along the path, looking out towards the islands of Capri and Ischia. The housewife I might have been two thousand years ago would have had the same view.

While I selected a basketful of tiny, gray-green artichokes, I told the smiling man who was helping me of my large, very hungry family. "*Otto bambini. Molto fame.*" He responded with the now familiar, "*Mama mia! Otto bambini!*" He waved his wrist expressively and dropped two more artichokes into my basket before escorting me to the sidewalk with exaggerated gallantry.

What joy there was in being, for a short time, with people to whom motherhood was next to sainthood in a culture that spanned the centuries. I readjusted my halo and strolled back to prepare dinner for my family.

# Chapter Fourteen

OUR CAMPGROUND IN ROME couldn't have been more beautiful and we found the perfect parking place beneath tall pines, with a view of the hills of Rome and the lights of the city. The camp was in a residential area, part of a large wooded park. There was a drinking fountain (only one, but near the bus), cold-water showers, laundry basins, flush toilets, and bidets. I was successful in convincing the children that the latter were not, repeat *not*, drinking fountains.

The ridged stone washboards on the side of the laundry basins were built for much shorter women than I. With the aid of brown bars of Italian soap, clothes came out clean even in cold water. Our area was always strung with lines of drying clothes.

A young American woman claimed the cold showers offered fresh vistas for adventure, that in the first stunning blast of icy water one found oneself suspended in time and space and, given the proper outlook, could even conjure up momentary visions. I continued to regard the showers as cold water.

The Metro was a short walk from camp. Even that was fraught with dangers. On our first trip into the city we were startled when Andy darted out the door and across the platform at one of the stops, making a beeline for a candy machine. Christie grabbed him just as the automatic doors were closing and asked, "What were you doing, Andy-Bo?"

"I was just looking at the candy," he answered.

57

Kara sat quiet and wide-eyed through the ride. Then she said, "Are we really under the ground?" I reassured her of our safety but that was not her concern. "Where are the worms?" she asked.

The subway was like a time machine. We passed through concrete tunnels with brilliant lighting, up the steps, and into the sunshine. There directly in front of us was the Coliseum, old and worn, just as in my high school history books. We were learning to ignore the vendors who wanted to sell us post cards or even let us buy pieces of a cherished family collection of priceless cameos. Court and Jeff chased each other to the top tiers of the seats and peered through the ancient arches. Vicki and Kara followed the scrawny cats, pale reminders of their more noble ancestors who had participated in bygone sporting events.

Over the next few weeks we would get to know Rome, from the Coliseum to the wedding-cake excesses of the Vittorio Emanuel Monument and all the churches and museums in between. At the Trevi Fountain I was prepared to toss coins into the water but restrained the urge when no one seemed certain whether this gesture signified longevity, a return to Rome, or fertility. The odds were in my favor but I couldn't afford to gamble on the outcome.

The four youngest children were happier spending time in simple play around the camp than in sightseeing. The rest of us took turns staying with them. We chose the sites we wanted to visit and two or three of us went by bus or subway, avoiding a group project. This also gave Christie and Jill the opportunity to move around alone and to test their newly acquired Italian vocabulary.

At first, I was reluctant to turn my teenage daughters loose, but Vernon had faith in their common sense and their growing travel know-how. Their knowledge of the language was increasing and they used ingenuity in choosing places to see, studying maps and learning bus and subway routes.

Jill wrote about one venture into Rome: "We asked the man at the ticket window and he told us to take the red bus. We saw it and ran across the street and I jumped on. However, dear ol' nearsighted Christie was left peering through the door after it closed. I yelled and pointed to her as the driver started to leave and screamed, *'Espere, espere!'* And Christie just stood there laughing. When we arrived at the *Giardino Zoologico* the driver and everyone

started giving directions and then they all yelled goodbye. As soon as we walked in the gate two fellows came up and in broken English said, 'We are good boys. Would you like to go through the zoo weeth us?' We said no and dashed off but they followed us. We pretended to be fascinated by a buffalo so they left, guessing we were off our rockers. At the next turn there were ten or twelve boys heading for us asking, '*Sprechen sie Deutsch? Parle Italiano? Speek Eenglish?*' We ignored them but they insisted on following. Christie turned and made a four-second mile for the zebras and stuck her nose through the cage looking at the zebras as if they were going to disappear...."

The chase continued through the zoo with new relays of young men joining the fun until, "...we decided to leave the zoo. '*Uscita*' (exit) was on a nearby sign so we took that path. The door was locked though, and we wound back around. When I wasn't looking Christie took a different path. I looked all over for her because I was carrying all the money and was just about ready to give up when she came running up, being chased again, and mad enough to spit. She said, 'I'm leaving.' I agreed and we started down another blind path. That did it. She hated Rome and wanted to leave *right now*. It was pretty funny, though, because we couldn't even find a way out of the zoo."

After talking it over they discovered they had learned their first lessons about wandering in foreign countries. Running away, they decided, looked too much like a game and invited a chase. A fellow camper provided the next lesson. Our American fashion of waving goodbye means 'come here' in Italy. They'd spent their afternoon at the zoo alternately running and waving goodbye to their unwanted companions. "Those boys must have thought we were nuts."

Christie and Jill had a sort of club of their own. It was only logical that they found their mother too demanding and their eleven-year-old sister Jenda a general pain. Court and Jeff had formed a union that eschewed feminine membership. Jenda was ready to be interested in almost anything I suggested and was a good companion.

One Sunday morning Jenda and I went to St. Peter's Cathedral. She may have expected to be invited inside to meet Pope

John XXIII. This optimism was probably a variation of her father's positive thinking, but it paid off. We walked from the bus stop through the enormous colonnades that ring the *piazza* in front of the cathedral just as the Pope came out on the balcony to address the crowd below. It was as satisfying to us as a special audience and we were the only ones in the family who, from that day forward, could claim to have been blessed by the Pope.

Vernon spent several mornings in the Soviet Embassy trying to find someone who spoke English. The building was typical of the Soviet embassies we encountered throughout our trip, with entrances bolted, iron gates, peephole windows, and a series of empty rooms filled with booklets about the wonders of their nation.

He finally found a man who assured him we would have no trouble obtaining a visa for a two-week visit in the Soviet Union. Then Vernon popped the crucial question. "Can we drive our bus across Siberia?" This cracked his diplomatic reserve.

"Maybe you could phone Moscow and get an official opinion," Vernon said.

The official said he would do so but suggested we wait and apply again from a border country when we were ready to go into Russia, probably hoping he would not hear from us again.

"At least someone knows our name," Vernon reported. "Maybe our request won't be such a shock next time."

On the last visit to the embassy Vernon drove the bus and we all went with him. The children were good evidence we weren't about to bomb any bridges. After running the gamut of gates and peepholes, we were received cordially. The children were given their share of booklets—Russian stories for children printed in English. They carried no obvious political message.

The consul himself accompanied us to the bus when we left and we were delighted to see his incredulous expression as he examined our California state flag on the front of the bus, which shared a couple of well known Russian symbols—a brown bear and red star. It was the end of April and we felt we had made some headway, but it was a temporary step forward.

On May 1 the Russians downed an American U-2 spy plane

and captured the pilot, Gary Powers. Tension between our two countries mounted again. The United States issued a statement that the plane had been on a weather reconnaissance mission, but when President Eisenhower acknowledged knowing of the mission and defended it, Khrushchev called a halt to the summit meeting scheduled for May 16. Both sides appeared but it broke up when the West blamed Khrushchev's rigid stand and he insisted that Eisenhower apologize for the spy plane.

# Chapter Fifteen

WHEN WE ARRIVED IN ROME the film *La Dolce Vita* had just won the sweepstakes at the Cannes Film Festival. Throughout Rome large billboards displaying the voluptuous charms of Anita Ekberg competed with views of ancient ruins. My husband admired the Swedish beauty but, as we also seemed to be living The Sweet Life, he seemed content to settle for me.

We planned to stay in Rome for several weeks and I developed a few innovations for my al fresco kitchen. It consisted of Andy's baby carriage covered by a large square of plywood on which I could set up the three-burner camp stove. Dishes and ingredients for dinner were placed on a large wooden crate (retrieved from the camp trash bin) next to the stove, partially supported by the bus's front bumper. Although the bus had a small icebox, we were seldom able to obtain block ice. Perishables had to be purchased on a daily basis but I enjoyed my morning shopping in new markets. Unusual foods made meal preparation challenging. Fortunately the children had developed insatiable appetites for pasta—a new shape and sauce each day.

On a balmy evening a week after our arrival Vernon and I were sharing a bottle of wine while I prepared a freshly invented sauce for our pasta. "I found some wonderful new cheese this morning," I said. "Guess I'll use it with fresh tomatoes and the little clams we found at the market."

While the pasta water came to a boil, Jeff and Court hauled

water for after-dinner cleanup. Andy pretended to help with his tiny red plastic bucket. Kara and Vicki played with their dolls beneath a big pine. Christie and Jill sat on the front steps of the bus trying to duplicate the new bouffant Italian hairstyle. Jenda was torn between dolls and hairdos.

Vernon gazed into his cup of wine. "Life couldn't be much more *dolce* than this, could it?"

A copy of that day's Rome *Daily American* lay on the table with a headline reading, JOHNSON AND FAMILY STARTLE ITALY WITH OUTRAGEOUS BUS. It continued, "Vernon Johnson, a man with a fine beard, a charming wife, and eight very blonde children, is threatening to set the well planned travel tour back 50 years." The reporter and Vernon had met outside the Soviet Embassy. The California flag on the front of our bus had triggered the reporter's curiosity. He and Vernon spent the rest of the afternoon at our picnic table swapping stories and sipping wine.

The reporter had quoted Vernon as saying, "It looks like Khrushchev didn't do us much good with his hysterics in Paris. I was tempted to send him a cable telling him to quit lousing up our trip."

I thought Vernon had taken it a little too personally.

While I fussed over dinner, Vernon sipped his wine. "It's a pretty good interview. Maybe this publicity will help us get permission to cross the Soviets."

Although crossing the USSR was the ultimate goal in my husband's mind, I tended to think of it with the thrill of being thrown into a piranha-stocked pond. I refilled my wineglass.

Vernon turned his head as a sky-blue Mercedes convertible pulled to a stop next to the bus. The driver was a handsome Italian with dark glasses, a gold medallion nestled in dense chest hair in the V of his open-necked shirt. His companion was a spectacular blonde. She opened her door, rose on two shapely legs sleekly encased in black slacks, drew her shoulders back thus filling a clinging white silk blouse, and sauntered toward us on stiletto heels.

"Mr. Johnson?" she asked. "I wanted to meet the man who is willing to talk back to Nikita Khrushchev. My name is Anita Ekberg and this is my very good friend Franco."

There were anguished moans from the beauty parlor. The boys stared. I wiped my hands on a towel and tried to regain my poise.

But it would take more than the star of *La Dolce Vita* to ruffle my husband.

"How good of you to visit us," he said. "Join us for some wine?"

Court and Jeff pulled up another bench. We poured wine into plastic mugs and settled down to get acquainted. Vicki, who even at the age of six had a predilection for Latin men, was soon sitting on Franco's lap. Christie and Jill settled for their normal hairdos and joined us. We poured more wine and found our guests to be as entertaining as they were decorative.

Before an hour had passed Anita invited all of us to go with them the next day to a party at a large Italian farm not far from Rome. "It will be wonderful if we can all ride in your bus." She spoke with the confidence born of success.

"We'll see you in the morning," said Franco as he helped her into the car. *"Ciao."*

We climbed out of our sleeping bags at dawn the next morning and spent the next few hours trying to give the bus that "unlived in" look. I began in an orderly fashion which was too slow for Vernon. Dirty clothes were soon hidden beneath seats next to the canned goods. Books ended up in the iceless icebox.

Franco, Anita, her secretary and a small poodle arrived in mid-morning. Anita selected the seat next to Vernon and we were off. We weren't far from the ranch when the axle that had been welded in the middle of Texas broke for the second time. With a flourish, Vernon pulled the spare out of the parts compartment. "I'll have this changed in no time."

"Allow me to help you," Franco said. "I was a truck driver in the army." He proved he was somewhat more than decorative and set to work with enthusiasm. Within a couple of hours we were off again, delayed only briefly when we ran out of gas within walking distance of a station. Vernon's luck was holding.

Our arrival at the farm also showed a degree of Johnson flair. Servants opened the heavy gates and Vernon wheeled through,

circled the broad courtyard and came to a stop only when he crashed the front corner of the bus into an overhanging iron grain chute. Attillio, our host, greeted us as though Americans in old buses careened through his courtyard regularly. He led us to a vine-covered veranda and introduced us to a dozen guests, all with some connection to the Italian film industry.

The enormous farmhouse had been in Attillio's family for three hundred years. We were shown whitewashed cellars where wine made from their own grapes was stored in huge wooden vats. More than four hundred thousand acres were home to great herds of cattle, sheep, and a collection of racehorses.

After generous rounds of drinks we climbed the stairs to the dining room, although Vernon insisted afterwards that there had been an escalator. Lunch was lavish with many courses, wonderful wines, and hilarious conversations. Guests disappeared, reappearing in costumes ranging from cowboy gear to suits of armor.

At the post-luncheon sheep shearing, Attilio let the children hold a lamb that had just been born, its tightly curled wool a match for Vicki's ringlets. When he saw their pleasure he brought a three-month-old lamb and presented it to them as a gift. Anita's poodle took offense and chased the lamb around the bus. The lamb made a mess on the floor. So did the poodle. We convinced Attillio we still had a long way to travel and it might be easier without his generous gift.

The rest of that week in Rome was equally wild. Our gang was whirled through Rome in sports cars driven by Anita's gang.

We had dinner one night at a small restaurant featuring roasted boar and wild strawberries. There were mandolins and Italian love songs and a crowd of photographers and reporters who stood at the windows chanting, "Anita! Anita!" Jill wrote in her diary, "As if Father hadn't been eating spaghetti for years, he had to ask Anita to show him how. Criminy!" With both arms around his shoulders and her well-endowed bosom engulfing his ears, Anita had leaned over him as she instructed him in the proper pasta method.

On the following night we had a memorable dinner at Anita's villa. She took Jenda into her bedroom (Jenda reported that everything was lavender) and set her hair in an *"estilo nuovo."*

On another night we had a spaghetti dinner at our camp at three in the morning when everyone in Anita's coterie, spurred on by good Italian wine, decided to autograph the white sides of our bus, using shoe polish as a medium.

The next morning Vernon and I decided that if we ever wanted to get a night's sleep, we would have to leave Rome. We packed up and drove through the city for the last time, stopping at Anita's villa to offer thanks for an exciting week and to express regrets for not making the next party. Christie and Jill quietly discussed how they would wash the autographs off the blue and white sides of the bus once we were out of Rome.

But Anita was one step ahead. She brought out enamel paint to make sure the signatures wouldn't wash away in a rain. The girls watched politely as she and Franco repainted the names. In a final burst of polyglotal goodwill she added, *Bon Viaggio*, You All! above the front window.

Over the following months we discovered what a happy inspiration the autographs had been. They helped to break the ice wherever we traveled and eventually the bus was covered with names and greetings in a dozen languages.

Anita's farewell gift was a ping-pong table. We were dismayed but it was folded into sections, stood on end, and strapped to the closet wall in the bus. Little did we know how useful her bulky gift would become.

# Chapter Sixteen

AFTER FOUR MONTHS with eight children whose demands ranged from the basic needs of a three-year-old to the mercurial expectations of teenagers, the charm of constant togetherness in a small space was wearing a bit thin. We had enjoyed a leisurely visit to Florence as well as up the rugged coast of Italy's Riviera di Fiore to France. Nevertheless there were times when it was difficult to remember this was the great adventure, the trip abroad, the once-in-a-lifetime opportunity. Furthermore, the cool condescension of the French contrasted sharply with the Italian warmth and their love of children.

For a week we settled into a seashore campground near the little town of Cap Ferrat, famous for its wealthy visitors, its luxurious cuisine, its glamorous people. We were not in that league, but we enjoyed the Mediterranean, where the children swam all day in water so clear that sea urchins on the sandy floor were magnified by twenty feet of clear water. They had all made friends, sprinkling their English with bits of Italian plus a soupçon of newly acquired French.

Vernon and I had no time alone in all those months, the only positive aspect being that with the lack of privacy our numbers would not increase. The close quarters of the bus was the surest form of birth control we had yet encountered but we longed for a romantic evening alone.

"Bouillabaisse," Vernon said, on a lazy afternoon in the sun.

"That's what we have to try. Isn't that what everyone enjoys in the south of France?"

"I can't imagine any of the kids enjoying fish soup, no matter what you call it."

"Who said we'd take the kids? Let's feed them early. Jill and Christie can watch the little guys while we shall...." He paused for impact. "...dine *a deux*."

Our wardrobe was limited by lack of storage space but we set out that evening in our least wrinkled tour-the-town outfits. We walked the short distance into the village and headed for a little restaurant. From what we could read on their sign in the window, their bouillabaisse was a veritable tour de force. The maître d' seated us at a table looking out on the sunset across the bay and a condescending waiter took our order. While we waited for the anticipated delight we started on a bottle of white wine, sipping it as we enjoyed the view and the tranquillity.

I looked around the almost empty room. "Looks as though the elite of Cap Ferrat dine later," I said. "But isn't it lovely to be alone?"

Vernon held my hand across the table and we enjoyed our wine. When the bouillabaisse arrived we took our first taste. The pallid broth and insipid flavor was a surprise. "This is nothing more than boiled fish and vegetables," I said. "I expected it to be rich like San Francisco's cioppino without the tomato."

Vernon tore a piece from a crisp baguette and peered into his bowl. "Isn't it supposed to have lobster and shrimp? Some sort of shellfish?"

"There's a tiny clam in the bottom of my bowl." I poked at it. "But it's just the shell. No meat." I reached for my wineglass. "At least the bread is good and the wine is getting better with every sip. Should we have another bottle?"

"Maybe the locals don't eat late," said Vernon. "They're just wise to this place."

As always, when we were alone, there was no lack of conversation. The disaster of the bouillabaisse became a joke as the wine relaxed us. We pondered the political life of Italy, France, and the world in general. We discussed California's death penalty in the

Chessman case, which had fascinated the Italians.* With the increase in threats regarding the U-2 spy plane we pondered our chances of being able to cross the Soviet Union. Mostly we flirted. The evening was as romantic as a first date enriched by the intimacy of eighteen years of marriage. We left the restaurant an hour later and walked down the dark cobbled street, holding hands.

"I suppose we should go back to the bus," I said.

"Not yet," Vernon said. "The kids will be fine. Let's walk out on the jetty and watch the water."

There was no one near on that moonless night and we sat, our legs dangling over the edge, leaning against each other, intoxicated by the romantic night. We could blame it all on the wine, or the long period without privacy, but no one disturbed us as we undressed and slipped into the water then climbed out to make love on the rocks. It was all so French!

---

* Caryl Chessman had been sentenced to death for the supposed rape of a young woman in Los Angeles. The case had caught attention around the world, particularly in countries that did not employ capital punishment.

# Chapter Seventeen

WHEN FATIGUE SET IN, it was difficult to keep "the big picture" in mind. When the day drifted into night and the bus was still bounding; when the children had played all their games several times; when buckets of wet, washed clothes were slopping puddles on the floor because it had rained for three days and we couldn't dry them; when the map showed no campground—it was not easy to remember we were a jolly, typical American family on a joyous, important mission. It was not easy to believe Vernon's carefree words about no problems and big pictures.

I hate to admit that his philosophy was verified often and was typified by our stop in Voutenay-sur-Cure en route to Paris. We'd been in the bus since early morning and the frequent stops we'd made had only given Vernon time to tighten bolts and perform makeshift repairs.

I prepared a hasty lunch at the noon bus-repair break. We had several kilos of glistening red cherries and the pits soon became missiles. Andy, at last, gave up and climbed onto my lap and I held his warm little body and listened to the smaller children playing with dolls or drawing pictures. Christie and Jill were writing post cards and notes in their diaries. "We need more post cards," said Jill.

Christie was more dramatic. "If we don't write more post cards all our friends will forget us and hate us!"

The cherry pit battle had stopped but new battles were shaping up. Court touched Jeff who bellowed, "He hit me! He hit me!"

Vicki and Kara wanted the same doll's dress—again. This time it fell apart in the scuffle. Christie and Jill reverted to childhood in a battle over whose turn it was to use the typewriter.

I said nothing, afraid my tone of voice might cause Vernon to drive over the nearest embankment. Then we saw a sign indicating a campground. Turning off the main road, we came to a gray stone cottage and stopped to ask, with little hope of finding a comfortable campsite. A skinny, gray-haired woman came to greet us, wiping her hands on a dingy apron.

"Camping," I asked.

"*Cahmpeeng? Mais oui!*" the woman responded. She mounted an old bicycle and rode ahead of us along the narrow lane, through cow pastures and unkempt vegetable patches, to a desolate site at the edge of a murky river. The only toilet was a hole in the floor of a wooden outhouse; a leaky pump provided water.

The children were building up to new battles. Vernon's admonition "Relax and breathe through your nose" was of no use to me. It was too late to relax and if I had breathed through my nose it would have exuded flame.

Vernon sauntered around on an inspection tour, taking Court and Jeff with him, and showed them how to fix the broken pump. Next he picked up Kara, who was ready to embark on one of her marathon crying sprees, and tossed her into the air until her tears turned to laughter. He sent Jenda for a campstool and Jill for his accordion and sat down and began to play everyone's favorite, "When the Saints Go Marching In."

I set up our camp kitchen and started supper. Soon the children were singing and the pump was filling shoes as well as pails. Jill and Jenda came running with news of a hidden, grassy spot for a small tent. And as supper cooked, I wandered down to the murky river, suddenly magically transformed by the clear late afternoon sunlight. On the far side of the river the old stone walls of an ancient building crowned a steep golden cliff and were reflected in the glistening water. I returned to our campsite as though

into a new world, alive with Vernon's music, the children's laughter and singing, and the smell of dinner cooking on the Coleman stove.

We ate our dinner and sang songs until dark—as though we had never been tired. There were no problems and the big picture was magnificent.

# Chapter Eighteen

"YOU SHOULD HURRY TO PARIS before it gets hot," fellow campers told us as we basked on an Italian beach.

"If you hurry you can visit Paris and miss the summer heat," we were told on the French Riviera.

We reluctantly left the sun-drenched Mediterranean coast and headed north. We missed the heat. We've never missed heat so much.

Photographs portray Paris in the rain with glistening streets reflecting the towers of Notre Dame. Old etchings depict a ride in a horse-drawn cart through the Bois de Boulogne. They don't hint at camping in the rain in that same Bois, dashing barefoot (to preserve shoes) through puddles to a distant bathroom. They don't give a clue of sleeping under a leaky, tarpaulin-draped ping-pong table, or cooking on a rain-drenched gasoline stove as dripping branches toss rivulets of water down your already soaked back.

Anita's folding ping-pong table had become a vital part of our life. Lashed to an inner wall against the closets while we traveled, it was the first item to be removed from the bus when we set up camp. With a tarpaulin draped over the table, the secluded area beneath it served as an extra bedroom at night. One end of it served as my kitchen with our smoke-belching camp stove. It had good reason to belch. Our pigeon-French request for white gas had produced kerosene. With it, after half an hour's effort, it was

possible to get a sort of flame, accompanied by thick black smoke that stuck to pans, stove, and the cook.

The same table was my laundry room. With washboard set firmly in a deep pot, I scrubbed in cold water and hard soap. It didn't really rain *all* the time. There were days when the laundry almost dried—days when I watched the skies calculating how long I could leave clothes on the line before the next downpour.

April in Paris may be heavenly but that June was hell. Jill and Court suffered through strep throat infections. Others coughed and sniffled. Court developed a flaming boil on his shin. The doctor at the American Hospital recommended hot compresses and I fought the stove and smoke to produce them. Cooking became less a problem as various members of the family succumbed to stomach flu. No one dared suggest the possibility of food poisoning.

If Paris is all about love, I certainly missed the point. I began to hate my husband, my teenage daughters, the bus, and the stove. Vernon and the two older girls responded by disappearing to explore the charms of Paris. I was left with sick kids, wet laundry, the bus, and the stove. I continued with the hot compresses and cursed Vernon's reassuring words, "Don't forget the big picture." If this was the big picture, I'd been framed.

Paris is many things to many people; I have always been deeply moved by sensitive descriptions of the city. Charles Trenet or Chevalier or Edith Piaf put it to music and created a world of sultry enchantment. (To me even children's songs in French sound sultry.) My personal experience of Paris had none of those charms. I could understand why Gaugin left for Tahiti. His wife probably nagged him about the kiddies' clothes not drying. And I would have bet a bottle of tetracycline that Van Gogh had an earache before he ever left for Arles.

One evening Vernon and I went alone by Metro with hopes of finding the Paris of artists and absinthe parlors, musicians, philosophers, life and *sin*...without tourists. After several transfers we spotted a station we knew to be in the Latin Quarter and climbed the stairs in search of adventure. We walked for blocks, past dimly lighted apartment windows and shuttered door fronts before deciding we had chosen the wrong station.

At our next stop we found a small restaurant with nothing to condemn it as a tourist trap. The proprietor grudgingly served us coffee before closing for the night. Large groups of young people emerged from the subway carrying knapsacks and wild flowers, returning from a country vacation. The hearty atmosphere convinced us our search for sin was not going to be easy.

A few nights later we swallowed our pride and our independence and joined a tour that promised the *real* Paris at night plus free champagne. The bus held thirty other humans as reluctant as we were to be tourists. We careened through the Bois, past the Eiffel Tower, around the Arc d'Triomphe as our guide, a Polish refugee (the last son of a noble family) described the more obvious landmarks. When we reached Montmartre the driver inadvertently sheared the fender from a parked car. We left him to explain that one and walked in a neat row past sidewalk cafes and admired the sidewalk artists who in some intuitive fashion took us for tourists.

"And now ve go to zee famous Pigalle and vatch ze danzing and dreenk ze free champagne," proclaimed our Polish prince. We obediently climbed back into the bus.

"*Voila!*" hiccupped an elderly German.

"Is it really a dangerous place?" Two blue-haired American women sounded hopeful.

The driver, untouched by his recent demolition, swirled through narrow streets with Gaelic flair and parked at the entrance of a dark alley. We stumbled over slippery cobblestones, through the darkness to our first night club. Women in tight slit skirts and snug striped T-shirts leaned against tables and stared coolly at the men in our group. A scowling young man in crotch-clinging trousers, beret, and red scarf knotted at the neck of his striped shirt leered at the women, a cigarette dangling from his lower lip. There were no other customers in the place and we were led to our seats—grandstand benches lining one end of the room—certainly not the intimate table for two we had anticipated.

For fifteen minutes we waited for action, admiring the natives who seemed no more bored than we but a lot less self-conscious.

Then the front doors burst open and another crowd of dazed but optimistic tourists was ushered to the adjoining bleachers.

Habitués of the club by now, we assumed suitable bored expressions, slumped casually in our seats, and watched them with narrowed eyes.

Half-glasses of sweet muscatel were served and the show began. For an hour we watched as female Apache dancers were tossed into far corners of the dance floor by their partners, who looked scornful and who never lost the dangling cigarettes that clung, leach-like to the lower lip.

Members of the audience looked despairing, except for a pair of honeymooners from West Berlin who were laughing with us. The grand finale included a cancan flurry of dingy petticoats and a strip-tease with our elderly German in the front row being asked to assist. He loved it.

Our guide spoke in glowing terms of the next club and the free champagne awaiting us. We followed obediently, up a narrow flight of stairs and into another bleachers-lined room. The entertainers looked familiar. "You don't suppose they hurried on ahead of us, changing clothes along the way?" asked Vernon. In desperation, hoping for any kick, we slogged down the cheap sweet wine and decided our first organized tour was our last, even though the laughs might have been worth it.

It would be a singular satisfaction to return to Santa Barbara with the same number of children, no more and no fewer. This balance was almost upset in Paris. One of the reasons we spent so many days there was to witness the July 14th Bastille Day celebration. There was no rain on Bastille Day, in itself a reason for jubilation. Most of the children had recovered and there had been only two sudden attacks of stomach flu during the night.

We left camp early in the morning to find a parking space near the parade route. So did several thousand others. We were lucky to find a spot across the river from the Place de Concorde. Court and Jeff were still weak and I stayed with them while Vernon led the others to the parade.

Staying in the bus wasn't all that bad. As the parade ended many of the marching units crossed the bridge, passing near the bus, and we could hear the bands and watch planes as they flew over leaving tricolor trails in the sky.

Our parade-goers returned several hours later, totally exhausted and bursting with stories.

"Andy got lost, Mommy."

"But we found him easily," said their father.

"We had to look for a long time," said Christie.

"I knew we'd find him." Vernon could make any mishap sound like planned entertainment.

"The policemen found him but he was crying a lot," said Vicki. She wasn't about to let her baby brother have center stage for long.

"Not policemen," said Jill. "They're *gendarmes.*"

"The policemen gave him sugar," said Vicki stubbornly.

"He hated it," said Kara, the girl of few words.

Vernon had set up a base station, sending scouts out in all directions. When they found the local gendarmerie and heard the screams issuing from within they knew they were in the right place. A hovering group of uniformed men were plying Andy with sugar cubes and trying to comfort him. Kara was right. He hated it.

With the children still reporting on the parade and the great search, Vernon started the motor and turned the wheels, ready to pull out into the long line of traffic. There was a squeal of brakes, a crash and a modest pile-up of cars. A young man picked himself out of the center of the heap and unwound his motorcycle from the front of a black Citroen. We wondered at the speed with which a gendarme appeared on the scene before it became clear that he had been the driver of the car that hit the cyclist, tossing the latter into the front of a car going in the opposite direction. Fortunately the injuries were negligible.

Everyone gathered beside the bus door, cursing Vernon in hysterical bursts of French.

"I hadn't even moved onto the street," Vernon insisted. No one heard him.

*"Mais non!"* screamed the gendarme.

The young cyclist, who had originally been angry with the officer, decided to accept the word of the law and turned his fury on us. I tried to calm him as I brought the first aid kit and cleansed and bandaged the small scrape on his leg—his only injury. People

who passed on the sidewalk became interested. It didn't matter whether or not they had seen the crash, they were willing to offer a verdict. No one spoke English.

The bedlam continued for the better part of an hour during which we exchanged documents. The gendarme carefully copied all of our information. "Why don't you copy down all of their information," Vernon suggested to me. It offered some variety to the scene.

Soon what had begun in a style that threatened us with nothing short of several years on Devil's Island, dissipated to a year in the Bastille, and finally faded to the point where everyone shook hands and departed.

The Frenchmen had vented their emotions regarding people who touch their cars (a more serious crime than adultery) and had enjoyed the dramatic moments. After three weeks of death-defying travel in Paris we knew the French acknowledge few logical rules of traffic. We had discovered that if a driver sticks out his arm to signal, it means only that his car window is open.

The next morning, with Bastille Day, rain, and pestilence behind us, we headed north.

# Chapter Nineteen

BELGIUM AND HOLLAND are a blur of images. In our brief stay in Antwerp and throughout Holland, we found hospitality, warmth, and assistance wherever we went. Like the Belgians, the Dutch were still grateful to the United States for helping to liberate them during World War II. We had not yet become the Ugly Americans.

We were so well established in our camping routine that we were truly "at home" all the time. Home was where the bus was and it was in a lot of places.

We spent a few days in Rotterdam and Amsterdam but the rains were so frequent that the campgrounds were drenched and the bus's tires sank into the ground. Near The Hague we found a wonderful seaside campground that took pride in offering accommodations for 10,000 campers. It was run efficiently and the rains passed over the coastline. The children found playmates. Christie and Jill were surrounded by young men.

I was pleased with a fresh breeze that actually allowed me to dry laundry that had been accumulating for days. Two young German men eyed my washboard enviously one morning and I told them they were welcome to borrow it and showed them where to return it.

After supper that evening Vernon had brought out his accordion and the boys returned with my washboard and a guitar. Their clothes showed no sign of having been scrubbed but as soon

as the guitarist went into action, joining Vernon in a hot rendition of the "Saint Louis Blues," the other young German began to stroke the metal ridges of the washboard vigorously with one half of a wooden clothespin. The rhythm section added the final touch. A large crowd gathered and joined in on American folksongs, fluent with the English lyrics although limited in conversation.

We never knew if the boys were courting my daughters or my washboard but they offered to buy the latter. Vernon said it was the "American Kleen Kween, Chicago, Illinois" label that attracted them. It may have been the Steinway of laundry equipment but I couldn't part with it.

The days by the sea were pleasant but July was passing rapidly and we had to move on. The bus, however, was still calling the shots. It wasn't long after leaving The Hague that it developed familiar complaints. High gear had been slipping occasionally for more than a hundred miles and Vernon had been able to tighten things and hope for the best. He was inclined to regard the bus as having a certain amount of native intelligence but gave himself credit for slightly more and hoped to outwit the beast. There was no telling what the bus might do if it sensed we were intimidated by it.

We headed north planning to drive through German Friesland and on to Denmark in a couple of days. But before we reached the Afsluitdijk, the long dike separating the Zuider Zee from the North Sea, high gear was snapping back and forth like a five-year-old's loose tooth. Christie, Jill, and I took turns sitting on a box in the aisle beside Vernon. By looping the handles of a string shopping bag over the gear shift and pulling hard we could hold it in gear but even then it could snap out and Vernon would go through a series of shifts and clutch maneuvers hoping a cog would fit and hold.

This helped dramatize the twenty-five-mile length of the dike. Kara questioned the rumor that a small boy had been able to plug a leak in the dike with his finger. "I think it would take more than a little boy," she said.

Court said, "It would probably be necessary to plug this dike with a lot of little boys."

For the last few miles Vernon abandoned high gear and we crept slowly along in second until at the north end of the dike we saw a welcome tent sign in the town of Harlingen. We inched our way along narrow streets and around corners, following the arrows until we found a tiny camp behind the dike wall. Only half a dozen campers were there and they gathered around, greeting us like old friends.

News spread fast in that charming little fishing village where an old-fashioned Dutch life, complete with wooden shoes at the doorsteps, flourished. The mayor arrived on our first morning and invited Vernon to go on one of the local shrimp boats with a skipper who spoke English. Vernon left on a shrimp boat with its spreading butterfly-wing nets at three o'clock in the morning. The children and I roamed the little town, which was checkerboarded by canals, with bridges at each cross street. We passed rows of small brick houses with steep roofs and windows hung with sparkling white lace curtains over flowering plants. Plump lazy cats looked out on tiny manicured gardens.

We noted rear-view mirrors beside second story windows and discovered that elderly ladies who sat sewing in upper bedrooms liked to look at the passing scene and thus had a discrete view of the length of their block.

In midafternoon we spotted the returning shrimp boats and hurried to meet Vernon. He introduced us to his crew and they gave us a parting gift of a dozen small flounder caught in the shrimp nets.

Vernon said that food had been the central theme of the twelve-hour trip. There was hot chocolate at four in the morning; hot tea at five; a breakfast of coffee and breads at six. In midmorning there was a break for another steaming drink. Lunch was a nourishing meal of meat and vegetables served in layers in deep bowls. For an afternoon snack they had fresh shrimp cooked in seawater.

Vernon's curiosity led him to a well-patronized liquor store whose curtained windows and veiled front door gave little clue to its wares. Privacy appeared to be of the utmost importance in such a purchase. He returned to the bus with a large tin labeled Esso

Lube and an innocent looking white painted milk bottle, each containing Dutch gin. He was told it was common practice to smuggle gin out of the country in this disguise but we preferred the image of a housewife demurely sipping from a milk bottle in the privacy of her kitchen while her husband was getting well lubricated in the garage.

Avocat, a Dutch beverage that tasted like eggnog, drew our admiration. It was so thick that when a child tipped a glass, as children are prone to do, one had the opportunity of picking it up before the contents could run out.

It was also in Harlingen that we met Piet de Jong, a journalist, from Leeuwarden, the nearby provincial capital of Friesland. He interviewed us as we sat on the grass although he probably answered more questions than he asked. Before he left that day we made plans to move on to Leeuwarden, where he said there was camping space and an excellent garage where the bus could be repaired.

We were led out of Harlingen by a small army of towheaded boys racing ahead of us on foot, on bicycles and tricycles, some of them pushing baby brothers in strollers in reckless exuberance, waving and shouting goodbye.

Our financial situation continued to be serious. Our agent in Santa Barbara, who had not produced the money he was to have received by selling several vacant lots for us, was victimizing us. We had priced the property for quick sales, agreeing we would have five-thousand dollars waiting for us at each capital and he could keep the balance of each sale. We had been living on the money from Vernon's Air Force retirement checks and the rent on our house. It was enough to get by but didn't allow for frivolous extras like a new transmission. Our accommodations required little cash.

In Leeuwarden Piet led us to a soccer field where we could park and use the facilities in the office. As the bus wheels sank slowly into the damp field we waited for news of the transmission and accumulated crowds of neighborhood children. Vernon's positive thinking again paid off and within twenty-four hours we had another transmission which was found, just as the first one had been, only twenty miles away.

The mechanic was a friend of Piet's and in order that we not have to spend a night in his garage, he brought all his tools to the camp. He and Vernon forced the bus onto large wooden planks, like water skis, to preventing further sinking and went to work. It was a delightful week.

One of the nicest things Piet did for us was to lead us to a source of hot baths. We hesitated to say it had been many months since we'd had such luxury but months of cold showers had held little enchantment. In the town hall, just a few blocks away, there was a public bathhouse and for seven cents we could spend a half-hour in the luxury of a steaming tub.

What a year that was in Europe! Oberammergau, the running of the bulls in Pamplona, the music festival in Avignon, Paris in the spring, the Olympics in Rome. We missed them all. Those losses were redeemed by Piet who introduced us to Polsstakver-springen, a singularly specialized Friesian sport.

Piet took us to the nearby village of Bitgum, where we could observe this annual event. It had begun when the natives hunted along the narrow canals for eggs of a small bird. The hunters had to leap across these canals, gather the eggs, put them in their caps, and jump back. The entire operation was pretty messy. Someone decided to use a pole and a technique resembling pole-vaulting evolved. Soon the eggs, which had an unpleasant fishy taste, were forgotten and the leaping, or *ljepping*, became the point of contests to prove the most skilled *ljepper*. There was a brief time when the *ljeppers* and the *ljeppe*-watchers disagreed as to who would be responsible for the event. A truce was reached in 1959 and the Frysk Ljeppers Boun was formed.

We were witnesses to their 1960 contest. As guests who had traveled the greatest distance (by some eight-thousand miles) to witness the event, we were given seats of honor in the judges' stand. Participants were divided according to age, including a small group of girls in their late teens.

A long pole was carefully planted in the mud and lightly braced against a long wooden platform at the water's edge. The jumpers made a long run, grabbed the pole, tried to climb higher as it progressed in an arc above the canal, and hoped to land on the far side of the canal. Shouts of joy and derision arose when a

jumper made it only halfway, splashing into the mid-channel muck.

The transmission search had unearthed the third and last 1947 Ford transit transmission in Europe. The cost had suddenly risen even though the demand was probably on a par with the supply. Even if we had the money to buy it, we had no space in which to carry it. Certain that the demand lay in our hands, we took our chances and headed north.

# Chapter Twenty

WE LEFT THE CAMPGROUND in Lübeck in northern Germany early on a rainy July morning, anxious to reach our friends in Sweden. Usually when we packed up to move on, the children complained. "We'll never find such a keen campground, or "There are so many cute boys in this camp."

The Lübeck camp was not one of those and the only complaint came from Vicki. "Can't we do something different today, Daddy?" Her voice was shrill with anticipation.

We controlled the urge to respond with, "What in blazes do you think we've been doing for the last six months?"

Our nomadic life in exotic places had become normal to our little gypsies. This was well demonstrated by Jeff's occasional post cards to his third-grade school buddy, Dowe. He could begin well enough, "Dear Dowe, We are in Italy…" or "Dear Dowe, We are in Paris…" Then he would turn to one of us, "But what have we done lately?" The wonders of Europe were not worth writing home about for a nine-year-old.

"We'll be taking a ferry to Denmark this evening," Vernon said. "That should be pretty exciting. The ferry is famous for a fabulous buffet table, with all kinds of food. They call it a smörgåsbord. We can eat all the way to Denmark."

As we stopped to fill our gas tank for the next leg of our trip (at five miles per gallon we stopped often) Jill spotted two trucks with U.S. Armed Forces license plates. Vernon asked the

attendant about them. In a German-English mix we learned there was an American radar station only a few miles from town.

"Hamburgers," shouted Jenda.

"Peanut butter!" bellowed Jeff.

Even Vicki thought these enticements were adequately different. Vernon's disability retirement from the military gave us privileges at the many American bases in Europe and satisfied the children's occasional yearning for the familiar. Nothing would suffice but that we should stop at the base before heading for the ferry. Make that two for the smörgåsbord, I thought.

The base was not easy to find. We knew we were in the British sector of Germany, about three miles from the Soviet zone. In those days accidental crossing into Soviet-controlled East Germany could mean long hours of questioning by the police and possible arrest. After almost an hour of wandering we were ready to give up. When we spotted an American jeep on the road ahead, the children shouted, "Follow that jeep." We turned onto a one-track muddy lane as the jeep disappeared in the mist. There were deep drainage ditches on either side. Halfway up a slippery hill we found three parked military vehicles surrounded by a mire of gumbo. We slithered to a stop, the kids tumbled out of the bus, and sloshed to the top of the hill where a dozen bemused soldiers explained that there was no base, only a small radar tower they hoped to dismantle and remove within the next two hours.

A sergeant advised us against trying to turn around. "If you stay on this lane for two miles, you'll come to a paved road."

A few hundred yards and several minutes later the bus developed a mind of its own, slithering to one side of the road, back to the other, and in a slow-motion nightmare tipping to a sixty-degree angle as it came to a rest against a mud bank. Our only two doors on the right side of the bus were jammed into mud, and water bubbled beneath. The only serious damage was to a flat of eggs on the kitchen counter that slid and cracked against the facing seat. No one was hurt.

"Hey, Vicki, is this different enough?" asked Vernon, restoring balance to a bad situation. Momentary fright disappeared in the delight of climbing out through the roof hatch. I decided to abandon ship by backing out of a window, causing my young

86

audience to giggle when I became temporarily wedged, with skirts caught high over my head.*

Christie, Jill, and I sloshed back through the mud to ask for help from our gallant troops. The soldiers returned immediately in one of their large trucks and wrenched our bus from its moat, causing the motor to shift slightly from its mounts. Although it still ran there was a raucous clatter as the fan chewed against the radiator. A twist here and there and, holding our breaths until we reached the end of the muddy lane, we chugged back into Lübeck and the campground.

The mechanics we found the next day said they had work backed up for a month and couldn't help us. Vernon asked if he could just drive the bus over an oil pit so he could try to repair the damage himself. Within a half-hour two mechanics were watching. In an hour four were offering suggestions and, within three hours, half a dozen men had gone to work. They repaired the damage, and we were again on our way to the ferry and the famous smörgåsbord.

---

* Having heard criticism of the way American tourists dressed, the girls and I almost always wore skirts or dresses instead of slacks, which were not yet accepted by many as suitable female garb.

# Chapter Twenty-One

WE ARRIVED IN SWEDEN with plans of spending a week before going on to Finland and across the Soviet Union, but August was almost over and nights were already cold. With a still unheated bus we spoke only of warm places for the winter. Maybe we could just make a quick trip into the Soviets and out through Germany and on to Spain for the winter.

The decision to spend the winter in Sweden grew quickly. The summer was almost gone. Six months of steady travel with ten people in a space the size of a dog run had taken its toll. We looked longingly at simple farmhouses. Then we met Sweden and our love affair with the country began. For our first few nights we stayed in country campgrounds, on the shores of crystalline lakes, surrounded by wild flowers and wild berry bushes. Wherever we stopped people were anxious to help and we liked the healthy good looks of the young men and women.

Our old friends, May and Lawrence Lithander, had returned to Sweden eight years before and had urged us to visit, even to camp in their yard. We found their home, on the edge of Torsby, a village in central Värmland. We stayed for several days, meeting their friends and learning our way around Torsby, a shopping center for a large farming and lumber community. The Lithander daughters took Christie and Jill to late summer outdoor dances and the younger children spent the days gathering flowers and berries in the woods and exploring the banks of the nearby river.

As we sat over a last cup of coffee one night, Vernon said, "Let's rent a house and spend the winter."

I breathed a sigh of relief. May and Lawrence were enthusiastic. From then on everything fell into place for us even though housing in Sweden had not caught up with the influx of refugees during and after World War II. "You are crazy to even think of finding a house," everyone said. They, however, weren't tuned in to Vernon's "everything's possible" philosophy. Within a couple of weeks we heard of a house for sale a few miles from town. The Lithanders decided to buy it, rent it to us until the snow melted in the spring, and then move into it, selling their house in town. Vernon may have depended on his positive attitude, but I began then to look at the Lithanders as our guardian angels. Everything they did for us that year validated that opinion.

We moved into our new house in gradual stages, taking over parts of it as the previous owners moved out. At first the luxury of a large kitchen and a sitting room, which tripled the living space of the bus, was more than enough. Next it was two more large downstairs rooms. By October the second floor with three bedrooms was available for the five older children. We had a stainless steel sink with running water that didn't have to be hauled in a bucket. There was an electric stove and lights. At a country auction we bought a large wooden tub that could be used for bathing and laundry. Furnishings were sparse but the narrow seats from the bus were placed on posts and became our new beds.

The fact that the house lacked a hot water system was easily solved by heating water on the stove or on the kerosene heaters. The lack of an indoor toilet became more acute as winter came on. Instead of being built over a pit, the outhouse was equipped with a deep bucket which had to be emptied. The former owner showed Vernon where to do this. It involved carrying the bucket some distance and Vernon had to fight down a rebellious stomach, which had always been too delicate even for diaper changing. When the bucket froze new problems faced him.

By the time we were well installed in the house our lives had taken on an entire new profile. Vernon and I had been asked to teach English for the ABF, an adult education organization sponsored by Swedish trade unions. One of Vernon's classes was a

*flygengelska*, or "flying English," needed by pilots to fly between countries. Classes met at our home three nights each week, forming the hub of our social life. Our students represented a cross-section of the local population—students, shopkeepers, nurses, clerks, taxi drivers, lumbermen, contractors, and housewives. I soon learned the best way to induce a conversation was to ask about their occupations. We discussed jobs, recipes, and holiday customs. We compared information on taxes, politics, medical care, travel, and housing.

Court, Jenda, Jeff, and Vicki were enrolled in the three-room Oleby *skolan*, about half a mile from our house. They trudged off each morning accompanied by other classmates up the narrow path that wound through the birch groves.

Within weeks the children were able to cope with the new language. The teachers spoke a little English. All children in Sweden were taught English—by radio in rural areas. Jenda reported on the best parts, such as the day they were working on singular and plural nouns. The radio voice gave the word "dog" and the class responded "dogs." The answer of "mans" for more than one man was understandable as Swedish endings were completely unlike English and did not use an "s" for plural. One bright child in class knew that one "child" became to two "children." After "foot" and "feet" the radio teacher came up with a request for the plural of "fool." The snappy answer was two "feels."

They were soon able to keep up with their classes in most of the schoolwork and I had the joy of listening to Vicki learn to read from a first-year Swedish primer, a relief after my years of listening to "Oh. Oh. Look. See Dick and Jane." The children were given a free hot lunch at school and learned to enjoy the new foods. There were after-school classes in *slöjd* or crafts. Jenda learned to knit, using four needles on a complicated mitten pattern. Court and Jeff made birch bark candle holders. The boys were also allowed to take embroidery and sewing classes. On Friday nights the boys hiked up to the school for hours of ping-pong.

Christie and Jill took longer to fit into a new way of life. During the first weeks, when they were a novelty as "the new girls in town," life was delightful, but they soon wavered between enthusiasm and absolute desolation. Although I felt sorry for them,

their teenage moods were not unique. They were given special permission to enroll in the *realskolan*, or academic high school, usually open only to those who had passed rigorous exams. For a month they attended classes and spent hours over Swedish grammars at home trying to learn enough to follow the lectures, but it was a tough battle. From eight in the morning until three in the afternoon, six days a week, they listened to lectures on chemistry, biology, algebra, history, French, German, Swedish, and English.

By the end of the month they decided to study at home. Vernon set them to work on mathematics and compositions and they helped him with his Flying English class. Nevertheless, day after day in the confines of home was not ideal for a pair of energetic teenagers.

We decided that Christie, after much pleading, could follow a friend to Oslo and enroll in the art school. Once accepted she moved into a boarding house with seventy-nine other young women, where she and her friend were the only Americans.

At first her letters were filled with glowing praise of the boardinghouse food but she soon decided home wasn't all that bad. They received one orange a week and she learned not to waste a bit of it, eating skin and all. She at last had independence, often more than she had hoped for, and her letters swung from enthusiasm to desolation.

Jill was lonelier than ever without Christie, but being a self-starter with plenty of initiative, she soon found a job as a clerk in Torsby's Varum Magazinet, a small gift shop. Mr. Persson's store was also the only outlet for the sale of alcohol. None was sold in Torsby but could be ordered from the state-controlled *system bolaget* in the next town. Our sixteen-year-old daughter was soon able to report privately to us regarding the drinking habits of many of the town fathers. Customers were anxious to help Jill learn Swedish and enjoyed her exuberant manner, an unusual trait in Swedish clerks. Business boomed. Mr. Persson said it had not been so good since he opened the place. At the end of a month he left Jill in charge of the shop and took off on a week's vacation, his first in years.

For Andy and Kara life was as it had always been; they played with their toys, helped me around the house, and picked up

Swedish from their siblings' friends. Andy greeted them one day with an unexpected, *"Jag är en häst jag äta gräs."* Claiming that he was a horse and ate grass made no particular sense and no one knew how he came by the idea, but he was rewarded with laughter and applause from an appreciative audience and he was filled with three-year-old pride.

# Chapter Twenty-Two

DURING OUR TEN MONTHS in Värmland we came to love it as our second home. There were even times when we considered staying, but Vernon's itch to move on was strong. We continued to read of the mad rush to build bomb shelters in the United States. People were serious about protecting themselves from nuclear war by digging holes in the ground and equipping them with food and drink. There was talk of those who were willing to shoot anyone who might ask for shelter after an atomic attack. It was not a reassuring time to enter the Soviet Union, with sabers rattling on either side of the Iron Curtain. My fears of taking children into the USSR were always just below the surface while Vernon became even more impassioned about continuing.

In the meantime, we continued to learn new customs and a new language, meet new people, and enjoy the simple life.

Värmland has always been the province of artists, philosophers and writers. The late Nobel Prizewinner Selma Lagerlöf had lived in Sunne, the neighboring town down the lake about an hour's drive from our home. Although the Swedes are highly literate and affluent, many of the old ways lingered. We still had the opportunity to learn some of the country customs and our life in the hamlet of Oleby was not the life most tourists would have been fortunate enough to see, even in the 1960s.

Throughout our ten-month stay in Sweden we enjoyed the view from our windows as our neighbors passed on errands to the

small shop at the Oleby railroad station or the Konsum market on the main road. Our narrow lane was little more than a quarter of a mile long with half a dozen houses along the way, but it was used as a short cut from other houses farther along the main road.

Across the lane was a small pasture where sheep had grazed in the early fall. A large red barn stood beyond the pasture beside a grove of birch trees that flamed with gold when we arrived in autumn. The same trees wore a soft rosy mist of hoarfrost on bare branches in the winter, and were sprigged with pale green leaves when we left in the spring.

Traffic in the lane was sparse. Only one car used it regularly, passing in the early morning and returning in the early evening. Like most of our neighbors, we depended on the two-carriage train or on our own two feet to travel the four miles to town. Children, who attended the nearby three-room school, stopped to collect our four each day and continued along the lane before cutting off on a narrow path through the birch trees. In the fall two old farmers passed frequently with large wooden carts filled with hay and newly dug potatoes. One man had a horse; the other pulled his own cart while his wife walked in the rear helping to balance the load.

As we had no car, feeding a family of ten necessitated at least two trips a day to one or the other of the small country markets. The children liked the "American Store" at the station, so called because the old couple who ran it had lived in Illinois for many years and spoke English. It was possible on one trip to carry the food we needed for a day; a second trip was needed to carry enough milk. One of the children trudged down the lane each day to fill our two-liter pail at the store.

Each day, after the snows came, I put on warm knitted gloves, scarf, and a heavy coat and with several string shopping bags in my pockets climbed on my *spark* and sailed off down the lane. A *spark* is little more than a straight-backed wooden chair attached to sled-like metal runners. On snowy days I always took it shopping as I could place my purchases on it, making it possible to carry several large sacks of food along the icy roads without slipping and sliding. The *spark* steadied me as I walked, pushing it in front of me, holding the bar on the chair back, hopping onto the

runners as I gained speed and slid smoothly along. It was even better if one or two small children were seated on it as ballast. It was splendid on a level stretch and terribly exciting on a descent when it became a matter of simply hanging on. Once, hoping to decelerate, I jumped off, thereby reaching an even greater speed and arriving at the bottom of the hill slightly ahead of the *spark*.

I greeted my neighbors on the way as they shot past on their *sparks*. Being good Swedish country folk, they were far more dignified than I, murmuring a pleasant *"God dag,"* holding themselves erect, with little motion except for an occasional push with one foot, and with no sign of pleasure. That degree of dignity must take years of practice. I had to suppress my urge to shout "Whee-ee!" as I whooshed along.

We realized the novelty of our first year when an American woman who had married a Swede and lived in Oleby for many years explained it. "I felt like you during my first winter. It was a novelty but since then each winter has become longer and darker and more lonely for me."

# *Chapter Twenty-Three*

THE SNOW HAD BEEN COMING DOWN steadily on that dark December day. Vernon was in Stockholm for a few days to arrange for our Soviet visas. I had never liked being on my own before (as though one were alone with eight children) and was always anxious when Vernon was gone. Yet there I was, thousands of miles from home, several miles from the nearest town, more content than ever before in my life. We discovered we could live without a car, a telephone, or even a radio. Secure in our country house, my days were busy, the evenings cheery beside the fireplace. In spite of time-consuming chores like heating water on the stove and washing clothes by hand, I found time to paint and write, to sew and knit. I looked forward to Vernon's return but didn't waste the days in loneliness.

Suddenly one evening we desperately needed a telephone and a car, not to assuage loneliness but for an emergency.

Six-year-old Vicki had been coughing relentlessly for several days. The dry hacking sound continued through the day and kept her awake at night. Before taking her to the clinic in the village, I decided to try an old home remedy.

I filled a small pan with boiling water, added a spoonful of mentholatum and, to be safe, placed the pan inside a large flat-bottomed kettle. "Now don't wiggle around and spill it," I said. "Just breathe the steam for a few minutes and it will help clear up your cough." I placed the kettle next to Vicki on the couch in the

sitting room, covered the kettle and her curly head with a sheet, and returned to the kitchen.

Unfortunately my warning hadn't reached four-year old Kara's ears. She moved faster than I could speak. The sight of someone playing peekaboo beneath a sheet intrigued her and she ran directly toward Vicki's draped figure, stumbling against the couch, and spilling both kettles. The scalding liquid drenched the pajamas of both girls and the screams of pain brought the older children.

I removed Kara's pajamas horrified to discover that in those few seconds the scalded skin had blistered and adhered to the fabric. Christie stripped Vicki, with the same results. Kara's white upper lip showed the first sign of shock. They needed medical help urgently. "We'll have to call May and Lawrence," I said.

Jill plodded through the deepening snow to our nearest neighbor, pounded on the door, and asked to use their phone. Lawrence's response was instant and he made record time over the six kilometers of icy roads.

While Jill was gone, I wrapped Vicki and Kara in fresh sheets while Christie brought in a pan of clean snow and packed it on the sheets around their legs. Their screams let up, but the pain was intense.

When Lawrence arrived we bundled the two girls off to the hospital where a sympathetic nurse immediately gave them small glasses of a pink liquid to sedate them, while the doctor cleaned the blistered skin, sprinkled antibiotic powder onto the burns, and bandaged their legs.

When we returned to the house they were tipsy from the effects of the medication and the intoxicating pleasure of being the center of interest. "The doctor gave us pink whiskey," Kara said. I could have used a little pink whiskey myself but settled for the remaining shot in a bottle of aquavit.

We never decided whether to credit the steam or the shock but Vicki's cough never returned. For several months afterwards if a child coughed, another asked, "Do you want Mother to steam you?"

On December 21 we were waiting for Vernon to return from Stockholm but his schedule had been seriously interrupted. As we

had no phone, he called the Lithanders and explained. Halfway home on the train he had become violently ill and had been taken to a hospital in Orebrö. May and Lawrence, who continued to look after us with love and concern, came the six kilometers from the village to our house. They explained briefly and tried to reassure me as we drove to their home so I could return Vernon's call.

Vernon's voice was blurry with pain. "I'm sorry I can't talk much. I'll be going into surgery in a few minutes. It's my appendix. The doctor speaks English and tells me I'll be fine. Don't worry."

There was no way he'd be with us for Christmas. Hoping my fear didn't show, I explained to the children. "Your daddy will be just fine. He wants us to go ahead with our Christmas plans."

Everything about our life that winter was new—our two-story white farmhouse with its view of snowy fields, frozen lake, and blue-green forests plus a new language and customs.

The next day classmates took Court and Jeff into the forest to cut a fresh Christmas tree. When they pulled it from the sled and hauled it into the house the air was filled with the fresh scent of the forest—not like Southern California where the needles on a newly purchased tree became unhinged before we could get it home.

Jenda taught Vicki and Kara to make ornaments of hollow eggshells painted in bright colors. They made garlands with yards of bright paper loops. Tears of anguish accompanied a broken shell and sometimes it was difficult to distinguish ornaments from scraps. Andy, who had just turned three, saved the red cellophane strips from cigarette packs, hanging them on the tree like tinsel. He rearranged them often and when he was annoyed with one of us he hid them, bringing them out again when his snit was finished. Everyone was making secret gifts.

New friends made sure we experienced a real Swedish Christmas. Early in the month, on St. Lucia Day, our English students had arrived early in the morning, one of them dressed as the candle-crowned saint who served coffee and saffron bread to the family. Our seven-year-old Vicki was given the coveted role of Lucia in the school's holiday program. During Christmas week friends brought baskets of red tulips, hyacinths, and lilies of the valley. Fru Halvorsen, the school principal's wife, gave us a home-

made birch candle holder with hand-dipped candles in a ring of fresh lingonberry leaves dug from beneath the snow. Our crusty neighbor Mr. Jensen, known even in Socialist Sweden as "That Communist," brought an armload of grain and tied it to our fence post for the winter birds. The Lindgrens at the "American Store" brought us a box of chocolates and a large beef roast.

On Christmas Eve, in the darkness of late afternoon (the sun set at 2:30), there was a knock at the door. When I opened it there stood a creature in red suit and cap with a pink-cheeked mask and white beard. The children stood back in awe. "It's the Jul Tomte!" whispered Jeff. His new friends had told him of the Christmas elf who bore a startling likeness to our Santa Claus.

"Have you been good children?" The Jul Tomte spoke in Swedish, urging the children to help themselves to fruit and candies from the large basket he carried over his arm, then he disappeared into the darkness.

We waited for the Lithander family, who were to bring a traditional Christmas dinner of boiled ham, rice with its single almond, lutefisk, and all the trimmings. While the children played in the snow that afternoon I had baked bread and cookies. The house smelled of gingersnaps and drying mittens.

Only one important thing was missing. Then we heard the squeaky crunch of footsteps on crisp snow and voices in the lane followed by the shuffle of feet on the porch steps. Vernon walked in brushing snow from his overcoat. Before he could collapse in the nearest chair he was engulfed in hugs. "I had to stand up for the two-hour ride from Orebrö to Karlstad, but someone gave me a seat the rest of the way," he said. "I guess I could have gone on into town and come home by taxi, but I thought it was easier to walk up from our stop." It was so typical of Vernon. Three days after his appendectomy he walked the half mile up the hill on the narrow snowy path through the woods, carrying not only his own suitcase but that of a neighbor. "Poor old fellow," Vernon said, "he needed help."

Christmas was complete—and Vernon didn't have to return to the hospital until New Year's Day—when the doctor mended a few torn stitches that had become infected. At last he was forced to lie still and recuperate properly.

# Chapter Twenty-Four

IT HAD BEEN A GLORIOUS, very Swedish Christmas. Vernon was recovering and Christie had returned to her art school in Oslo. With four of the children back in school, I could give more intense attention to the situation that was facing me.

I don't remember quite what white-haired Dr. Lindahl said in his heavily accented English, but it was clear that the rabbit had died. It wasn't the first to give its life because of my boundless fertility. It would, however, be the last.

"It's a terrible time for me to be pregnant," I said. "The worst part is I feel there is something really wrong."

"You could have an abortion," Doctor Lindahl said.

My head was in a whirl as I left the hospital and walked to the train stop for the ride back to our house. There was a fresh pot of coffee on the stove and Vernon and I sat at the kitchen table discussing our options.

"If we are still going into the Soviet Union and across Siberia, I can't face pregnancy and that at the same time," I said. "I can't explain it, but something's really wrong."

Vernon, who had always wanted a dozen children, was less certain. His blue eyes showed concern and he repeated one of his favorite theories. "You must admit, you are always more contented and peaceful when a baby is on the way—once you get used to the idea."

"Maybe I'm just more resigned," I said. I have told my children,

"I may have had unplanned pregnancies but I never had an unwanted baby." After the first jolt of finding out I was pregnant, I was always as broody as a hen on a clutch of eggs. To me, giving birth was a magic experience. "But this is just too much," I said. "Dr. Lindahl says I can get an abortion if two doctors and a psychiatrist agree. It won't be hard for me to convince them that my mind will self-destruct if this continues. He says I will have to agree to sterilization, too."

"Are you sure you'll be able to cope with that?" Vernon asked.

"Are you kidding?" I answered. "If we only had one or two children it might be different. But we have eight and I'm only thirty-six! With another ten years of fertility, I could be having children younger than our grandchildren."

I was faintly aware that it might be a greater problem for him than for me. Was it possible that for my tender lover, procreation was such a major part of sex? Impossible! I anticipated abandoning all concerns and adding new zest to our intimate hours.

Vernon accompanied me to the interview with the two doctors. We had come to know them during our stay in the community and they were in full agreement with my decision. They confirmed that to qualify for the procedure at my age, I would have to agree to sterilization. I would need an interview with a psychiatrist in Karlstad, the provincial capital of Värmland.

The Lithanders drove me the one hundred kilometers through the forests beside a broad river to Karlstad and waited for me in the car. Vernon stayed at home with the children. I felt terribly alone as I walked through the dark corridors of the old brick hospital, isolated even more by my limited knowledge of Swedish. Fortunately the doctor with his mop of brown curls and warm smile spoke English. I was in tears as I poured out the reasons for my choice. Even though I had made up my mind, it wasn't easy to make such an irrevocable decision.

"You've made a good choice," said the doctor. "I'll send my decision to Dr. Lindahl."

The whole process had taken weeks and the sterilization procedure called for major abdominal surgery. "Your feelings were right," Dr. Lindahl told me when I came out of anesthesia. "The

fetus was abnormal. Furthermore your appendix was ready to burst. We got it all in time."

I had no way of knowing if he was reassuring me, but it eased any lingering doubts. I spent ten lonely days in the hospital, able to have visitors only two days a week. By necessity I had learned a new lexicon of Swedish phrases, most of which I would never need again.

I returned home with the pleasurable knowledge I would never have to worry about getting pregnant, but a small voice whispered, "Never again will you have the joy of giving birth and holding a new life in your arms."

# Chapter Twenty-Five

AFTER THREE TRIPS to the Soviet Embassy in Stockholm and a long series of letters, Vernon's efforts paid off. We had known there was no problem in obtaining a two-week visa but he hoped for a two-month stay. Vernon's request to cross Siberia was greeted with doubt and confusion. We were told the railroad had been closed to foreigners for forty years.

Vernon continued to refer to his meeting with Khrushchev. He never explained the exact nature of his "friendship" with "my friend Nikita" but found the embassy officials were always duly impressed. When they became overly balky about our requests, Vernon's response was casual. "I will write to Mr. Khrushchev and ask his advice." And the wheels would again begin to turn.

It was mid-April when the letter arrived from the embassy.

Dear Mr. Johnson,
Referring to your conversation with vice-consul Taranov, I have the honour to let you know the following. Your trip to the Soviet Union may be arranged through the mediation of the Soviet Tourist firm "Inturist" and you and your family may go there by your own bus on the route: Helsinki-Leningrad-Moscow.

From Moscow the bus can be sent by train through Khabarovsk to the harbour of Nahodka, situated on the Pacific ocean, then by ship to Tokio. You and your family

may fly by plane from Moscow to the city of Irkutsk where it is possible to arrange a tourist programme for 1-2 days, including fishing on the Lake Baikal. Later on you may continue your trip by plane to Khabarovsk and then by train to Nahodka where you may take a boat to Tokio. The city of Vladivostok unfortunately is not included in the routes of "Inturist."

If you agree with the proposed route you may get in touch or write to the representative of "Inturist" in Stockholm....

Yours truly,
Consul of the Embassy of the Soviet Union
V. Mojaev.

There was no mention of the length of the visa but we felt it was an exciting beginning. Vernon left for Stockholm immediately to complete arrangements with Inturist.

"Where did you get this letter?" said the Inturist representative.

"It was sent to me from the Embassy," said Vernon.

"I think you should have a Photostat made of it."

It seemed mysterious to Vernon. Tourists had been allowed to fly to the cities mentioned in the letter. Even though Vernon still hoped to drive, there seemed little reason for this caution. The people at Inturist said he would have to complete final arrangements for travel in Moscow.

Vernon returned to the embassy. The doors and gates through which he passed were unlocked and relocked behind him. He waited in a bare room until a small window opened and he presented his request. He was ushered through other rooms and spent an hour in confusing, circuitous conversation. No one at the embassy knew anything about our letter. Mr. Mojaev said he didn't know who had given authority for the letter. Such a runaround was typical of Soviet Embassies from Rome to Stockholm.

Vernon asked an aide to join him for lunch, hoping for further enlightenment. He soon discovered that if he asked for the moon, he might receive lesser favors. "What do you think of our going from Siberia into China?" Vernon asked over coffee.

"China?" exclaimed the aide. "You don't want to go there. We couldn't be responsible for letting you leave our country to travel in China!"

Vernon didn't tell him that the United States took an equally dim view of having its citizens travel in China. They could lose their passports if they tried.

"Let me tell you about dealing with the Chinese," the aide said. "Why, just a trip to their embassy is dreadful. You have to go through many gates that are unlocked and relocked...." He continued, describing the precise routine Vernon had faced a few hours earlier with the Russians. "And do you know that when you have finished your conversation and many cups of tea you don't even know what you've been talking about?"

Vernon's response was straight-faced. "It sounds difficult."

"You certainly don't want to go to China."

He was right. We didn't want to go to China, but it was one of Vernon's reaching for the moon tests.

Vernon repeated his desire to drive from Moscow across Siberia.

"You can't do that," the aide said. "The gas stations are much too far apart."

It would be several months before we discovered there was not only a shortage of gas stations but there were no highways between the large new cities spaced every thousand miles along the Trans-Siberian Railroad. The shortage of automobiles at that time made the situation somewhat less of a problem to the Russians.

The rest of the preparations with Inturist continued satisfactorily. We were slightly surprised to discover it would cost two dollars a day per person for camping. We had seldom spent more than a dollar per night for the busload. On our tight budget, it was a significant amount. Vernon continued to bargain and it was agreed to charge per passport. With the younger children on one passport, the total cost went from twenty-five dollars per night to twelve. When we finally received our visa it specified our stay to be for fifty-eight days, during which we would be able to travel to Moscow before going to Jalta, Odessa, and back to Moscow, exiting through Poland. What had happened to our Trans-Siberia invitation?

"You'll have to arrange that in Moscow," was the firm response.

The mild inconvenience of changing our country of exit was only a tantalizing challenge to my husband.

What a predicament. For over a year I had followed Vernon around the world so he could fulfill his dream of crossing the Soviet Union to prove that the world was still free and a single American family could make a difference. In May, when the ground was beginning to thaw, Vernon was ready to load us back into the bus for the Soviet leg of our trek.

I found it less than thrilling. Terrifying was more like it. For months newspaper headlines had threatened us with Communist aggression. The Berlin wall had just gone up. There was the Bay of Pigs disaster. The Cold War was as icy as it would ever get, with an ongoing mood of confrontation and talk of World War III. Letters from friends at home said we were endangering our children's safety, that we should head for safer ground to be among friends should war break out. Americans were escalating the construction of air raid shelters.

I appreciated Vernon's commitment but entertained traitorous doubts that we could make a dent in international affairs. The temptation to begin a mutiny was building in my heart. I would stand on my rights as equal partner. I would wage war against my benevolent dictator and set up a democracy and let the children decide. I mentally counted the vote of who would abandon ship with me and who would go with their father.

Christie would be exasperated. Parents could be such an embarrassment.

Jill would undoubtedly stick with Vernon. She believed his dreams, admired her father's ability to pull us out of hopeless situations and had a valid though blind adoration of the man.

Court would make a joke in a glib blend of Spanish, Swedish, and French then return to his drawing, hoping to avoid emotionalism.

Jenda might go either way depending on how much she felt picked on by Christie and Jill. Still, she couldn't depend on her sisters' mercy and I usually had her devout loyalty.

Jeff would go where Court went.

Vicki would go if she thought the Russians would take her picture and appreciate her curls.

Kara might agree to go if no one would take her picture but there was a chance she would sit silently in a corner and stare at us.

Andy would follow me anywhere.

I was outnumbered even though the bus was certainly on my side with its unpredictable and petulant complaints. There had never been a day on the road without some sort of breakdown. We had already lost two transmissions, and parts for a 1948 Ford bus would be scarcer than freedom of speech in the USSR.

My spirit lifted when I read that the international situation had deteriorated and Khrushchev was going to close the Iron Curtain and seal the borders. At least we weren't yet on the other side if he shut the door. I comforted myself with that fleeting burst of hope that the trip might be cancelled.

In the long run, I knew I couldn't run a respectable mutiny with a three-year-old boy, a twelve-year-old girl, and a thirteen-year-old bus. Furthermore, if Vernon accomplished his mission, I didn't want to miss out on my small corner of glory. The bottom line was my rash promise nineteen years earlier to love, honor, and obey.

What the hell, I thought, you only live once.

# Chapter Twenty-Six

SAYING GOODBYE TO Oleby and Torsby became a community-wide event. For nine months the novelty of ten casual, informal Californians had made its impact in different ways. There was Jill's job at the gift shop, the four children at Oleby School, and all the students in our English classes. Although the children had adapted to a new language with ease, Vernon and I still spoke in halting Swedish, but we had consistently received hospitality and kindness.

In early May, when the snow melted and we could dig the bus out of its winter nest, we were ready to push on to the Soviet Union. To thank our new friends for all they had done, we rented the Oleby Folkhuset (a sort of grange hall), laid in a stock of värmkorv (hot dogs), cases of soft drinks, and pots of coffee, and invited everyone, from doctors to first graders. As foreigners, we were excused for violating the social caste system which, in those days, didn't allow for doctor, teacher, and butcher to meet socially. We sang and danced to music supplied by records, talented guests, and by Vernon on his accordion. We were presented with a large blue and yellow Swedish flag to accompany our California and American flags. In turn we donated the ping-pong table to the Folkhuset as the carpenter husband of one of our students had built us a more compact folding table and benches. Then, accompanied by Vernon, with Court on trumpet and Christie on guitar, we sang our theme songs: "The Saints Go Marching In" and "California Here I Come."

Fru Bergman, Jeff's teacher in the third and fourth grade, burst into tears when she spoke of losing him. The fever of farewell climbed to a heady pitch and we all became emotional. Sweden had become home to us and who knew if we would ever return. It was not like leaving Santa Barbara for a few months. Christie and Jill sobbed on the shoulders of their girlfriends and exchanged tearful farewells with the boys.

Finally came the morning of departure. All was packed and space had been found for armloads of Värmland souvenirs. A television company from Stockholm and several newspaper correspondents arrived to cover our leave-taking. We climbed into the bus and edged slowly down the lane waving goodbye for the cameras. Nobody was sad or tearful. Then we returned to the house for the final goodbyes.

The last stray items were being tucked into the bus when we heard the sound of voices. From the hill near school, down a twisting path among the fresh green-sprigged birch groves and around the red farmhouse on the corner, came the student body of Oleby School—sixty strong—led by the three teachers. They formed a semi-circle around us. Some of the children carried bouquets of tiny white, blue, and yellow spring flowers—*vitsippor, blåsippor*, and *tusilaga*—and handed them to us. Others gave us pictures they had drawn, small books, and little bags of fruit. The school cook handed me a basket of freshly baked coffee rolls.

Fru Bergman was being stalwart. Hardly a smile crossed her face and her teeth were clenched as she turned her back to us, faced the students and lifted her arm. The first moving notes of "Värmland the Beautiful," Sweden's unofficial national song (the heart-wrenching theme Smetana borrowed in "The Moldau") and the children sang in their sweet high voices.

Tears poured down my face. I heard choked sobs from Jill and Christie. I turned to Vernon. His eyes were filled with tears. Then Fru Bergman abandoned her staunch pretense. The other teachers were weeping. Some of the children cried as they sang.

When the songs ended we stood silently. We didn't try to say goodbye. The children paraded through the front door of the bus and out the back, shaking hands with each of us, the girls

dropping little curtsies. They marched away toward the school, waving to us until they passed the crest of the hill.

After driving down our lane we circled the schoolyard as they had asked. The doors of the school burst open and the children piled into the bus again. Even another ten minutes would have had us unpacking and staying forever.

We stopped in Torsby for last-minute supplies and shop-keepers ran out of stores with small gifts. There were more teary goodbyes. Then, as though the volume of tears had raised the humidity, the sunny morning changed and as we drove over the bridge at the edge of town, the skies burst with rain.

# Chapter Twenty-Seven

WE CAMPED NEAR STOCKHOLM for almost two weeks before taking the ferry to Finland, where we enjoyed a month of long summer days while waiting for the date set to enter the Soviet Union. We slowly accustomed ourselves to the old pattern of living in confined quarters after luxury of space in our Swedish home. Our campsite on Laotasaari Island, on the outskirts of Helsinki, was a vacation delight. Our days were filled with the relaxed joy of summer, the company of other young campers, wild flowers, and a breeze through the birch trees that shaded the beautiful campground.

Still I could not quell my increasing apprehension about going behind the Iron Curtain. Tension between the United States and the USSR had heightened. At home there was intense discussion as to whether it would be proper to protect one's own air raid shelter if someone tried to enter it after an atomic attack. Meanwhile in Russia the death penalty had been initiated for anyone caught exchanging dollars on the black market.

We made frequent trips to the American Express in the hopes of receiving money, but funds were still not reaching us as planned from the agreed upon property sales back in the States.

Throughout the trip Vernon seemed to believe we might be going soft despite our vigorous camping life, which used up a lot more calories than strolling across the lobby of a four-star hotel. He continued to rouse the children for morning exercises.

Christie, our eldest, was always agile and inventive in gymnastics and led the pack as her siblings urged Vernon to initiate a favorite exercise. With the handicap of an artificial leg he had some trouble with routines calling for jumping but felt obliged to set the pace for the children lined up in front of him as they shouted a noisy, "one, two, three, four" in the language of the current country. This had proceeded from the *uno, due, tre, quattro* of Italy through half a dozen other languages. Some languages had a better rhythm than others but the one that most enchanted them was the *yksi, kaksi, kolme, neljä,* and *viisi* of Finland. It prompted Christie to rewrite Peter Rabbit with Yksi, Kaksi, and Kolme replacing Flopsy, Mopsy, and Cottontail.

There was occasional rebellion in the ranks. Court and Jeff were suspiciously willing to duck out of PT and run for pails of water needed for breakfast preparation. It was the only time of day they did this task willingly. All became self-conscious when sleepy-eyed campers emerged from their tents to see what was going on. Kara the Inscrutable participated according to her mood but often stood stubbornly by and watched. Andy, the youngest, was willing to try anything. His push-ups were pure delight as he lay on his tummy shouting, "Watch me," pushing his head and chest up with straining arms and dramatic grunts while his middle remained on the ground. Jenda, the middle daughter, dissolved in tears when her big sisters told her she did exercises just like her mother. It was the ultimate insult.

In Finland we were able to catch up on work that needed to be done after the weeks of rain in Stockholm. The camp even had a hot-water heater, which eased the laundry chores. For twenty-five Finn-marks we received ten liters of hot water and, if that proved too steep for our limited financial reserves, we also found a way to use our leftover twenty-five *ore* Swedish or Norwegian coins which fit the slot but were of slightly less value. It was our first experience with planned dishonesty but the camp attendant didn't seem to care.

The children swam daily in the frigid water of the Gulf of Finland and chased a dozen baby ducklings that were quite willing to share their swimming hole.

Court lost his glasses in the water one day and was desolate without them.

"Why in the world did you wear them swimming?" Mothers ask dumb questions.

"How did you think I'd find the water without them?" Court answered.

To keep life from getting too tranquil Kara and Andy had a Cain and Abel battle one afternoon with rocks. Another little boy was involved in the fracas and was getting ready to throw a rock at Andy. "Don't hit me," said Andy. "Throw it at my sister."

As the little boy had no particular bone to pick with Andy, he hurled the rock at Kara, opening a bloody gash over her eye. Kara was her usual stoic little self but the little boys were terrified. Vernon picked her up and I applied a temporary bandage before we took her to the hospital for a few stitches.

Our plans to go into the Soviet Union made us suspect to many Finns who had not recovered from the last chunk of Finland the Soviets had taken. They felt the hot greedy breath of their neighbor and couldn't imagine why anyone would want to visit. On the other hand, we were invited into the homes of several hospitable Finns. One had sailed in the Golden Grain races around Cape Horn in the days of the great sailing ships. Another, an avid Communist, was a well-known poet who applauded us for our trip, ignoring the fact that our politics varied strongly and that we were not there to approve the Communist line, only to reach out a hand across the Iron Curtain.

At the time the Scandinavian countries were trying to cope with a heavy alcoholism problem. In Sweden alcohol could be purchased only in state stores, and they were scrupulous about designated drivers for any gathering that included alcohol. To get behind the wheel of a car with even one drink under your belt could mean the permanent loss of a driving license. In Finland everyone was issued an identity card for the purchase of liquor. If, however, a drinker's behavior was in any way a public nuisance, he or she received a punched hole on the card. After three punches (not necessarily having anything to do with driving) the card was confiscated and no alcohol could be purchased. We were soon to

find that the search for a drink was the sole purpose of a few Finns to visit Leningrad. They drove by the busload to the nearest campground, just west of the city, bought their bottles of vodka, and began the festivities. By late evening we had to watch where we stepped to avoid an occasional outstretched body. The next day they climbed back on their buses and returned to their own country.

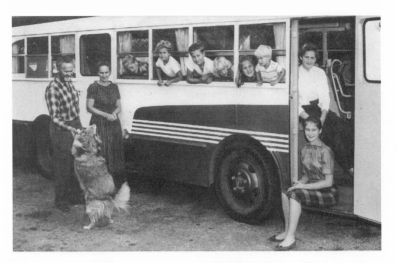

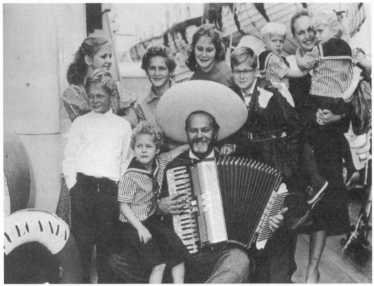

*ABOVE:* *Preparing to leave Santa Barbara. Left to right: Vernon, Anne, Jeff, Vicki, Court, Kara, Jenda, Andy, Jill, and Christie.*

*BELOW:* *Leaving New York following our press conference aboard the Vulcania. Back row: Jenda, Jill, Christie, Court, Andy, Anne, Kara (the last picture she let us take); front row: Jeff, Vicki, Vernon.*

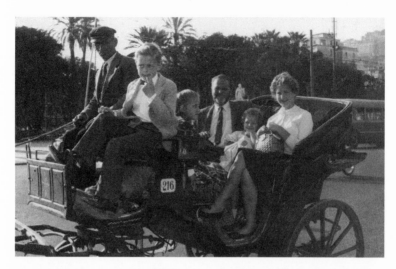

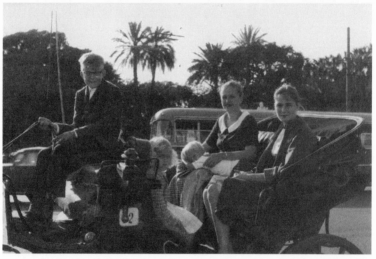

*It took two carriages to complete our first tour of Naples.*
ABOVE: *Our chauffeur, Jeff, Jenda, Vernon, Vicki, and Jill.*
BELOW: *Court, Kara, Andy, Anne, and Christie.*

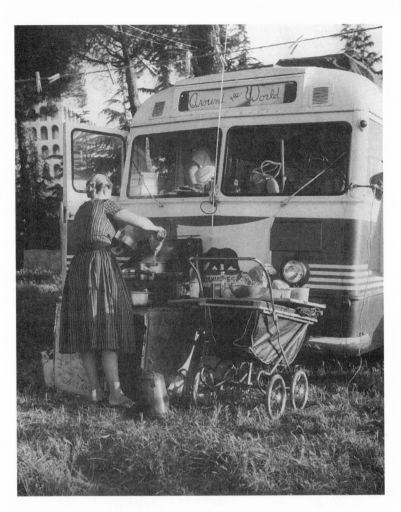

*My kitchen in the Rome campground.*

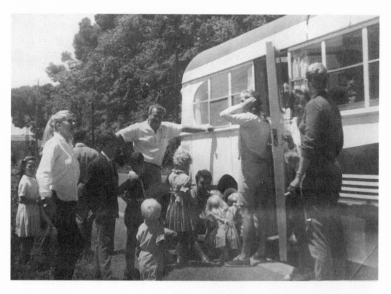

*ABOVE: The second axle breaks while we have Anita Ekberg (left) and her handsome beau Franko (kneeling) on board.*

*BELOW: La belle Ekberg decides we should have autographs on the sides of the bus. Our shock soon turned to gratitude for this idea.*

*Never too young to help with chores, Andy washes dishes
on the bank of the River Rhône in Lyon.*

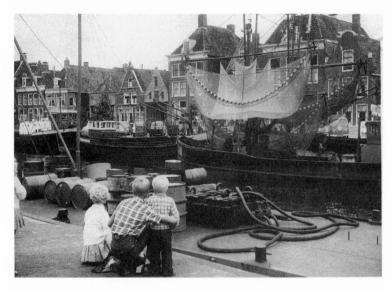

*Our second lost transmission stranded us in Harlingen, Holland, where Vicki, Court, and Andy wait for their father to return from a day at sea on a shrimp boat.*

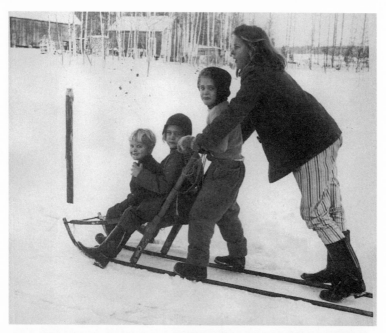

ABOVE: *One of our Swedish delights—riding a* spark, *a wooden chair on runners. Left to right: Andy, Kara, Vicki, and Jenda.*

BELOW: *Vicki (with crown of candles) as St. Lucia at the Oleby School Christmas program.*

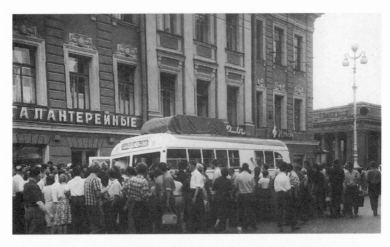

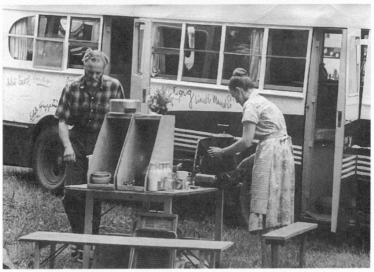

*ABOVE*: *Crowds in downtown Leningrad swarm to ask,*
*"Are you capitalist imperialists?"*

*BELOW*: *Preparing a meal in Moscow.*
*My kitchen had improved, with a table and*
*benches built by one of our English students.*

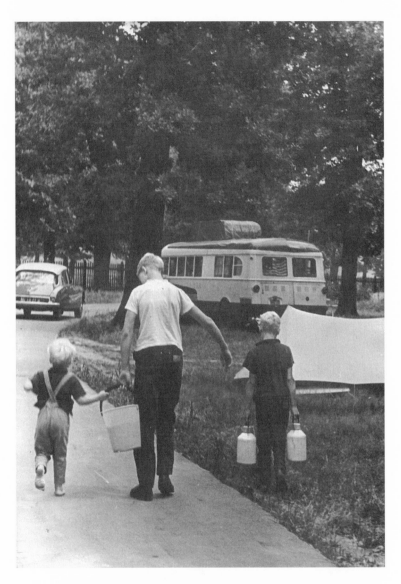

*Andy, Court, and Jeff haul water for cooking in Moscow. (The photo was taken with a telephoto lens by an Izvestia photographer, who gave us prints when he met us.)*

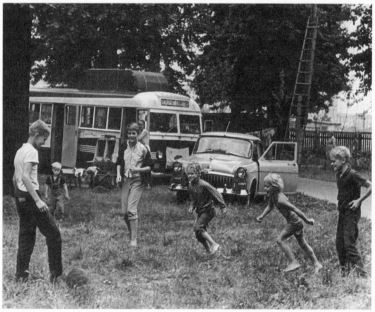

*ABOVE*: *Court's rendition of life on the bus.*

*BELOW*: *Another telephoto shot, showing Court, Jenda, Vicki, Kara, and Jeff playing soccer in Moscow.*

*The driver of a Moscow passenger bus (at left) kept his passengers waiting while he offered Vernon an air hose to fill a tire.*

*Vernon and Premier Khruschev talk at a Fourth of July party at U.S.
Ambassador Llewellyn Thompson's home.
Front row, left to right: Mrs. Thompson, Khruschev,
Ambassador Thompson, Vernon, and the same interpreter
who assisted at the Santa Barbara railroad station.*

*We awoke in our camp site in Kyoto to find a movie crew setting up to shoot a Samurai film, and one of the actresses posed with Christie.*

*The* San Francisco Chronicle *announced our return with a front-page banner. Left to right: Jeff, Anne, Vicki, Vernon (holding camera-shy Kara), Jill, Andy, Christie, Court, and Jenda.*

*Our triumphal return to Santa Barbara, towed ignominiously down
side streets. Our autograph book on wheels bears a dove
and the Russian word for "peace" on the door—
painted by Russian mechanics in Kalinin.*

# Chapter Twenty-Eight

WE ARRIVED AT THE BORDER between Finland and Russia in midafternoon after an all-day drive from Helsinki. The last miles were through thick forests along a narrow, twisting road that was unpaved but well scraped. Although it was sunny and warm, I felt a chill at the thought of leaving the security of Finland. People we had met who had traveled in the USSR had spoken of harassment by the police, constant surveillance, and occasional arrests where they were held for many hours for questioning. At times I had felt that they only wanted to surpass each other with their horror stories, but that thought did little to comfort me.

There were no houses along the last stretch of road and only an occasional truck passed driven by Finnish soldiers. The presence of soldiers made us feel the pressure of Soviet strength. They had taken a chunk of Finnish land along the border and it was possible more would be swallowed.

The Finns wasted no affection on the USSR and most of them were willing to fight to the last man to save their country from further aggression.

The Finnish customhouse was typical of their contemporary architecture—well designed and constructed by master craftsmen. It was a long, sleek building set in a clearing beside the road. Forests shouldered against the clearing. A crossing gate barred the road.

Smartly uniformed guards greeted us in English and invited us in while they checked our passports. We had overstayed our allotted time in Finland but they made no comment. The guards regarded the children's passport pictures as though browsing through a family album and showed us into a small kiosk where we were able to buy Cokes.

While we sipped our cold drinks we reported on our month-long visit in Helsinki. Hoping for encouragement, I asked, "Are many tourists driving alone into the Soviet Union?"

"No. We see tour buses from time to time but we don't get much traffic," a guard said. "People have a lot of fear about traveling in the Soviet Union and when they return they are always relieved to be back on this side."

"It's getting so late in the afternoon, we thought about spending the night in the forest near here," said Vernon. "Even though our visa specifies today. It can't make that much difference."

"We'd advise you to comply with your visa. The Russians are very strict about these things and you might not be allowed in tomorrow."

I made my drink last as long as was decently possible. The guards walked with us to our bus. In the distance across an open, plowed field we could see two Soviet soldiers beside a small frame guardhouse. "Do you ever talk with them?" I asked.

"That is the Iron Curtain. We do not speak."

My stomach felt leaden as we shook hands and said goodbye. A guard cranked up the wooden crossbar and we drove through. The bar fell shut behind us and we returned the waves of the Finns as they watched us cross the field.

I thought of a no-man's-land as a wartime necessity—an open strip of barren land between trenches where tired, unshaven men huddled for safety. In the rest of Europe there had been no gates or barriers. We usually had to request a stamp on our passports.

Our way of life changed in the short ride, shorter than two city blocks. The change was established before we touched Soviet land. It fell on my shoulders like a yoke. The feeling of freedom was like a glass bubble, easily shattered.

We stopped in front of a second gate and a Soviet soldier came to open it. He wore a dusty faded khaki uniform with limp

red epaulets. He was young with dark hair and slightly Oriental eyes. His assistant joined him and signaled us to drive through and stop beside the little house.

We greeted them in Russian, *"Dawbry d'ehn."* Good afternoon. Our limited Russian was a mistake. They answered pleasantly but in a rapid volley of words. The right foot we hoped to start on had tripped us quickly. We offered our passports but they shook their heads.

"Maybe they want to inspect the bus." Vernon offered to show them through it. No, that wasn't it. The guard with the dark eyes pointed down the road and repeated his words patiently. We climbed back in the bus and Vernon started the engine, assuming we were to go on, but they signaled us to stay where we were.

For an interminable half-hour we stood in the road, searching our phrase book, pointing to appropriate sentences in the chapter "Passport, Customs & Baggage." There was no chapter "Confused & Hopeless." The guards made no effort to help.

Mosquitoes droned around us, flying up in clouds from the swampy ground beneath the stunted, shaggy trees in the forest. We swatted the insects furtively hoping not to create the impression of criticizing their country. The guards were impervious to both insects and our discomfort.

The sense of frustration grew. Our determined smiling efforts to be friendly left us with aching jaws and Cheshire Cat smiles.

A half-hour crept past. At last our keepers pointed to a small cloud of dust rising over the dirt road. An olive drab command car emerged from it and pulled up beside us. The man who descended wore a uniform with embroidered bars on the shoulders and it bore signs of having been pressed. He spoke tersely in English and with a humorless, stern expression signaled us to follow his car. We never discovered how he knew we were there. The two guards had never entered their kiosk nor had they left us long enough to phone. Possibly it was one of his regular trips and we were lucky to wait only a half-hour.

We drove behind his car between the trees out onto a level stretch of cleared field, arriving after several miles at a large white building. It had a veneer of modernity but nothing like the

Finnish architecture. High arched windows were festooned with swags of dingy white drapes. There was no sign of a town. An assortment of officials wore a variety of uniforms. One of them signaled us to a parking place and the driver of our lead car escorted Vernon into the building. We followed like a flock of nervous pullets not wanting to be separated.

Two Finnish buses were parked beside the building and there was a flurry of activity as passengers cleared customs on their way out of the country. A kiosk did a rapid business as passengers bought wines and vodka, consuming generous amounts on the spot. Each of them carried a suitcase, which was thoroughly inspected before loading on their bus. We were appalled at the detailed inspection. Occasionally items were removed and there was a great deal of discussion and confusion regarding their travel documents.

I was intensely conscious of all that went on around us, as though possessed with small quivering antenna sensing everything new and strange. The alcoholic intake of the Finnish tourists added a bizarre quality to the activity.

Our passports and visas were checked and stamped and information copied into ledgers. Vernon was given a form to fill out listing in detail the funds we had with us. We carried American dollars as well as traveler's checks as we had heard the exchange rate was better.

I leaned over Vernon's shoulder as he wrote. "Are you sure you listed everything? I still have some Finnish coins in my purse. Do the girls have any money?"

"Will you stop worrying?" he said. "Have a little confidence. We aren't going to get into trouble."

The heavy-set woman at the money exchange manipulated the beads on a wooden abacus and checked Vernon's totals. The official rate of exchange was $1.10 per ruble, an arbitrary amount set by the Soviet government. It bore no relationship to international exchange rates, as the actual value of the ruble was less than fifty cents. We knew there was a lively black market in dollars but a month previously the death penalty had been set for such dealings.

Vernon bought a supply of rubles in exchange for some of the traveler's checks and was given a printed form noting the amount. Whenever money was exchanged it was to be registered on the same form which was to be turned in when we left the country.

Meanwhile a man handed me a form on which to declare all valuables we were taking into the country. As I thought of the motley assortment of pots and pans and worn clothing, I was tempted to write "none" but my obsession of complying with every rule swept me along. We were to list in detail any cameras, film, guns, gold, and diamonds. There was a limit of two sweaters per person. The last gave me some concern. We had never counted the number of sweaters but after a winter in the north we certainly had more than two. If they wanted to confiscate the ragged remains, it would lighten our burden.

My engagement ring had a small diamond, visible on a clear day. I noted it on the list. The thought of traveling with firearms was bizarre. Zero on that line.

The section on cameras sent me into a moderate anxiety attack. It said, "One camera per person." "What shall I put down?" I asked Vernon. "Maybe they mean one camera per car or one per family."

Vernon's patience was being stretched. "They say one per person, don't they? Okay so we have three cameras and ten people. I'll give Jill a camera. Christie can have one. The other is mine." Obviously I had become persona non grata, camera-wise.

I listed the cameras. The inventory official accepted the paper without comment. I remembered a ring I seldom wore. It was hidden in a case on my shelf in the bus. I was going to ask Vernon's opinion then decided in the worst-case scenario, I'd swallow the damned thing.

The official in charge of vehicles asked Vernon to drive the bus to the rear of the building for inspection. We started to follow but were told to wait in the main room. What if they found my ring? It was a family heirloom. It would be terrible if they took it, but what did they do to people who made false declarations. My mind resembled the littered planter box on which I sat.

I smiled bravely at the children for a split second. Then

another memory surfaced. I'd forgotten to list the Brownie camera. Of course, it was broken but it *was* a fourth camera. I could say it belonged to Court.

A slim, kind-faced official joined us. He was interested in the children and in our mode of travel as well as our itinerary. When he left us to return to work, he spoke warmly, "You have a fine family and I hope all of you will enjoy every minute of your trip through my country."

My first truly human contact with a Soviet citizen made me feel better about the whole project.

Vernon returned with the bus after about half an hour and was directed to a parking place. We climbed aboard and peppered him with questions. Did they find the other ring? What did they say about all the film and cameras? How many sweaters did they take? Did they take any books?

"Hold it a minute," he said. "First I had to drive the bus over an open pit and a soldier looked underneath. Another came inside and looked around."

Our hodgepodge and the quantity of stuff he was supposed to search had startled the inspector. He looked in the kitchen cupboard and apologized for having to confiscate our thirty pounds of new potatoes and supply of big yellow onions.

"Finnish vegetables no good," he had said. "Much disease." He took our healthy potatoes, the last we were to see for many weeks. I don't know about the onions as I never found any to compare. We could only hope the guards ate well that night.

The inspector asked about the luggage rack that held ten suitcases and several bulging (with sweaters) duffel bags but was willing to accept Vernon's word on the contents. He paused for a short glance at our small library and picked up one of the children's books, *Christmas in Many Lands*. One of the stories was of the old Christmas celebrations in Russia and he leafed through it carefully, feigning knowledge of English, but replaced the book without comment. He ignored a Bible, which we had included to round out our library but never read.

We were at the customhouse for two hours when an officer told us two interpreters would accompany us into the town of

Vyborg, where we were to obtain camping tickets and insurance for the bus. He failed to mention that they were Finnish interpreters and needed a ride. Our trip into Vyborg was a quiet one. I had ample opportunity to worry about the possibility of an accident before we obtained insurance.

The road was paved but the country through which we passed resembled the destruction left in the wake of a retreating army. The land had belonged to Finland fifteen years before but if any Finns were still living on it they had lost the industrious nature that created trim farms and well-kept forests. Fallen trees lay like giant jackstraws and the few structures were simple log cabins.

There were no gardens or vegetable plots. The unkempt forests crept close to the small shacks and foot traffic had packed the earth into narrow dusty clearings. We saw a few women and sometimes a child sitting on splintered, crumbling front steps. They were motionless, tired, and dingy looking individuals who might at any moment be swallowed by the scraggly growth of trees. A few dust-covered windows reflected the afternoon sun but others were broken and their hollow-eyed aspect resembled the inhabitants.

It was eight o'clock when we arrived in Vyborg but the streets were almost empty. The sun was still high in the sky during those long summer nights, known as the white nights in northern Europe, when the sun is gone for only a couple of hours. Our so-called interpreters mumbled, "Inturist," pointed us in the direction of the railroad station, and walked away. There had been no interpreting.

In a corner of the deserted station was the Inturist sign. We entered a small office with the charm of a dank cave. Dante's words over the entrance to the Cave of the Styx in Naples sprang to mind, "Abandon hope all ye who enter here."

A pretty young blonde greeted us with a superficially pleasant manner lying like a veneer over a rigid spirit. She helped us with our insurance papers and was firm in insisting that we pay in American dollars, refusing our newly purchased rubles or traveler's checks. She translated for a man who arranged our camping coupons. He was jovial and friendly but her translations stayed firmly within the demands of the task.

We were given a book of tickets, one for each night of our

stay, and another book that provided free tours and guides for every second day. Large pictures of Lenin and Khrushchev looked down on us from the dark walls and monitored the transactions. The crumbling condition of the old building and the echoing gloom of the high-ceilinged room were depressing.

The blonde's farewell words held a warning. We were expected in the Repino campground, forty miles this side of Leningrad. We were not to stop along the road. When we arrived at the edge of Vyborg we were to take the right turn. "Do not turn left," she repeated. My imagination added, "Or else."

We returned to the bus. "That right front wheel has been making an unusual sound," Vernon said. "You start up the motor and drive back and forth a couple of times while I listen." As I pulled forward there was a squeal like an ailing tomcat. Vernon kicked the wheel a few times and climbed aboard. "Well, I hope it doesn't drop off."

The warning not to stop beside the road, combined with the bus's devotion to stop wherever and whenever it was so inclined, fueled my mind. Vernon's attitude toward the bus was as solicitous as a lover's toward a petulant mistress. He listened to each bleating squawk from the wheel and handled gears and steering wheel with the utmost gentleness.

We had no trouble finding the designated turn. A barricade of armed guards blocked any left turn.

Only three cars passed and an occasional old truck. Guard stations like telephone booths were frequent but we were not stopped.

Road signs, printed in Cyrillic and Roman, named small settlements and at intervals pointed to a post office or medical aid station. That was a fresh new thought, what if one of us was sick or injured?

It was almost midnight when we saw the sign saying Repino. The sun had at last gone down but twilight lingered and the sun would show itself again in a few hours. We drove slowly until we saw a fence surrounding a group of tents. Vernon pulled up to the gates and we waited for someone to open them. Christie knocked at the gate. Vernon beeped the horn lightly. If we were expected, as we had been told, there was no sign of welcome.

As we were considering pulling off to the side of the road to sleep, an elderly man rode up on a bicycle. He pointed to the camp. *"Russki,"* he said, *"Niet too-reest."* He pointed back to the main road and motioned us to follow him as he peddled madly for a mile before turning up a narrow dirt lane. He pointed up the low hill, *"Da,"* he said, *"Too-reest cahmp."*

Vernon thanked him and offered him a tip for his assistance and he shook his head quickly. His expression was of fright and expressed more than injured pride. He backed fearfully away, climbed on his bicycle, and rode quickly out of sight. We were to learn that to accept a tip was against the Party line.

A man in a dark brown suit and brown fedora opened the gates. He directed us to a parking place and signaled to me to come with him to the office. I followed him to the office where a woman sat behind a wide desk. Neither of them spoke English and there was some confusion as I made a cheerful effort to produce the desired papers. Names were copied carefully as I pronounced them in English and were transcribed into Cyrillic letters in a large book.

When they finished I reached for our precious passports and visas but was led to understand that they were to be kept in the office. They saw my reluctance and pointed to tomorrow's date on a calendar. I remembered the warning of an American consul in Helsinki: "Always keep your passports with you." My hosts considered the matter closed.

We returned to the bus and the stern, brown-suited man directed us to a campsite and pointed out the conveniences of the camp. A pavilion contained a small restaurant and was the scene of a noisy gathering of drunks. At the far end of a grassy square was a community kitchen with stoves, tables and sinks. The bathrooms were new, white stucco buildings containing sinks and the hole-in-the-floor toilets the children called "squat downs." On the surface the baths looked clean and efficient but as we turned the corner behind the building I saw a deep pool, an open sewer, home base for the mosquitoes that permeated the air.

Our assigned campsite was in a grassy corner of the grounds, bordered by a fence that led to the entrance gates. Three red Volkswagen campers were parked near us.

We quickly readied the bus for bed. All of us were tired and quiet after the busy day. The locked gate, the missing passports, the unfriendly manner of the manager—all combined to make an uneasy feeling. We were far from home and cut off from everything familiar—even our passports. We hadn't eaten since midmorning but we had passed hunger.

There was a noise beside the front door and we heard a man's voice with a clear American accent. "Excuse me," he said. "You must be the Johnsons."

Vernon and I stepped out of the bus. "How did you know?"

The man's wife had joined him. "We're from Santa Barbara," she said. "We read about you in the *News-Press* and have been looking for your bus all over Europe. Welcome to Russia."

# *Chapter Twenty-Nine*

THE APPROACH TO LENINGRAD* is beautiful. Huge trees line the banks of the Neva River; wide bridges cross it. In the distance blue domes and shining gold towers point toward the sky.

We slowly found our way around the city—the streets, the people, the police, and the restrictions. The pervasive fears of the police that had accompanied us into the Soviet Union, along with stories told by other tourists in our own press, faded but never quite disappeared.

We had been warned to watch for small signs that designate traffic flow but it seemed simple enough. On several occasions we heard the shrill blast of a police whistle as we neared the center of town. Through the rear window we could see a policeman waving madly. The children returned his greeting. Vernon assured us the policeman must have been signaling someone else. On our third visit, we noted a sign that told us we were going the wrong way on a one-way street.

The sidewalks were jammed with people and when we came to Nevsky Prospekt, the eight-lane main street, we had long pauses beside crosswalks jammed with pedestrians, like ants on a cookie trail. We decided it must be a national holiday of some sort.

---

* St. Petersburg became Petrograd in 1914 following the Russian Revolution. In 1924 it was changed to Leningrad and in 1991 again returned to St. Petersburg.

There couldn't be such enormous numbers of people with free time in a land where everyone worked.

With the hypercritical judgment of teenagers, Christie and Jill carefully noted clothing styles, particularly shoes. The stiletto heel and pointed toe had not poked a hole in the Iron Curtain. Dresses were generally of flowered material in a style reminiscent of outdated mail-order catalogs. Men's suits were poorly cut, with double-breasted coats and wide trouser legs. Women's hairdos were of two styles—luxuriant, shining braids or permanents resembling the stuffing of a scorched horsehair mattress.

As we had been offered free guide service we decided, on our first visit, to take advantage of having an interpreter as we learned our way around. While Vernon and Jill went to inquire the rest of us stayed in the bus, where a crowd soon gathered. A young woman spoke to us in English and translated for the crowd, who waved and asked questions. Several people gave the children small enameled pins bearing pictures of Leningrad, Gagarin,* or Lenin. The crowd grew until it was twice as long as the bus, filling the sidewalk, and spilling over onto the street, and taking up two lanes of traffic. I was apprehensive when I saw two policemen approaching. They edged their way through the crowd to the window by the driver's seat where I was sitting. Then they leaned their elbows against the bus and added their own questions.

We would soon learn to understand the basic questions. "Are you really Capitalist-Imperialists?" "Did the Soviet government pay for your trip?" "Did your government pay for your trip?" "Do your children have any free education?" "Do you have any chewing gum?" "Do you have any ball-point pens?"

"So many people are walking through the streets," I said. "Is it a national holiday?"

"Don't people walk in your streets?" the English-speaking woman said.

We discovered that on beautiful summer days people stayed

---

* The Soviet cosmonaut Yuri Gagarin had been the first human in space, orbiting the earth a single time in his space capsule *Vostok* 1 on April 12, 1961. Alan Shepard's suborbital flight took place about a month later, placing the USA and the USSR firmly in the space race.

outdoors as much as possible, away from their crowded small apartments. In the winter they did not have that choice. A woman chemist told me that she and her husband lived in a one-bedroom apartment with her daughter and mother-in-law. "We would like to have more children but there is no room for them. You are a very lucky woman," she told me.

Jenda received a gold and red pin from a teacher from Odessa. I lit a cigarette and offered one. The teacher refused but moments later said, "It's just a gift, isn't it?"

I didn't understand. "Of course, it's a gift." I answered. "I want to give you a cigarette."

"Remember," the teacher said as she accepted it. "It's just a gift. And the little pin I gave to your daughter, that is a gift, too." She tucked the cigarette in her purse and walked away.

A young man posed one of the more intriguing questions. "Is it true that Americans need all those cars so they can drive around looking for jobs?"

A slim, dark-haired young man with anxious eyes edged his way onto the bus's steps. He spoke no English and I resorted to our Russian phrase book. He was intent on telling me something and after a search of the little book picked out, *assist, border frontier, travel,* and *out.* The fear in his eyes made his message appallingly clear.

When Vernon returned with our guide, Galina, she asked me what the man was doing in the bus. I explained that he wanted to meet the children but that we couldn't understand each other. She pierced him with a frigid glare and asked him to leave though we insisted he was welcome to visit if he wanted. He climbed reluctantly out of the bus and gave me one last pleading look before saying *"do zvidaniya."*

"What did he say to you?" Galina repeated.

"He just said goodbye. We were trying to talk but it was impossible to understand." Instinctively I wanted to protect the young man.

One of the early electronic games for children allowed players to ask questions and when a plug was stuck into the correct socket on the board an answer would light up. Galina was like that game. She spouted statistics, dates, and recent Soviet history as we

drove through the city. When she pointed out the old churches and palaces she referred only to their current use. Her manner was defensive as though she considered our questions criticism. It took an hour for her to discover that we had no intention of attacking her statements, whereupon her conversation became slightly less robotic.

"We were told not to take pictures," Vernon said.

"Another ridiculous bit of propaganda," Galina said. "You may take all the pictures you want." She pointed out, however, that we could not take pictures from bridges (a difficult feat in Leningrad) or photograph people in uniform. The latter would have eliminated any scenes of crowds, as uniforms were commonplace.

Leningrad had been under siege, surrounded by German troops on the immediate outskirts of the city for nine-hundred days during World War II. Starvation was everpresent but the Russians never gave up. After more than fifteen years the scars were still visible on many buildings. Galina led us past an area of newer housing, begun in 1958 according to the date over the entry. Construction was so shoddy that after only three years many windows were broken and balconies were pulling away from the building, some dangling precariously.

Before we parted company, Vernon asked Galina if she could show us how to shop in the large food shops. We had found the system to be complicated. First we had to stand in line to see what was offered behind the counters as well as the price; second, we stood in line to pay for the food after telling the cashier what we wanted; third, we returned to the counter and waited our turn in line to present our sales slip to a clerk in order to receive the item. This was very difficult to do without a greater knowledge of the language. It was a cumbersome, time-consuming system of waiting in three lines for each purchase. In the small shops and at kiosks in the streets we could simply point to what we needed. When I expressed mild dismay, Galina looked as though she found Americans to be unusually dense.

I withheld any comment about either shortages of many basics or the outrageous prices caused by the arbitrary exchange rate. Margarine was two dollars per pound (versus about thirty-five

cents at home). Butter was even more. Sugar was one dollar a pound versus ten cents in the States. Considering that our stores expected to make a profit on sales and that the Russians sold "at cost," we were nonplussed.

I said, "People must spend most of their money on food."

Galina's answer was simple. "Of course."

# Chapter Thirty

IT WAS ONLY A WEEK since we had set up our gear beneath tall pine trees at the Repino campground outside Leningrad. I was not yet comfortable on that side of the Iron Curtain but we found that, like us, people wanted to reach out as though to grasp at peace.

A battered, unpainted wooden fence separated the camp from a dirt road along which local residents walked, pulling their carts or carrying their day's purchases to their homes tucked away in the nearby woods. These had once been country houses, the dachas of the wealthy who came from St. Petersburg before the revolution to enjoy the countryside. Now the houses were slowly crumbling.

For the first few days we drove into Leningrad each morning, touring the once-beautiful city and answering questions when throngs of people gathered around the bus, almost closing two lanes of the broad Nevsky Prospekt. As in other cities, I found that the little ones needed playtime and I was happy to stay with them while Vernon and the older four explored the city.

Children stopped at the fence on their way to a nearby beach on the Sea of Finland to stare curiously at the foreign campers. Vladimir, a young boy who was studying English in Young Pioneers, invited our fourteen-year-old Court to join them. That day the two boys had dug up a German helmet from World War II. A bullet hole had pierced the metal and the young German soldier

had probably died there on the beach. Would Court and Vladimir one day be enemies?

A Soviet soldier, rifle slung over his shoulder, patrolled the lane, walking slowly back and forth beyond the fence. Despite the lack of a mutual language, he and our Andy became friends. That morning the soldier lifted him over the fence and took him for a walk down the lane, chatting cheerfully as they went. They returned with a bunch of wild flowers for me. Andy had become *Andrushka* and he saved some of his lunch to share with his new friend.

A friend of ours who was a child psychologist wrote to us while we were still in Sweden. "You have no right to deprive your children of the security of home." We searched our own and our children's attitudes to see if he was right. We found only that they were more patient with each other. They had gained a confidence and independence they'd never had before. They were gaining on-the-hoof knowledge of arithmetic in the daily business of money exchange and in the use of the metric system. They were no longer afraid of the dark after many dark nights of camping in tree-surrounded grounds. Christie and Jill were able to discuss subjects of importance with more interest and a deeper understanding; they had confidence in moving around new cities on their own. All of them were willing to try a new word in a new language without concern about saying it wrong or having someone laugh at them. Andy could say ice cream in half a dozen languages, having just added *morozhnaya chocoladniya*. We decided that in our busy lives at home we had not provided as much security as we did in the unity of life as we traveled together.

We did not tell the children that the way people saw us would form their opinion of Americans. If we were the first they met, they would surely think, "All Americans are like this." Nevertheless, the children understood more than we could explain and were worthy ambassadors. When people ask, "Wasn't it a handicap to travel with children?" we can only answer, "They were our passports. They opened doors that might have been closed."

Feeding a family of ten had become a challenge. I was unable to replace the potatoes and onions taken at the border. I searched the

tiny markets along the way as we drove into Leningrad with little success. It was the land of potatoes without the potatoes—or much of any other food, for that matter. At least hearty Russian bread was always available and it became the base of our diet.

One afternoon I looked at nine hungry faces and then scanned our iceless icebox and began to assemble what I found there. That morning I had been able to buy a large cucumber, a bottle of milk that had curdled, and a pinkish gray chunk of a substance that looked like bologna. The butcher had called it sausage. There was an unidentifiable lump which when scraped turned out to be a piece of cheese, along with an onion that had escaped the notice of the customs officials. From the pantry beneath a bus seat, I removed a small can of tomato paste and a pound of pasta. I blended these with the chopped Russian sausage and curdled sour milk and heated it on our camp stove. I knew it was dinnertime only by the clock for the sun was still high in the sky.

How can I describe that never-to-be-forgotten dish? I say, "never to be forgotten" because God knows I've tried, but the memory lingers. Hoping it would sound more elegant than the contents warranted, I called it a casserole. It must have looked acceptable to Christie and Jill because they promptly invited four young Australian men who were camped next to us to share our meal.

It was one of the make-do dinners I speak of as a "loaves and fishes" meal. With the addition of the large cucumber for a salad, there was enough for everyone. It didn't take a large serving to qualify as enough.

I don't know why I consider that a memorable dinner. Certainly no one asked me for my secret recipe for Desperation Casserole. Hopefully it will never be repeated, but it had all the other qualities of a memorable meal—good conversation, a perfect summer's day, exotic surroundings, and leisure time.

We decided to treat ourselves to one great luxury while we were in Leningrad—the Kirov ballet. We took turns; Vernon took Christie and Jill one evening to see "Swan Lake" and the next night Christie and Jill baby-sat in camp while Vernon and I took Court and Jenda. It was an exquisite, unforgettable performance.

The camp was buzzing with excitement when we returned. Christie, Jill, and our Aussie friends gathered around to tell us about it.

Three of the Australians had made an appointment with a pair of Russians for an illegal exchange of dollars. On the black market they were able to get two or three rubles for a dollar instead of the official $1.10, although they knew they were tempting fate and Soviet law. Some of the dollars involved were ours; Vernon had wanted part of the action.

They arrived at their roadside rendezvous and had only begun to negotiate when the police arrived. All five participants were taken to the local jail and the ensuing two hours were spent in thorough interrogation. All staunchly insisted they had met for the sole purpose of having a drink in a nearby restaurant. As the police were unable to prove the consummation of any nefarious business, they were finally freed.

Did they return to camp and the honest life? Perish the thought. Our Aussies didn't have the old Botany Bay heritage for nothing. As soon as they left the police station they returned to their rendezvous. The two Russians met them, they had their drinks in the restaurant, the money was exchanged, and they parted. The Aussies returned to their truck to find the doors broken open. Their clothes, cameras, and two suitcases were missing.

After the earlier events of the evening they hesitated to make further contact with the police but one had lost his visa and traveler's checks. He would be unable to leave the country without reporting it. They returned to camp and reported the missing visa. The manager called the police, who suggested that the boys had sold the missing items and reported them stolen as a cover-up. The Aussies felt that their black market pals were involved. Their visas were extended for a couple of days and they spent a morning in court where they were told to file a claim with their embassy in the next country. They were to leave the USSR immediately.

For some odd reason our black market rubles survived the various searches and Vernon received his allotted amount. Our Aussie friends had not implicated him. We were sorry to part with our jolly team from Down Under.

# Chapter Thirty-One

TORZHOK IS NOT A TOURIST STOP. There was no hotel for tourists, no campground, no service station. It is several miles off the Leningrad–Moscow highway over a rough, unpaved road. There is nothing of historical note to prompt a visit.

We had a late start that day for the 360-kilometer ride to Kalinin from Novgorod. The country through which we passed was low and flat with a few isolated houses and an occasional cluster of small homes beside the road. Even houses under construction were built of logs but lacked the carved gingerbread trim around doors and windows that enhanced the old homes.

In the small settlements we saw women with heavy buckets of water hung from wooden yokes across their shoulders, carrying water from community wells. Windlasses by the wells lifted water from their depths. There was little motorized traffic on the main road but many carts pulled by horses or by a man or woman. With wooden-pegged rakes women gathered freshly cut hay in the fields, stopping their work to wave as we passed.

Toward suppertime we passed through a section of rolling, tree-covered hills. My shopping trip that morning in Novgorod had not been very productive—just enough for lunch. We had little hope of reaching Kalinin before dark and longed for a hot dinner and a rest. Our map showed a town, Torzhok, sixty kilometers from Kalinin, where we hoped to find food. We turned from the highway when we found the small sign pointing to

Torzhok. The road was dusty, unpaved, filled with ruts and stones.

We drove for several miles, stopping to ask an elderly couple, "Restaurant?" Fortunately the word is the same in Russian and they pointed down the road. As we entered the community, we asked again and were directed along our way.

I sometimes wonder if I dreamed Torzhok. It wasn't like other Russian villages. Little houses clustered next to dusty streets with an occasional slab of stone sidewalk. In memory the houses were of whitewashed stucco or frame and there was the feeling of a small Mexican town.

We arrived at the steep banks of a slowly twisting river. To our right was a rickety, two-story frame building with a faded sign "Hotel and Restaurant." As there was no room to park we drove across a narrow suspension bridge that spanned the river and stopped in a broad dusty square lined with young trees. There were a few old houses but no one in sight.

We walked back to the hotel, climbed the splintered wooden steps, and entered a small drab room. A flight of stairs led up from one corner and behind a pair of faded red curtains we saw the dining room. The waitress, a woman in her thirties wearing a print dress and a stained white apron and headband, led us to a round table in the corner of the room. There were six other tables and through a wide archway another room of the same size. There were many men at the tables but few women and no other children.

A buzz of interest accompanied our entrance. Although there was only paper covering the other tables, the waitress spread a clean worn cloth on ours and took a small bunch of drooping flowers from another table to adorn the center.

The menu was handwritten. We could cope with printed Cyrillic but script was a challenge.

"What do you suppose this first line is?" I asked.

"It says 'cutlets' over here," responded Jill.

"And this is 'salad' isn't it?" asked Christie.

The waitress joined us, reading aloud from the menu. A few familiar phrases caught our ears. Cutlets—that sounded like meat. I hadn't been able to buy any meat for the two weeks we had been

in the Soviet Union. Cucumber salad with onions had become a staple. Vernon ordered and asked for beer for us and bottled lemonade for the children.

Although we had washed small hands and faces before leaving the bus, there were some remaining spots. I explained to the waitress that I would like to wash them. She signaled to a woman who had just come from the kitchen and with warm smiles and motherly murmuring, they took Vicki and Kara and disappeared. The children returned with shining hands and faces and the older woman demonstrated how she had scrubbed them.

The girls were bursting with descriptions of their short trip. "Pigs," they shouted. "You should see the pigs!"

Kara tugged at my hand and pulled me toward the door. The waitress and cook invited the other children to join us and proudly took us through the kitchen where other smiling women greeted us. Work came to a standstill.

Indeed, there were pigs—in a pen right outside the kitchen door. The children babbled on about the animals and pointed to the little outhouse with its nimbus of big black flies circling in the late evening sunlight.

"You're right." I tried to match their exuberance. "Those are just about the biggest pigs I've ever seen."

The waitress beamed at my apparent enthusiasm and as I came back into the kitchen, the cooks wiped their hands on their aprons and shook hands with us before we returned to the dining room. Vicki and Kara continued their talk about pigs until Christie pleaded, "Moth–er, make them stop."

The plates of food were attractively arranged but the quantity was overwhelming. The cutlets were very large sausage patties.

"Is that pig?" asked Kara. "I don't love it!"

Vernon, who had missed the backyard expedition, started to agree but I stopped him. "Of course not. It's hamburger."

We were the objects of a good deal of attention as we ate. For the audience's benefit, I smiled broadly at the children while muttering, "You'd better eat every bit or you'll regret it! They'll think we don't like their food."

They got the message but there was so much food on the plate that it was rough going for the younger ones. The "cutlets"

had a distinctively aged flavor, though God knows the meat should have been fresh. Food moved from one plate to another and bites that we couldn't finish were pushed around in less conspicuous waste. I'm sure that more than one chunk of pig ended up under the table or in a pocket.

When the waitress had cleared our plates she returned with a small tray containing eight pieces of chocolate candy. She pointed to two men with bowl-shaped haircuts who were dressed in rough working clothes. "For the *malinki*," she said and passed the candy to the children. We nodded our thanks and the children obligingly found space for a few more bites.

The waitress then returned with a large bottle of champagne and two glasses. Again she nodded to the two men in the corner and placed the tray in front of Vernon. He motioned the men to join us and they walked over to our table and bowed deeply, kissing my hand with an easy grace and shaking hands with Vernon and each of the children.

The taller of the two took the bottle of champagne, removing the top with a satisfactory explosion, and decanted the bubbling wine into four stout water glasses. He proposed the first toast, "American-Soviet *droozhba*." We all drank to our friendship.

The next toast was "Kennedy-Khrushchev." One of the men asked, "Khrushchev *horosho*?"

Vernon repeated "Khrushchev *ochi horosho!*" Then he asked, "Kennedy *horosho*?" The men echoed agreement of Kennedy's goodness.

With our limited Russian vocabulary, the conversation somehow encompassed the fact that Vernon and the two had fought the Germans. Hopes of peace between our countries were expressed. They then toasted the mother of the chocolate-covered faces. The waitress accepted a small glass of champagne. We finished the bottle. The atmosphere was friendly and joyous and most of the other diners shared the feeling.

We were so swept up in camaraderie that we failed to notice two men who were not so approving. One of them spoke to the men at our table and they answered abruptly. The jubilant spirit of understanding was not unanimous. Not wanting to create an incident in that peaceful village, and still very aware that we were

Americans in the USSR, we expressed our thanks to all, paid our bill, and left the restaurant.

Foot traffic on the bridge was heavy as we returned and many people nodded and greeted us pleasantly. When we reached the edge of the square it was jammed with several hundred people. We could barely see the bus. Attention was riveted on us as we tried to get through. Everyone wanted to speak with us, to shake hands, or to touch the children. Christie and Jill were little islands in a cluster of young people. The small children stayed close to me but were frightened by the crush of bodies. A tall man lifted Vicki and Kara and I carried Andy while Vernon made a path for us through the crowd to the bus.

At last Vernon stood beside the bus speaking to the men and shaking hands. I stood on the steps and smiled at the women who waved to me. Several women pushed through carrying little children in their arms. The small ones handed me big bouquets of wild flowers and I put them in glasses of water and set them along the window ledge so they could be seen.

And always the question we had learned to understand, "Does America want peace?"

Many of the women were crying as we assured them of our desire for peace and friendship. These people, who had seen the agony of war so recently, accepted our assurance as if it were official policy. I felt my own tears as I held a tiny girl who had given me a bouquet.

The pitch of excitement and the mob hysteria was wonderful and frightening simultaneously. That sort of excitement is a fragile thing. A man who seemed to enjoy a certain amount of prestige and was better dressed than the others tried to move some of them away from the bus. His manner was abrupt and a bit hostile. Feeling that he must be one of the town's leaders and that his manner could easily turn the enthusiasm in a less desirable direction, Vernon used his skill at easing a tense situation. He approached the dissident and asked for his help. Could he show us the way to the highway?

The man's manner changed perceptibly. He motioned to Vernon to drive on and with an air of authority and pride he entered the bus and sat down on the front seat. He was stony-faced

as the crowd waved and shouted. The women threw kisses and waved their babies' hands in farewell. Vernon edged the bus slowly forward as our guide motioned brusquely to them to get out of the way. We turned back across the bridge. At the edge of the town he signaled us to stop. He climbed out, pointed in the direction of Moscow, said a polite *"Do zvidaniya,"* and with great dignity walked back toward town.

Before we came to the main road, Vernon pulled the bus to the side. We sat for several minutes, speechless, and then everyone burst into talk at once. It had been a strange and awesome experience. I doubt if most of the people in that isolated village had ever seen a foreigner, American or otherwise, and yet the exchange of emotion needed little language or introduction.

At the peak of the Cold War we had found warmth and understanding. To us, Torzhok symbolized Vernon's reason for making the trip.

# Chapter Thirty-Two

AS THE MOON ROSE OVER THE VOLGA, Vernon and I sat sipping wine on an old wooden bench by the Kalinin campground. It was difficult to believe we were behind the Iron Curtain, so far from Santa Barbara.

I was far more philosophical that evening than I had been earlier in the day.

Anyone who has not done several days' accumulation of laundry for eight people (Christie and Jill did their own) might not share my emotions. The fact that washing was done in cold water, on an old fashioned washboard, in a bucket that sloshed sudsy water over my feet, might better explain my mood.

As I scrubbed, I developed a suitable mental state, mumbling caustic responses to past and current unkindnesses, and carrying on lively mental conversations with all those who had ever crossed me. Thus fueled and with sweat running down my neck, I waded barefoot across the flooded shower room for another bucket of water, returning to empty it into the larger pail that rested on a narrow shelf by the door. Halfway across the room I slipped, spilling half of the water on my already drenched self.

Vernon chose the moment to appear at the laundry room door. In all fairness, I should have admired his bravery. He didn't wither beneath my searing gaze. "The children have done a great job on cleaning up the bus," he informed me. "Christie and Jill have dressed the little ones and we're all set for the day."

"Admirable," I muttered, as I dragged a pair of Court's encrusted blue jeans across the board, rubbing the fabric with a brown bar of laundry soap, the only soap we had found in the Soviet Union. My hands stung from the awful stuff. "I hope I'm not holding everyone up," I added.

Good old Vernon. At least, he hadn't lost his sense of humor. "That's the way I like to see a proper wife," he said. "Barefoot...." He dodged a wet sock. "...at the sink," he added. My aim was good. A wet towel caught him amidships, and he made a prompt exit.

Realizing that my sense of humor was stretched thin, Vernon changed his approach. "Why don't I take the kids swimming while you roam around town. They'll probably never have another chance to swim in the Volga." He even helped me hang the laundry to dry on a line between the pine trees by our campsite.

I jumped at the chance to spend a few hours shopping and exploring by myself. Wearing a dress well worn from harsh laundry soap, my hair in a simple twist, string shopping bags in hand, I moved unnoticed among other shoppers. The apprehension I had experienced in our early days in the USSR was easing and I was just another Russian housewife on daily errands.

When I spotted a package of needles in the display counter of a dry goods store, the clerk asked how many I wanted. Thinking she meant how many packages, I said, in my best basic Russian, "Just one." She carefully removed a single needle from the pack for me and another for the woman standing next to me. Not wanting to elicit the frequently asked "Are you really a capitalistic imperialist?" I settled for a single needle, which the clerk secured carefully in a fold of newspaper.

One street was lined with vendors selling from small carts. Packages bore no bright pictures to tempt the buyer or identify the contents, but slowly I translated the Cyrillic lettering and selected two much-needed items, soap powder and dried milk. The milk later proved to be good but the soap powder was disappointing. They might well have been interchangeable.

A food shop displayed toxic-looking fish in a mustard-colored liquid next to large glass tanks of improbably colored fruit juice. Ignoring the fish, I bought a glass of watery orange juice, the first in months, downed it, and bought two more.

A vegetable stand sold tomatoes, cucumbers, and cabbage—the only vegetables we saw during our two-month stay. Like other housewives, I stood in line patiently to pay two or three times per pound what we would have paid at home and wondered what prices would be if it weren't the height of the growing season.

The best find was a small butcher shop. As usual, there was no meat but a display of partially plucked chickens gave me a moment's hope until close inspection decided that our limited supply of cooking fuel was no match for chickens who were so far past their prime of life. I settled for something labeled cutlets which, when we ordered them in the restaurant in Torzhok, had proven to be pork sausage. The plump, crumb-covered patties were only twenty cents each. It was a real find and I bought ten for dinner.

In another store I tried on hats delivered via time warp from a 1935 movie location. I sniffed at perfumes worthy of a Tijuana whorehouse. Those few hours of walking alone, wherever I chose, gave me a sense of freedom, as well as a new outlook on the USSR. I returned with enthusiasm to our intense togetherness in the old bus.

"We are having succulent crunchy cutlets for dinner," I announced that evening as I stood outdoors beside our picnic table while the cutlets cooked to a golden brown on our camp stove. A salad of tomatoes and cucumbers was dressed with salt, pepper, and a dash of sunflower seed oil. I had been unable to find vinegar in the shops. Hearty chunks of fresh-baked, black bread completed the menu. The children added a small bowl of wild strawberries they had gathered beneath the pines.

Vernon took the first bite of cutlet. "It tastes like mashed potato," he said.

"Maybe they mixed a little potato with the sausage." I took a bite. Then, like a good Soviet wife, loyal to the cause of the fatherland, I added, "Well, it's certainly *good* mashed potato and we should look on the bright side. It's the first time we've found potatoes."

With the children settled for the evening, Vernon and I roamed away to sit on a bench near the Volga. We carried a newly purchased bottle of Georgian wine and a pair of stained plastic

coffee cups. After all the months of intense togetherness, a few hours without the children had the makings of a romantic tryst.

I can still taste the wine. Or was it a dream? It was the palest gold in color with the dryness of a fine sherry, the richness of an aged port, the airiness of champagne. There should be poetry dedicated to Georgian wine.

A full moon cast a luminescent glow on the tall pines and left its reflection on the broad, slowly moving river. The air was light, just touched with coolness, and scented with the pungency of pine needles and the sweet mustiness of nearby hayfields.

We covered a lot of subjects before the moon tipped behind the pines and the bottle of nectar was depleted. It was the conversation of a man and woman who are just falling in love but blessed with the bonus of eighteen years of intimacy and familiarity. Our lives past and present were reviewed and wild plans for the future were made before we took our sleeping bags from the bus, where the children were sleeping. Then we made our bed beneath the trees by the wild strawberry patch where we heard the wind through the pines—and the soft flap of our laundry drying on a nearby line.

# Chapter Thirty-Three

OSTANKINO, THE MOSCOW CAMPGROUND, was in the northern sector of Moscow. A grand boulevard led to that section of the city but the minute we turned toward the camp a country atmosphere prevailed. Old frame or log houses and spreading shade trees lined the bumpy street that led to the camp. For the first time we found a manager who spoke excellent English.

While Vernon attended to our registration the woman introduced me to Ivan, a stocky, middle-aged man. "Ivan will help you find a campsite," she said.

Ivan spoke no English but he hooked his arm through mine with mock gallantry, and his eyes sparkled with laughter as he marched me around the camp pointing to available sites. His teasing gallantry added zest to our choice. We decided on a level spot beneath a tall pine where a small tent, outfitted with two cots, could be ours for an additional sixty cents a night. Then, arm in arm, we circled the grounds as he pointed out showers, restrooms, and a small dingy building he referred to as a buffet. The latter served as a mini-mart and a gathering place for drinks and snacks.

Ivan was a joy. During our stay he played with the children and shared an occasional glass of vodka with Vernon. He could be grumpy with other campers but his attitude toward us set the pace for everyone who worked in the camp. Another factor was that we stayed there for a month, much longer than the average tourist on the usual two-week visa.

Within a few days the women who swept the driveway and made half-hearted cleaning efforts in the dark, damp bathrooms knew the names of all our children. They frequently stopped to visit with me as I cooked or washed clothes. If Andy showed signs of wanting to help, one of them would hand him her long, faggot-tied broom and praise him as he struggled to sweep the lane.

The Russians' love of children was a match for the Italians'.

We had been in camp two weeks when a young man who worked in the office told me of Andy's early morning activities. Andy, at the age of four, had gained an independence I had never witnessed in his brothers and sisters. He was up two hours before we were, wandering over to the office in his pajamas and accompanying the work crew on their pre-breakfast rounds. As the camp was fenced and a guarded gate faced the street there was no reason to worry about Andy's safety, but he had reverted to his candy-begging routine. The young man in the office asked me if we had trained him.

"Of course not," I said. "I don't want him to eat sweets but he manages to look either cute or pathetic and people give them to him."

"That's odd," he said. "He has a remarkable system. I asked him what he liked in Russia and he told me, 'Khrushchev and candy.'"

Moscow would have been a unique experience if we had never left the campground. We had forfeited our projected trip south to Odessa in order to seek permission to cross Siberia. In our month's stay we met tourists from many countries as well as vacationing Russians. The community kitchen provided a couple of stoves, tables, and sinks. It was a place to meet and talk with new arrivals. Both the kitchen and the bench-lined gazebo in the center of the camp were frequent forums for discussion of cooking and shopping. A favorite subject was the problems of finding food. It was even more difficult in Moscow than in smaller towns. Shortages were all that could be called plentiful.

We exchanged recipes on how to cook cabbage and sausage so that it tasted less like cabbage and sausage. We clued each other on newfound shops where a needed item had been available, at

least for a brief time during the day. We complained of prices, which we still converted to recognizable dollars and cents. The dialogue could be compared to that in a prison camp.

"There were potatoes in the market on *Prospekt Myra* this afternoon."

"The vegetable shop near the park had oranges for twenty-five cents each."

"Where can we find eggs? I looked in ten dairy shops this morning."

"I'd sell my soul for even a tiny green salad."

We longed for Mexican food. Other Americans would have settled for a hamburger with "the works." The English spoke of succulent roast beef and a proper cup of tea. Swedes longed for the smorgås table and strong coffee. Ethnicity played a strong role in desires for various foods.

I spoke one afternoon of my finds of the day to a young couple from New York. "I found wonderful thick sour cream in that shop at the corner. You have to take your own container and they fill it for you," I said. "And in the bread shop there were fresh baked bread rings, sort of like bagels. If we just had some lox."

"Stop it!" The wife laughed. "You'll make me cry." Her husband tried to explain. "You're making us homesick. We're from Brooklyn and our name is Goldstein."

The grandest use of Vernon's big Mexican hat came when we were camping in Moscow. I had somehow managed to make a Swedish-Finnish-Russian version of a Mexican meal with the limited ingredients in my mobile larder. I boiled Swedish brown beans with onion and a bit of chili powder and used our last can of tomato paste to make Mexican rice. In that land of shortages it was a reasonably exotic meal and we enjoyed the aroma as it simmered on our old Coleman stove.

"Now's a good time to pull out your Mexican hat," I suggested. "Maybe we can liven up the campground with some Mexican songs."

Vernon was never one to hold back when the chance of livening a crowd was possible and he brought his accordion from the bus and sat on one end of our picnic bench. First a round of the children's favorite, "Chiapanecas." They swirled and clapped their

hands. Then a few rounds of the "Varsovienne," as they sang "Put your little foot, put your little foot right there." Christie and Jill taught the little ones the steps. He continued through "El Rancho Grande" and "Cielito Lindo"—all the songs he had played at Fiesta in Santa Barbara as well as when we lived in Mexico.

He had just begun the first notes of "Jalisco" when a tourist bus of campers pulled into the far end of the campground. Two dark-haired young men stood out from the others. Taking a chance, Vernon shouted, *"Hola, compadres!"* and began to sing "Jalisco no te rajes." The young men snapped to attention, shouted a rousing Mexican *grito*, and joined us at our campsite.

José and Pepe, who came from Mexico City, were relieved to speak Spanish and to share an evening of pseudo-Mexican food, after a bland Scandinavian diet. José appropriated the *charro* hat while Pepe flirted with our daughters. We sang every Mexican song we knew. It was like being home again for them and for us.

As we sang, others in camp gathered together on the grass. An Englishman brought his violin and played several classical pieces known to all nationalities. Vernon played "Two Guitars" and segued into "Dark Eyes"—two of the best songs in his repertoire. A portly Russian woman joined in and everyone listened as her sweet, clear voice soared into the perpetual light night of the northern summer skies. There were Italian songs and German songs. Everyone joined in, singing the words in the languages they knew best. Jenda added her mandolin, José borrowed Christie's guitar, and Court brought his trumpet and with Vernon played "When the Saints Go Marching In" and "California Here I Come." We ended the evening with a round of the beautiful "Midnight in Moscow" which had recently become popular in Europe.

Vicki, with her predilection for Latinos, had fallen in love at first sight. She sat on Pepe's lap all evening and two days later wept bitter tears when he told her he was leaving. Only in his twenties, he had been gracious in accepting the adoration of the seven-year-old and he treated her with gentleness and understanding. He promised to say goodbye before their bus left the next morning. I was awakened early by a light knock on the bus door. There was the sound of small bare feet padding down the

aisle and the click of the opening door. After a teary *adiós* and the faint smack of a farewell kiss Vicki climbed disconsolately back into her sleeping bag. He had written a Spanish greeting in her autograph book, ending with, "I love you." Vicki added crooked red crayon hearts and "I love you, Pepe" and kept the book beside her for weeks in spite of the teasing from her siblings.

In a tent next to ours was a Russian whom we frequently saw lurching through the camp on one leg, a crutch and a cane. He was a stocky man with thinning dark hair. He seldom smiled but his dark eyes were alert and friendly. It seemed a pity that we were able to exchange no more Russian than a "good morning" or "good evening." He sat alone one evening at a table beneath a strip of awning outside the camp restaurant. An open space in front of the entrance separated his table from ours. We were drinking sweet, pale coffee with two Dutch men, their wives, and Father Gabriel, a bearded Capuchin priest who, except for his skirted brown habit, looked like Vernon's twin.

Father Gabriel was on a tour of the old cathedrals and seminaries in the Soviet Union. He spread a large map on the table and pointed to the places he had visited. Our Russian neighbor sat quietly sipping vodka and eating his dinner of sausage and bread.

"We've been looking for an accurate map of Moscow," said Vernon. "The only maps available are schematic and out of proportion. It's as though the real layout of Moscow is some kind of secret."

"Ah, you can't buy one like this," said Father Gabriel. "I brought this with me into the country. It was printed in France." He continued to point out places we had heard of but hadn't been able to find on our simplistic map of the city. "See, it even shows the prisons. Over here is the infamous Lubianka and here is another where political prisoners are held."

After breakfast the next morning, Vernon and I sat on our picnic bench beside the bus drinking our breakfast coffee. Our Russian neighbor approached us, swinging along on his crutch and cane. "Good morning," he said in faultless English. "My name is Alex Neyelov. I noticed, Mr. Johnson, that you too have lost a leg."

I thought uncomfortably of the discussion of prisons and political prisoners the previous evening, knowing Alex had easily understood all we said, but he didn't refer to it. The apprehension that he might be watching us was strong. Our fear was built on facts laced with paranoia. If the government chose to have us watched, they couldn't have selected a more congenial person. We preferred to think that the interests Vernon and Alex shared were only a coincidence.

Alex had lost his left leg during World War II also, in November of 1944, the same as Vernon. He told us he was forty, the same age, but he looked ten years older. He was married and had two children. Both men were students of history and political science and they shared an interest in philosophy. Alex was the only official Communist Party member that we met in the Soviet Union, unless we counted Nikita himself. Actual membership was a privilege held by about five percent of the population. He was a high school teacher in the Caucasus and a key member of their local party organization, rather like a state assemblyman in the United States. Born and raised in Kiev, he had returned after the war to find his home destroyed and his entire family killed by the Germans. During that summer of 1961 he was doing a research paper on Chaucer at the Lenin Library, translating the *Canterbury Tales* into Russian from the original middle English. He was also one of the ranking chess players and he kept us posted on how the current games were going. On days when he won, his spirits were high.

Vernon and Alex spent night after night in earnest discussion. Their political viewpoints were less sensitive than discussions between a Republican and a Democrat. They spoke of the different approaches to education, labor problems, and the legal system with great tolerance for each other's opinions.

Vernon told me there was only one way Alex showed discomfort on ticklish subjects. His usually shiny face would grow more so as tiny beads of sweat broke out on his broad forehead but he never dodged an issue. His frankness was surprising but he was absolutely devoted to the Communist dream.

I asked Alex to share dinner with us one evening. We had discussed the food shortages. I served him a portion of the invariable

salad of tomato and cucumber. "We miss having mayonnaise for a salad or a sandwich. Do you use mayonnaise in your country?"

"Of course," said Alex. "You should be able to buy it in any of the shops in town."

"I've looked," I said. "Maybe I missed it."

The next day the camp shop, which usually sold very few items, had small jars of mayonnaise. I thanked Alex for his help but he said he knew nothing about it.

A week later Vernon spoke to Alex about the reporter and photographer from *Izvestia* who had interviewed us. "It's unusual," said Vernon, "that none of these stories have been printed. We have always welcomed publicity in other countries because it has drawn people to us and we have shared experiences we might otherwise have missed."

"I'm sure they plan to use the story," said Alex.

Two days later *Izvestia* published a kindly, full-page story in their weekly supplement. Coincidence? Or did Alex have some special connections to smooth our path?

Alex became a welcome fixture in our lives. He was one of the few Russians who owned his own car. He acknowledged that he was in an upper income bracket. His wife also worked and with the inclusion of a thirty-ruble monthly pension they made 500 rubles per month. Like others he did his own auto repair work as the ability to do so was one of the requirements for a driver's license.

Alex's artificial leg was in the repair shop and he took Vernon with him for a fitting and for repairs on Vernon's leg. One day they went for a ride around the outskirts of the city where Alex pointed to a big dome. "That's a new atomic energy plant," he said. "I suppose neither of us is supposed to be near here."

By the time we left Moscow our friendship was deep and strong. Separate ideologies couldn't separate a mutual respect and affection.

"I'm sorry we didn't get to meet your wife," I said on our last night. I had searched our belongings for an appropriate farewell gift and chosen a silver and turquoise Navajo bracelet, given to me when I was thirteen. Nothing could have been more American but it took a special situation to make me willing to part with it.

I had intended the simple gifts in gratitude for the kindness Alex had shown us but he had the last word in generosity. As we were preparing to leave for the railroad station, he came from his tent with gifts for the family. Mine was an exquisite gold and black lacquered box, the famous Pelekh ware, containing a choker of milky white beads resembling moonstones.

He gave the children beautifully illustrated children's books, Russian stories printed in English. Vernon's gift was a pipe carved in the likeness of Laika, the little dog who was first in space, and a beautiful inlaid cane. His final gift was a book. "If you read this you may see the problems we face and maybe you will understand us," he said. We read the book as we crossed Siberia. To us it was a damning statement on the Soviet system, yet it was printed in English for foreign consumption. There was no opportunity to discuss it with Alex.

Vernon always spoke fondly of Alex as "my personal spy." We kept in touch by letter for many years but never saw him again.

# Chapter Thirty-Four

DURING OUR ALMOST FIVE WEEKS in Moscow we became acquainted with members of our embassy as we went to collect letters from home and to seek aid and advice for our hoped-for trip across Siberia. As the "new guys in town" we were invited to dinner at an apartment within the compound and often went to the American Club, a large home on the banks of the Moscow River. The Club had been rented by a group of noncommissioned military men attached to the embassy who said our length of stay qualified us for membership. The fact that we had two pretty teenage daughters contributed to the hospitality offered all of us, but the men seemed to enjoy the younger children too. We welcomed a few American goodies such as peanut butter, canned fruit, bacon and eggs, fresh milk, and coffee.

Vernon talked to one of our consuls. "Who should I see about obtaining a flatcar to ship our bus across Siberia?"

"You tell me, if you ever find out. For four years we have been trying to get a flatcar to haul our supplies from Leningrad to Moscow." He added, "I suppose you know that foreigners are not allowed on the Trans-Siberian Railway." Nevertheless, he wished Vernon luck and gave him a letter of introduction to an Inturist official. Vernon began weeks of bargaining that took him from door to door in the Transportation Ministry in search of someone who could, or would, say yes.

He also became a namedropper. There was only one name worth dropping and when he said, "Oh yes, I met Khrushchev

when he was in America," he was met with respect. It assumed a quality of intimacy and sparked a feeling of "Any friend of Nikita's is a friend of ours."

We were thrilled to be invited to the Fourth of July festivities at Ambassador Llewellyn Thompson's home, an impressive old mansion decorated in comfortable elegance.

We freshened our wardrobe to the best of our limited ability. A fellow camper offered to watch the six younger children so Christie and Jill could attend the festivities.

Although they claimed that everyone would think they were slobs, it's probable that no one noticed. The elegance of others was far more interesting. There were full-dress uniforms for military attachés from other embassies, exquisite saris from India, formal kimonos from Japan, and the elaborate robe of the dignified, bearded patriarch of the Russian Orthodox Church.

The rooms were buzzing with rumors as to whether Khrushchev would attend. He had not accepted the invitation for the two previous years and it was said that his attitude toward current crises could be gauged by his attendance, which was never announced in advance.

After an hour a sudden flurry and a hum of voices from the entrance was heard by the crowd in the ballroom where lavish food and drink was being served.

"He came," a man said. There was no need to ask who had come.

He came. So did Mikoyan,* and sweet-faced Nina Khrushchev. Mrs. Thompson greeted them in fluent Russian and led them out onto a broad balcony where, for half an hour, reporters and photographers surrounded Khrushchev. He was in a jovial mood, smiling, making jokes, and answering questions. At last Mrs. Thompson led him out to the garden and introduced him to her children. Vernon, Christie, and Jill met him there. I had gone inside thinking the excitement was over, happy to sip a frosty gin and tonic and munch the delectable appetizers.

---

* Anastas Mikoyan was Khrushchev's close adviser and a first deputy premier of the Soviet Union.

Khrushchev greeted Vernon with almost the same words as he had in Santa Barbara. "I like your face. You have kind eyes."

Vernon introduced him to our daughters. "We are seeking permission to cross your country with our family," he said.

Khrushchev smiled. "I know." There was no time to pursue that provocative statement before he turned and walked away.

It was a small incident, but it gave Vernon a fresh chance to say, "I met Nikita."

He continued making suggestions to the people at the Railway Ministry. "If you can't send my bus by freight train, maybe you could attach the flatcar to a passenger train. We could live in the bus as we travel."

The absurd suggestion left the official too confused to say a blunt no. Vernon returned the next day for an answer.

"Mr. Dzohnson, this thing you request is impossible. Our engineers say that a flat car cannot be attached to a passenger train. It would shake apart."

Vernon nodded sympathetically.

"You will have to send the bus separately and you cannot stay with it. You must go on a passenger train."

"That will be quite all right," said Vernon. He controlled his wild sense of success until he returned to camp that evening. I tried to match his enthusiasm and Alex, who was obviously impressed, joined us in a toast to Vernon's coup.

The Railway officials next insisted the bus be crated for shipment to assure its arrival in Nahodka, on the East Coast. At first we thought it was the Russian sense of humor, their spin on the acknowledged shortage of lumber, but they were quite serious. Between Vernon's trips to the Railway Ministry to argue the impossibility of this we amused ourselves with plans of how to do it. We might nail small scraps of firewood to the sides; or we could drive to the station, and live there as we sheathed it in bits of lumber. Eventually the officials caught on to the fact that this was a real bus, not a VW van, and proposed insuring its safety by sending two guards with it.

"I have no objection to paying for the guards." Vernon continued to bluff his way through the maze of officials. "But I am perfectly willing to send the bus unguarded."

"Mr. Dzhonson," said the official, "you would, of course, lock it securely."

Lock it securely? A burglar in a motel parking lot in New York had tampered with the locks, and we hadn't been able to lock the doors since. Vernon, nevertheless, agreed to the request.

Our last few days before the bus left Moscow were busy ones. We had to set up temporary housekeeping in three small rented tents in the campground. We were not accustomed to living out of suitcases, which had only been used for storing extra clothes. Our daily clothing had been stored in the overhead cupboards and beneath the bus seats. For the approaching two months, until we again met up with the bus in Tokyo, we would have to live with what we could carry. I packed and repacked, trying to narrow our needs to what could be held in four suitcases and a pair of duffel bags. "If only we had some idea of where we will stay in Japan and what we will need until the bus arrives," I said. "It's all so vague and uncertain."

"Don't worry," said Vernon. "It will all work out. It always does."

"That certainly solves everything," I said. I added our sleeping bags, one cup and bowl per person, a few forks and knives, and a small pan.

We dismantled the luggage rack on top of the bus and stored the contents beneath the seats and in the small closets. Our exposed film was left in the bus along with souvenirs, gifts from friends, and our collections of notebooks and diaries. Some of Vernon's questionable purchases like the oriental carpets from Belgium and a large cast iron statue of Don Quixote (one of Vernon's whimsical purchases in Leningrad) would stay in the bus.

Vernon refused to ship his accordion, as it was always an entree to meeting people along the way. Christie felt the same way about her guitar, as did Court his trumpet. My typewriter was essential. There were two bags of cameras and I filled another with a few books, dolls, and drawing materials for the younger children. Vicki was reasonably contented with a small doll and her autograph book containing Pepe's farewell words. Jeff had to have his favorite stuffed monkey, Mona. Kara would go

nowhere without the enormous rag doll I had made for her. Why, I wondered, couldn't I have made a teeny-weeny stuffed doll?

By then we had long since exceeded—if not doubled—four suitcases and two duffel bags. We were told that sometimes there was a dining car on the Trans-Siberian but not always, and they frequently ran out of food before arriving at their destination. It would be impossible to carry enough food for ten people for six days, and we gathered items that could be eaten cold. There wasn't a lot.

If I had worried about our possessions reaching Japan safely, I worried even more about our own arrival in Japan. Despite Khrushchev's appearance at the Fourth of July party the situation in Berlin had become critical by the end of July and when we said goodbye to friends in the American Embassy, the talk rang with hollow jokes of our eventual internment in a salt mine.

"It's been forty years since they've allowed westerners on the Trans-Siberian," we were told. "Look at yourselves as the advance guard." It had been easier to joke about Siberian salt mines when we weren't so close.

When the day came for Vernon to deliver the bus, he drove to the station, where several officials were on hand to assist. He had driven the bus onto the flat car before it was discovered that locks were nonexistent. It was too late to change plans. One of the men twisted pieces of wire around the door handles and applied an official-looking lead seal. As the bus would not go straight through across the country but would be left on sidings and hitched behind various engines along the way, it was easy for me to worry about losing our treasures forever.

There was a great farewell gathering in the campground when we left. We had stayed much longer than most tourists and knew everyone who worked there. A Swedish student offered to carry some of us in his car; the others climbed into a taxi. We drove off with armloads of loose clothing, mesh shopping bags stuffed with laundry, and last-minute gifts.

Moscow's Yaroslavl Station serves the Trans-Siberian line. The waiting rooms were crowded; people overflowed the seats and sat on rope-tied suitcases. We were barely noticeable among

packages of food, crying babies, and exhausted travelers trying to sleep on hard wooden benches or on the dusty cement floor.

We found a man to help load our luggage onto a long cart. While we waited for the train we leaned against the cart and listened to the children who complained about their hunger and begged for *morozhnaya*, which was being sold by an ice cream peddler. All but Christie. She had been sick the previous night and still had cramps; she sat on a stone curb curled in pain. Vernon bought the ice cream for the others and they lapped it greedily, dripping it onto recently clean shirts and dresses. The platform was dusty and sooty and the children attracted dirt like magnets.

Just before time to board, we were hailed by one of the Canadian Embassy's young men who had flirted with our teenage daughters when they met at the American Club. He brought with him two large canvas sacks of food from their commissary.

Then suddenly and irrevocably we were aboard the train, fumbling for tickets, searching for car and compartment numbers. We found one compartment and dropped our luggage. Two doors away was our other compartment, but it was occupied by a man, his wife, and two children. We compared ticket numbers; they were the same. We tried to talk to the conductor while everyone offered voluble advice in rapid Russian.

"Hello, Mr. Dzohnson," came a voice from the end of the car. "How can I help you?" The representative of the Railway Ministry and his wife had come to wish us a happy trip. After a discussion with the conductor it was discovered we had indeed been given only one and one half compartments. There was nothing to be done. We said our farewells and returned to our compartments and began to sort out luggage and sleeping arrangements for ten bodies in six beds.

We decided that Christie and Jill would share the compartment with another family who were traveling light and offered us their extra storage space. Court made a bed on top of our luggage compartment over the door. Jeff would sleep on a light mattress on the floor between our bunks. Andy and I could share a bunk and Vicki and Kara could sleep together. That left a bunk for Vernon and one for Jenda. We had been well conditioned by the bus and it was almost spacious.

The compartments were well designed and comfortable. We were traveling in "soft" class. It meant that the bunks were upholstered and cushioned. There were thin mattresses on top of the comfortable seats. A small folding table with a lamp extended from the window ledge. A little Oriental rug covered the floor. There were hooks for clothes and small shelves over each bunk. A large mirror faced the room from the sliding door into the public passageway. We soon learned that the next class was "hard." It had a similar layout in compartments, that were slightly smaller and had only thin mattresses over unpadded bunks. The third class consisted of narrow wooden bunks in tiers of three, lining the length of the car, with no provisions for privacy. It was do-it-yourself travel: bring your own mattress, your own bedding, your own food. We never discovered how one qualified for the different accommodations in a classless society. It was not just a difference in price. There were more students in third class but no other distinction and they managed to maintain patience and consideration for one another in the midst of discomfort and inconvenience.

As soon as the train started, I sent the children to the upper bunks and began to store our kitchen supplies beneath the lower bunks. The sacks from the Canadian Embassy were like Christmas stockings. There were peanut butter, crackers, a new space-age powdered drink called Tang, pineapple and tomato juice, instant coffee and cocoa mix, jam, raisins, Spam, canned beans— all exotic foods by Soviet standards. They had even included a bottle of Irish whiskey and two bottles of Rhine wine. We had brought tomatoes, cucumbers, powdered milk, bologna, cheese, butter, sugar, and hard-boiled eggs. We had our first meal and slept comfortably that night.

I had tried to pack carefully but the wrong suitcases were always on top and I spent a lot of time burrowing through the luggage. The train was coal-fueled and the soot seeped through the windows. Christie's stomach ache was almost gone but Court and Vicki had touches of it. There were two unsegregated and much-in-demand washrooms in our car, each containing a sink and toilet. Cleanliness *may* be next to Godliness, but it was a lot closer to impossible.

In the compartment next to ours were a woman, her tiny granddaughter, and two other women. The little girl slowly began to smile at us; Vicki and Kara took turns playing with her and carrying her up and down the corridor. On our other side were four men who changed into striped pajamas when they embarked and stayed in them until the end of their journey.

We were the only foreigners on the train and were greeted with friendly curiosity by fellow travelers. Some of them visited us and patiently struggled through the exchange of personal histories. Others would stand at the door listening and sharing laughter when we came to an impasse on the meaning of a word. Someone would then repeat it, add new words and pantomime until we understood. With our basic Russian vocabulary of perhaps one hundred, we could not by the wildest stretch of the imagination claim to speak Russian, but we somehow carried on extensive conversations during those six days.

Much of the time we watched the scenes from the window, hating to miss anything, even the endless flat fields of grain disappearing over the horizon. Small clusters of houses and little villages with names like Yaroslavl, Biu, Novo Poloma, Shvecha, and Kirov were far apart. There were approximately one thousand miles between the larger, newer cities like Sverdlovsk and Novosibirsk. We had heard so much of the great mechanization on farms but we saw none. Maybe it was early for the main harvest but the fields were filled with peasants carrying hand scythes and wooden-pegged rakes.

A timetable in the corridor listed the names and we unscrambled the Cyrillic with help from our new friends. They pointed out their destination on the chart and we explained we were going as far as Irkutsk.

In the morning and evening the porter lit a wood fire under a samovar at the end of the corridor and served hot tea in thin glasses set in silver-metal holders. We were charged three cents a cup, payable at the end of the trip. Sometimes I drew a pan of water to make a cup of instant coffee or cocoa for the children. Occasionally a vendor came through the cars selling cabbage-filled, soggy-dough piroshki.

At station stops everyone climbed out to stretch. Any diversion

was welcome, particularly for the youngsters, who needed to stretch their legs. Vendors sold fresh produce from baskets of vegetables, including paper cones of wild berries, packs of dried chanterelle mushrooms, and berries. If the stop was for more than ten minutes we searched for a bread shop, putting one of the older girls in charge of the small children with a warning not to leave the train. There was one frightening time when the train started up and Vernon was not in sight. For endless minutes we thought he had been left behind until one of the men in our car said they had seen him board another car farther down the track. He returned with two loaves of sour dark bread and a long string of small solid bagels draped around his neck. We hung the string on a clothes hook and the children broke off rings whenever they were hungry—or bored. The string was empty within a few hours.

Food in the dining car was expensive, seating was sparse, and it was hopeless for us to struggle through the long line of cars with any hope of sitting together. We made do with what we carried and could buy at the stops.

Christie and Jill made friends with a group of university students who were traveling third class to do their obligatory summer work in the "virgin lands." Two of them spoke English, the only passengers who did.

Jill was next in line to succumb to the stomach bug. When her student friends heard about this they searched the train, found a young doctor, and accompanied her to our compartment. The doctor wanted to wire ahead to Krasnoyarsk (a day's distance) for further assistance. I explained that the others had recovered without a problem but that we had a generous supply of Soviet medicines in our bag given to us by a doctor we had met in Moscow. The doctor selected one and by morning Jill was back in action, but the doctor returned several times to make sure she had done everything possible to help us.

As anyone who has driven with children for even a day knows, travel games are essential. We had to invent new travel games based on the view from our windows. Name that license plate was out. Roads existed only within towns, with dirt streets extending to the edge of town before narrowing into double ruts. Near Sverdlovsk, on our second day, we saw asphalt streets and big new

buses, and the new game began. It was based on a point system and it kept the children busy for brief moments. Five points for a car, two points for a bus, one point for a bicycle.

One afternoon the train pulled over to a siding near a small village. A small group of children played soccer on a level field beside the river. Nearby a few little boys herded a flock of stubborn sheep toward an enclosure. Others swam in the river, shouting and splashing each other as they dove from an old log. In a little rowboat three youngsters rocked back and forth, testing how far they could roll without tipping over. They were like any children, anywhere, enjoying the warmth of summer and the coolness of water, running barefoot through the dusty fields, carefree and happy.

"The lucky guys," said Jeff. "They get to swim!"

The rural scene made our children restless. They argued and fussed and poked at each other. In desperation I told them that they were not to say another word to each other or to me. I gave them a sheaf of paper and some pencils. "If you want to say something, you must write it down."

It was hard to keep a fight going in such a fashion. Four of them sat on the bunk over my head, writing their notes and helping each other with spelling. It was a bizarre mixture of English, Swedish, and scrambled Russian. Messages to me were sent by airmail. "I'm hungry, Mommy." "When do we eat?" "Where are we?" "Court hit me." "I did not! Jenda hit me first."

Then came a missive from Court. "Hey, Mommy, I have to go to the bathroom."

"Well, go then." I, too, wrote my answers.

"But you won't let me get down from up here."

"Okay, you can get down."

"Thanks."

"You're welcome."

"Goodbye, Mommy."

When Court returned, he grabbed the pencil and wrote a fresh note. "Whew, what a relief."

A curious thing happened on the way to Choolymskaya. Well, maybe it wasn't Choolymskaya, but it was near there and I liked

the name. We were again jammed on the bunks reading some children's stories. Suddenly Jeff clapped his hand over his nose as a nosebleed sent droplets raining on those of us below. It had started without warning. It wasn't a very warm day. It certainly wasn't the altitude. A sibling had not struck him. I gathered a bunch of toilet paper, poured water on it, and held it on his neck as he stretched out on the bunk.

The bleeding had almost stopped when Kara leaned over the upper bunk. "Look, Mommy." Drops of blood plopped on the floor beside me. We set to work on Kara and soon had it under control but it was not more than ten minutes until Vicki's nose was bleeding, too. We still search for an answer to the mystery.

One of our best songfests took place late one night. We went through the long verses of Andy's favorite, "Clementine." We sang "She'll be comin' round the mountain," and then Jenda started "God Bless America." It was the first time on the trip that we had sung it. When we came to the end, another young voice began, "Oh say, can you see…" and we sang all the words we could remember of "The Star-Spangled Banner." It was quiet after that and we fell asleep as the train rumbled across Siberia.

# Chapter Thirty-Five

I SAT BESIDE ANDY, sponging him with cool water and smoothing his blonde hair. When I last took his temperature it was 104 degrees.

Through the open, lace-draped windows of our hotel I could hear the sound of a horse-drawn cart on the cobblestones. It was a day for playing and for picnics, not for being sick. The air was summer-morning fresh with a warm breeze stirring the pale green leaves on the trees that bordered the street. It could have been a midwest town in June. I had to remind myself we were in Irkutsk, the very heart of Siberia.

We had arrived the previous morning after five days on the train. Svetlana, a pretty blonde guide, met us with a private bus and driver. I was grateful, after so many months of camping and the cramped quarters on the train, to be in a comfortable hotel, with clean linen, and a white-tiled bathroom with hot water, and with meals prepared and served by others. We were being treated like royalty.

Andy was feverish when we arrived. He probably had the same bug the other children had gone through but he was more susceptible to high fevers. While Vernon and the others went on a tour of nearby Lake Baikal that morning, I stayed in our hotel room with Andy. The little boy stirred and whimpered. His usual bright blue eyes were glazed with fever and he stared fixedly and pointed to something on the ceiling. "There's a moo-cow," he said.

Once in Santa Barbara when he was a year old he had gone

into convulsions with a fever. Fear of a recurrence made my heart pound wildly. I gave him half an aspirin and sponged his little body with cool water.

"Cow," he repeated. His eyes followed his fever-dream cow to the far corner of the room. Then he slept quietly.

As mother of such a gang, my approach to medicine was simple. According to our family doctor in Santa Barbara, if a child didn't have spots, lumps, or a definable pain, it was best to wait for some symptom to develop before calling a doctor. While Andy slept I caught up on laundry, enjoying the luxury of hot water.

Shortly after noon, Andy woke up. "Where did they go?" he asked.

Was he still talking about cows, I wondered? "Where did who go?" I said.

"Everybody," he said. His eyes were clear. His forehead was cool. There was no keeping him in bed. He insisted on getting dressed and we went for a slow walk down the street until we passed an ice cream vendor. I gave him a ruble and he ran to the cart and asked for *chocoladnaya morozhnaya*. When I asked him to say *pujalastah*, please, the man looked at me in surprise. We were his first *Americanskis*.

On the way back to the hotel we passed a barbershop. I had always given the boys their haircuts. "Let's surprise everybody and get your first big boy's haircut." I said. He emerged soon after, transformed from a little boy with curls over his ears to a big boy with a parted-on-the-left haircut, slicked down with rose-scented pomade.

The family returned from their tour of Baikal in late afternoon, carrying armloads of wild flowers they had picked in the forests and little packets of a special lake fish left over from their lunch. Jeff, however, was the uncrowned hero of the day, returning bruised and bleeding from the trek. While I fussed over him, everyone wanted to tell me about it at once.

"Jeff fell over a cliff."

"Boy, was that a big cliff! You should have seen him, Mommy!"

Seeing that he would survive his wounds without serious complications, I could almost be grateful I hadn't been a witness to his fall.

"We sure were scared. And Svetlana almost fainted and she started crying, too."

"Yeah, and Daddy took pictures of it!"

I wheeled and turned to Vernon. "You what?" I was furious. "You actually took pictures?"

"Well, yes," he answered. "Of course I didn't have time to get any pictures of him while he was falling but I have some good ones of the rescue."

Nine-year-old Jeff had been standing with the family at the edge of a steep cliff, a hundred feet above the water's edge, when the earth beneath his feet gave way. He had gone over the cliff feet first, digging his heels in where he could on the way down. Most of the damage was to the soles of his feet. The Soviet bus driver, Svetlana, and the children headed instantly for a nearby path and steps that led down to the lakeshore. As Vernon explained, they moved so much faster than he could that it seemed a good idea to take movies of the rescue while he waited. He had shouted en-couragement to Jeff, whose healthy bellows proved his likelihood of survival. The driver had waded through the water along the shore and carried our son back up to their bus. Svetlana, who was in charge of her first American tourists, was distraught with fear but she helped rinse Jeff's feet in fresh water and wrapped them in towels.

I tried to joke with Jeff. "Try to remember, if someone men-tions Lake Baikal sometime in the future, you can always use it as a great opening, 'Speaking of Lake Baikal, that reminds me of....'" I was trying to divert his attention from his sore feet. "Or if someone even mentions a lake, or a fall, you can say, 'Speaking of lakes, that reminds me of Siberia.'"

# Chapter Thirty-Six

WE HAD NOT RECEIVED PERMISSION to travel by train for the stretch from Irkutsk to Khabarovsk along the Amur River boundary between the USSR and Mongolia. Apparently it was a sensitive area. After our visit in Irkutsk we were to fly to Khabarovsk, spending a few days there before the last leg by train to the port city of Nahodka. Vladivostok, the primary Pacific port, was off limits, even to most Soviet citizens.

It took some planning to condense our luggage for airline travel. Before we left our hotel I filled the wastebaskets in our rooms with worn clothing and shoes. The room maids made sure I intended to dispose of these items, then with pleased smiles carried them away. We had about twenty wire coat hangers in our luggage and I added those to the trash at the last minute.

Our plane was scheduled to leave Irkutsk at eleven in the morning and Svetlana accompanied us in the bus. Even with the extensive repacking our luggage was bulky. I was convinced we had exceeded the weight limit, which gave me a new concern, on a par with my fear of flying. It is difficult now to remember the panic I felt. I comforted myself with the warped viewpoint that in the worst case, we would go together. I had plenty of time to consider my current concerns. The plane was three hours late.

As we were ready to board, the chambermaid from the hotel pushed through the crowd, feeling obliged to deliver a few items I had left behind—the twenty discarded coat hangers. We boarded

the plane with loose coat hangers sticking from our carry-on baggage. The hooked ends grabbed at everyone who passed. I longed again for the chance of boarding a ship or plane with some sense of elegance, carrying little more than a small purse, a fur stole, and a good book.

A slim, blond man with smiling eyes greeted us at the airport in Khabarovsk. "I'm Nick," he said. "I work for Aeroflot and have never been a guide but I speak English and I've been asked to help you during your stay." Nick led us to another private bus.

The old Amur Hotel was undergoing extensive remodeling and we picked our way through the lobby over canvas drop cloths, crumbling plaster, and splinters of wood, while Nick translated for a committee consisting of two chambermaids, two clerks, and a Munchkin-shaped doorman with huge mutton-chop whiskers, who escorted us to our large room. Six beds lined each of the two long walls. The windows were open and the cheap lace curtains hung motionless in the humid warmth of early evening. The room was basic but clean. A sink stood in a closet in our room; toilets were down the hall; there were no baths. We thanked everyone profusely and they disappeared.

The committee was replaced by the dining room manager, who was eager to have our requests for dinner. We asked Nick to explain that we had eaten two large dinners during the past six hours (a complimentary one to atone for the late takeoff from Irkutsk and another on the plane) and that it was impossible to eat again. The manager's face dropped.

"Can't you think of something?" Nick urged. "He has never served American guests and he wants to feed you anything you desire."

"Maybe if we saw a menu."

"No menu. Just order what you want and he will get it for you. You don't even have to go to the dining room. He will bring it to your room."

"Well, maybe a few sandwiches and some cold drinks would be wonderful."

The sandwiches and drinks arrived quickly. We had not seen such food since leaving Sweden. Between thick slices of rich white bread lay succulent slices of roast pork and generous slabs

of cheese. At any other time during the past two months, we would have pounced on the food, devoured it, and cried for more.

We were rejoicing in the fact that at last all of us were healthy and would be able to tour together the next day when Court called our attention to Kara. "She looks funny."

Kara was always a stoic child, rarely complaining. She had been fine in the morning and on the plane. At least she hadn't complained. I felt her forehead. She obviously had a fever and admitted that her stomach ached and her head hurt. If hers was like the previous cases, there would be two more days of sickness—the two days of our Khabarovsk stay.

At breakfast the next morning the chef hovered over our table trying to fill every desire, intent on stuffing us with food in which he took deep pride. Even at breakfast there were bottles of lemonade and beer on the table. The children mentioned pancakes. Nick relayed the request. Thick, fluffy pancakes arrived by the plateful accompanied by pots of thick sour cream and bowls of rich dark berry jams.

The family went with Nick for the day. I stayed with Kara and tried to keep her cool and comfortable in the sticky heat. Khabarovsk is north of Korea some five hundred miles but the summer heat was tropical. The chambermaids visited us frequently, bringing little packets of candy to entice Kara and offering to call a doctor if we needed one. I tried to catch up on our laundry, washing clothes in the small sink and hanging them on the repossessed coat hangers in the wide windows. They only added to the humidity and took hours to dry.

The family returned in late afternoon. The highlight had been a tour of a children's park where they rode on merry-go-rounds and saw a film in a movie theater made out of an old airplane. Nick had arranged for them to talk with Russian children and they had exchanged candy. In the afternoon they had attended a soccer game in a huge stadium.

"An interesting thing happened at the game," said Vernon. "The man next to me stared at me for several minutes then reached in his pocket and pulled out the Pravda story of our trip. He told Nick he had kept it in his pocket as an expression of his

own dreams. He was excited to meet the man responsible for such a crazy trip."

While Vernon stayed with the kids I had another of my solo walks in a Soviet city. We had heard much of Khabarovsk when we were in Moscow. It was said to be one of the most beautiful cities in the Soviet Union, nestled among the hills above the broad Amur River. Bright flowers in pots sat on windowsills of old frame homes with gingerbread trim. Unlike the western part of the country, many of the houses had been painted. Children played in the dirt yards beneath the shady trees and I could indulge in my usual fantasy of living in houses I passed.

As in Kalinin, with my faded cotton dress, simple hairdo, and string shopping bag, no one appeared to notice me as a foreigner. I walked several miles through the business district, stopping at bookstalls to examine books and post cards, buying a few at each stall. I tried on frumpy, shapeless hats in a small shop. A consignment shop was the most tempting, filled with old treasures. From among the magnificent cut crystal bowls, ivory carvings, and lavish silver flatware, I made my selection—a pair of hand-carved bone hairpins. I returned to the hotel, content to have missed the official tour, feeling I had "caught" Khabarovsk in my solo trek. Like my day in Kalinin, it is one of my most vivid memories of the Soviet Union.

Nick asked us if we had any special wishes for our last night. We had noticed a bandstand in the dining room and Christie and Jill asked if there would be dancing in the evening.

"I'm sorry," said Nick. "There is dancing only two nights a week, unfortunately not tonight. If you like, we can go to the other hotel, where there might be amusement. The famous Kabuki Theater group from Tokyo is staying there and maybe there will be entertainment."

"We can't leave the little ones," Vernon explained. "We're quite happy to have dinner and settle down for the evening."

Vernon and I went downstairs to dinner with Christie and Jill after feeding the younger children and getting them settled for the night. Kara's fever had dropped and that worry was behind us.

We never knew how it was accomplished but an orchestra was playing and the dining room was crowded with people. It was a

party atmosphere. As we crossed the room to our table, men stood up and nodded to Vernon and women smiled at us. Some magic had occurred in answer to our girls' simple inquiry about dancing. We felt like royalty. The dining room manager brought us small glasses of vodka to start our dinner. The orchestra played a few American tunes and bowed to us when we applauded.

As we finished dinner the waitress presented Christie with a bottle of champagne and a small note. We read the familiar Cyrillic words for *American-Russian peace and friendship*. In German it said "Friendship," and in English, "Soviet Officers." The waitress was hesitant to point out who had sent it. There were many officers in the room and it was impossible to guess, but eventually Nick pried it from her as she opened the bottle and poured the sparkling wine into our glasses. She nodded toward a table where three young officers grinned self-consciously. We raised our glasses and toasted them and glasses around the room were raised simultaneously.

Nick explained that even though the orchestra was playing, it was not a night for dancing. Nevertheless when the orchestra played our new favorite, "Midnight in Moscow," Vernon led me to the small dance floor. Our fellow diners watched us for a few minutes, smiling at us as we circled the little floor, then began to join us in the dancing. The young officers asked Christie and Jill to dance. The maître d'hôtel took me on a few whirls around the floor, and the waitress asked Vernon to dance. In the stifling heat of the dining room, we danced until midnight. If, as Nick had said, it wasn't a night for dancing, it was a reasonable facsimile. By the time we left, we had danced with, spoken to, or shook hands with everyone in the room. Whoever or however the evening had been arranged, the hopes for friendship and peace seemed quite possible.

Even the younger children had become familiar with those two words—*druzhba* and *myr*—and understood them when they were spoken. Everyone spoke hopefully of the inherent goodness of Kennedy and Khrushchev. We repeatedly agreed that they were indeed *horosho*. Their popularity almost matched that of the Soviet cosmonaut Gagarin, their first man in space and a great hero throughout the country. We didn't realize how intensely

these words had been embedded in our consciousness until that night.

As usual, Court had been drawing pictures before he went to sleep. As usual, he left them scattered beside his bed. As I stopped to turn off his small light, I noticed a new picture of the bus. It was headed toward space accompanied by fluttering doves of peace with Khrushchev and Kennedy faces sprouting from feathered bodies. It was the inscription on the side of the bus that moved me most. It read, "Anybody for a war?"

Nick joined us before breakfast the next morning and asked if it would be all right if a television crew took a few pictures of us. I packed our bags and a pale but improved Kara shuffled along with us to the dining room, where the three-man TV crew waited for us to eat our breakfast. Then we were loaded into taxis and taken to the promenade on the riverbank. We carried Kara, taking turns as we walked along. Her fever was gone but she loathed cameras and felt miserable. For two hours the crew followed us with their cameras as we walked around town. They were an odd bunch of characters and Vernon shot film of them taking movies of us. Christie and Jill dubbed them The Three Stooges.

That last twenty-four hours on the train couldn't compare with our five-day trip from Moscow. It was a select group of travelers with interpreters to take care of our needs. There were no Soviet passengers. Meals with a set menu were served in a dining car. There was no more bargaining for food on the platform. It was efficient. There were half a dozen cars containing a group of Japanese mayors, the Kabuki troupe, and two French reporters who had flown from Moscow to Khabvarovsk. The children visited other compartments in our car, accumulating small caches of souvenirs, pretty silk scarves, small Japanese dolls, and fans. I had a ready supply of baby-sitters.

The radio in our compartment kept up a soft background of music but during the afternoon was interrupted by an excited voice. The interpreter explained that the Soviets had just put a second man in space, Gherman Titov. She translated a few of the reports. It was exciting to us.

"Aren't you proud and excited?" I asked her.

"Yes," she answered, "But we are used to this."

"You mean you are used to men in space already?" I persisted.

"Well, not exactly," she said. "But we are used to our great space achievements."

I told her we had been given an autographed copy of a photograph of Yuri Gagarin, the first man in space. The man who took the well-known picture after the cosmonaut's return from his history-making orbit gave it to us. Gagarin was in uniform and holding a white dove.

"You really have an autographed picture of Gagarin?" Our guide's casual attitude was broken. "That is exciting."

# Chapter Thirty-Seven

DESPITE THE HORROR STORIES we had heard about Soviet customs, the inspectors had little interest in our baggage but many questions about the children and our trip. It was nothing like our entry.

The guide whom we had met on the train escorted us to the gangplank of our ship, the *Alexander Mojaesky*. It had been a Dutch ship, sunk during World War II. After its salvage, the Soviets bought it for travel between Siberia and Japan. There was no plane traffic between the two countries, she said, and the ship was the only means of travel at that time. The *Mojaesky* made the trip between Nahodka and Yokohama only five times each year, during the summer months. Our trip would be the next to the last voyage and, God willing, our bus would arrive on the last before the winter shutdown.

"I have a favor to ask you," said Vernon to our guide. "I left a very special cane in our hotel in Irkutsk. If by any chance you hear that they have sent it on to us, will you see that it is put in our bus when it comes through?"

The guide nodded agreement. I laughed. Two hotels, planes, trains, ships, guides, plus a bus on a train chugging its way across the steppes contributed little if any chance of seeing the cane again. Vernon was always reaching for the moon, but the cane that Alex had given him had a special meaning.

"It will be a miracle if we ever see our bus again," I said. "Much less your cane."

Then there was a blast of the ship's whistles and we edged slowly away from the dock. A three-man band played and the Japanese mayors and Kabuki actors burst into song. "Auld Lang Syne" sung in Japanese is a rare musical and linguistic experience but the feeling of farewell and the nostalgic melody were powerful. We were misty-eyed as we waved goodbye to total strangers on the dock.

We were served a lavish luncheon and enjoyed two hours settling into our comfortable cabins and enjoying the view from the deck. Then we hit the Sea of Japan's roller coaster. It was not what could be called rough weather but the ship rose and plummeted in the deep troughs and one by one the children succumbed. By evening Vernon and Jill were the only members of our family on deck. I stayed in one cabin with the four youngest, moving from bunk to bunk with a small pail. For a short time I made forays into the adjoining cabin to hold the heads of the other three, but finally had to tell them they were on their own. By then they had tossed up everything but their socks and I had embarked on my first bout with *mal de mer*. Emptying buckets of vomit had its way of breaking down my resistance.

Our lady purser, a wispy blonde with tiny eyes behind half-inch-thick glasses, came to our cabin often. She even brought the ship's doctor to administer medicine to Christie, who suffered more than the rest of us. By the next morning, however, we were on our feet.

My favorite memory of Vernon's morning calisthenics took place that day. The chartreuse pallor of that first night's nausea had barely faded from faces when Vernon recruited the troops for an on-deck workout. A Japanese shipmate who had shared our agony on the previous night grinned as we came on deck. "You Amelicans yerrow, too," he said, pointing to his tawny complexion. When Vernon initiated the first exercises, the children began counting off in Russian. Two of the Kabuki actors joined us on deck. One was a rippling mass of flesh with small black eyes lost in folds of fat. The other was a slight young man whom we later discovered played the lead female roles in their theater. The big one could barely touch his knees when he leaned over but huffed and puffed enthusiastically. The small one played the clown, mimicking the

children's counting and initiating Japanese numbers, *ichi, ni, san, shi, go.* He moved with grace and giggled with a trill that rippled through the Oriental five-note scale. The two French reporters maintained their Gallic dignity by taking pictures of the antics and exhaling wafts of pungent Gaulois cigarette smoke over the deck.

The exercises, combined with the intimacy brought on by the previous night's nausea, had opened the lines of communication and we spent the next few days being introduced to the Japanese culture. The actors were great teachers and baby-sitters and taught the children Japanese dances, games, and folk songs. By the time we docked in Yokohama we were well equipped with polite phrases and simple sentences. The Kabuki troupe offered us a private box for an upcoming performance at their theater. Each of the Japanese mayors presented us with cards inviting us to visit their cities.

Vernon and the other musicians in our family had joined the three-piece band each evening. They welcomed the addition of new songs to their repertoire. As we pulled into the dock the band played a lively rendition of "The Saints Go Marching In" followed by "California Here I Come."

We found only one major snag—how to obtain permission to put foot on Japanese soil.

# Chapter Thirty-Eight

WE SAILED INTO YOKOHAMA HARBOR after four days at sea. Japanese paintings we had known instantly became real. Beyond the harbor with its masses of small boats and great ships, distant hills rose pale blue with brush strokes of jade and ochre. In the harbor hundreds of small, square-rigged fishing boats bobbed on the water. We were instantly immersed in the sights and smells and sounds of the Orient.

Our welcome to Japan can be summed up with one lingering phrase in Japanese-accented English. "Very sorry, but you must return to Moscow for proper visa," hissed the stern-faced customs officer.

As one who took official decisions with great seriousness, I felt a chill run up my spine. Vernon laughed jovially at such clever Japanese wit and returned to the deck to take pictures of the colorful welcoming scene on the dock. It took some time for him to become serious.

Explanations didn't help. We said that we had gone to the Japanese Embassy in Finland and had been told visas weren't required. Apparently they had thought we were Swedish. The exchange had been so convincing that we had not considered visiting their embassy in Moscow.

"I can't believe your excuse," the officer insisted. He said it so firmly that I almost doubted us. "You must return to Moscow for proper visa." I was ready to characterize him as one of the brutal guards in a World War II prison camp movie.

An hour crawled past as we argued and pleaded. All of the Japanese passengers had debarked. Vernon sent Jill for our collection of news clipping and the children huddled around as we tried to prove this was truly a good will trip. Vernon suggested that international understanding would be jeopardized by this inhospitable attitude.

The Russian purser hovered near us and offered the reassuring comment that it would probably be impossible to make the return trip even if the Japanese refused us entry. We were in a nautical limbo—the family without a country. We couldn't stay aboard and we were not allowed to land.

The French reporters, who expressed concern when they heard our dilemma, stopped by to say they would be willing to vouch for us. Vernon explained that we had good friends in Japan who would attest to our character. At last the officer began to relent. He said if we would go to the immigration house on the Yokohama docks, we might receive a forty-eight-hour transit visa. The ludicrous notion that ten people with little money could transit anywhere in forty-eight hours was our only hope, the slender lifeline that would let us put foot on shore.

Our luggage was stored in a warehouse on the docks and we all set off on foot in search of the immigration office, stopping en route to place a phone call to our consulate in Yokohama. The voice that greeted Vernon was incredulous, "You *what*? Of course you can't enter Japan without a visa. There's no way we can help you. Where are you calling from?"

Vernon explained and the answer that came over the wire crackled wildly. "My God! How did you get off the ship? And you say you have eight kids with you?"

Vernon's no-problem theory was seriously in jeopardy.

Cruel officialdom, aching feet, and exhausted children replaced our dream of the land of cherry blossoms, exquisite women, flaming maple leaves, and mist-covered mountains. August in Japan would make a Finnish sauna seem like a refreshing refuge. We trudged the docks, shuttling from office to office, up and down steep flights of stairs with the littlest children dragging limply behind us, knowing better than to let out a whimper. Vernon's face was pale from the pain I knew he was

experiencing from so much walking, but he never lost his aggressive stride.

A reassuring phone conversation with our old friend, Walt Sheldon, assured the officials that something could be done about our mutual impasse. It was agreed that if we were to continue on to Tokyo a forty-eight-hour transit visa could be arranged.

In exchange for the way the United States immigration had treated Japanese trying to enter the States, it was only logical that Americans should be treated in the same way in Japan. The official glowed with his beneficence, which would allow us a stay of execution. He even wrote directions in Japanese for us to give to a cab driver who would take us to the proper railroad station for the short ride to Tokyo.

We were immune to the death-defying performance of our cab drivers after more than six hours of verbal combat and didn't much care if we should be carried broken and bleeding to a comfortable hospital. We survived the Japanese train system at rush hour while trying to make sure our little ones were not suffocated in the crush of bodies. At Tokyo Station we transferred into two more taxis with crazed drivers who whipped through the city on the fifteen-mile trip to the suburb of Nerima-ku where the Sheldons lived.

Walt and his wife Yukiko, a breathtakingly beautiful woman, were waiting for us. We had known them when they lived in Santa Barbara, but both had been homesick for Japan, where Walt was a correspondent for the Far East Network. Being greeted by them was like coming home. The stress of our surrealistic day disappeared in the cool, calm of their living room.

# *Chapter Thirty-Nine*

ON OUR FIRST NIGHT IN TOKYO Walt and Yukiko arranged for our overnight stay at a beautiful inn, a *ryokan*, with deep, steaming hot tubs, air-conditioned rooms, a lovely garden with the refreshing sounds of a waterfall, and delicate, kimono-clad serving maids. We could afford only one night of such luxury.

The next day Walt and Vernon found a more modest inn and proceeded to work on extending the transit visa. The days passed slowly. Once installed we found the only serving maids were those who arrived with male partners late at night, departing in the early morning. Our new inn bore little resemblance to the first one although it, too, had paper *shoji*-screens, *tatami* mats, four paper walls, and the sound of running water. The *shoji* opened directly onto a busy street; the running water was the sound of an open drain running beneath the window. The four walls were a lot closer together and there was no air conditioning.

The temperature and humidity stayed in the nineties through those late August days and nights of 1961. Sleeping was sheer hell with ten bodies packed close together in two rooms. It was impossible to leave the window open as we apparently were next to the Tokyo mosquito breeding grounds. They hovered around us revving their engines like fighter planes.

"I'm so hot I could melt. I feel like one of the tigers in Little Black Sambo," I told Yuki the children's story. "He ran round and round a tree until he turned into butter."

"That's funny," laughed Yuki. "The Japanese think Americans smell like rancid butter."

Even more traumatic than the mosquitoes was the business of removing shoes. Japanese rules were too much for young minds. I included my own in that category. On entering the front door we took off our shoes and donned a pair of grass slippers. That was the easy part. We crossed the glistening wood floor of the narrow hall to our rooms, leaving the slippers at the door and walking barefoot on the *tatami*-matted floor. We again wore the grass slippers when we went down the hall to the *benjo*, or toilet, where we removed the slippers and put on a pair of communal leather slippers. The *benjo* was the type with two footrests for balancing oneself over a strategically placed hole. (When we first discovered this variety in Italy the kids dubbed it a "squat-down." Good for the bowels, we had been told; not so good for the knees, we found.) Then it was off with the leather slippers, on with the grass, down the hall, and off with the grass.

(Walt once had written about Vernon when he published a book on the Japanese way of life. "My friend Vernon has the solution to the Japanese on-and-off slipper routine. He simply thumbtacks the silly things to his wooden leg.")

The last straw for the desperate landlady was when the children dashed outdoors barefoot, returning with dusty bare feet and leaving a trail of footprints on the glistening floor from the front door to our room. The Dragon Lady stood wringing her hands in despair and, I assumed, muttering appropriate curses. I polished off my *gomenasai*, or excuse me, and folded my five-foot ten-inch body in a deep bow, arriving at her height. Then I turned to shout directions to the next child.

In the daytime the neighborhood children decided our window was just about the most entertaining place in town. The landlady shooed them away regularly and I tried to cooperate by keeping the windows closed, but whenever we heard a scratch on the shoji, one of our children rushed to open it, on occasion plunging a finger through the paper. Their elbows seemed to have become unusually sharp, too. Our large American bodies were not suited to the fragile Japanese architecture.

The window became the passageway for gifts from our new

friends. Little girls brought long strings of origami birds and I hung them near the window to show our appreciation. The neighborhood boys noticed Jill's predilection for bug collecting and brought dozens of fat, chirping cicadas in tiny boxes, until our room hummed with the noise of the small creatures. Cicadas are way too big to step on and, though the children were enchanted with them, I looked at them with a jaundiced eye. Their serenade blended with the drone of the mosquitoes during a week of sleepless nights.

One chubby little boy was very proud of his English and stood at the window watching me with shining black eyes, bowing and repeating in a lilting voice, "Sank you berry much." His friends were so pleased with our initial reaction that they echoed their thank-you's. When we replied with, *"Domo arigato,"* they giggled and repeated the chant.

"If that child says 'Sank you berry much' one more time I won't be responsible for my actions," I said.

I dropped a lot of desperate, bitter tears that week. Vernon was gone most of the day struggling with our travel documents. The transit visa had been extended unofficially although I wished someone would transit us right out of that pesthole. I lost all sight of the glamour of our surroundings, the quaintness of sights from our window, the sweet friendliness of neighborhood children.

The immigration people told Vernon and Walt they were doing their best. "Get lost in Tokyo for a month. We'll be in touch with you."

It was easy to get lost in Tokyo. During our first week we were lost whenever we stepped out on the street. The Sheldons' house was only a few blocks from our inn but the streets twisted and turned, running at deceptive angles. Even if we could have spoken the language, an address served no purpose. The streets were named but houses were numbered according to the sequence in which they had been built. House number 23 might be at the end of the street, numbers 24 and 25 blocks away, with even and odd numbers on the same side of a street. Even for cab drivers, the only solution was to stop at a fire station, where a map was available with the detailed information. You have to know where you

want to go before you can get there and we didn't even know where we were.

Assuming we would receive a visa eventually, and with a three-week wait for the bus to arrive, we had to find new accommodations. It was Yukiko's mother, Oba-san, who finally produced the impossible. Housing was still in short supply in Japan and a place was seldom rented without at least a year's lease, but she discovered a small western-style house that was due to be demolished within a few months. The owners were delighted to discover tenants who needed a place for such a short time. I still get pleasure in saying where we lived. The names trip off my tongue like a haiku. "We lived in Nerima-ku close by the Ikebukuru Station."

Our demands were few. The little house might have been the Imperial Palace as far as we were concerned. The four small rooms were all ours; the lack of furniture seemed unimportant. We saw only the advantages: the tiny gas stove could be lit without endless pumping; there was a deep bathtub and western-style toilet in the bathroom; a hot water heater produced plenty for baths and laundry; and a small fenced-in yard afforded play space, albeit an utter lack of privacy on the busy street corner.

We packed our bags, slippered our way across the shining floors of the inn and bade goodbye to the landlady, who was so delighted with this unexpected good fortune that she dashed out and bought two beautiful lace fans to present to us in affectionate farewell. Her final bows were deeper than usual.

Walt and Yukiko lent us a table and a few odd chairs. We bought five *futon* mats and cared not a bit that we had to crowd ten people onto them at night or that they were less resilient on hardwood floors than they had been on the padded *tatami* mats at the inn. It was all ours and if shoes didn't come off at the door, it didn't much matter.

# Chapter Forty

THE CHILDREN CONTINUED to make friends and the house was crowded from morning till late evening with inquisitive, almond-eyed youngsters who wandered in and out without knocking. I sat in a tubful of cool water one afternoon, reading a book, and thinking I had escaped the hubbub, only to look up and see the observant dark eyes of two eight-year-olds.

Vicki informed me one day that she could tell how they knew we were foreign. "It's my curly hair," she told me. As I looked into her round blue eyes and her mop of platinum ringlets, I didn't have the heart to disagree. By her logic, her brothers and sisters, with equally blond hair and blue eyes, passed unnoticed.

Vernon's beard was a constant curiosity and giggling young girls would point and murmur, *"Ainu,"* referring to the hairy men of the northern island of Hokkaido. His beard also intrigued a tippler who staggered up to him one night in Tokyo. He patted Vernon on each cheek and murmured, "Ah, Ay-bu-ru-ham Rincon, Amelica's first pu-res-i-dent." The man may have been a bit fuzzy about the sequence of American history but Lincoln's fame had spread. The Japanese manner of inserting a vowel with each consonant created another mystery for us—Ed-du-ga-ar-am-po, which we finally untangled as Edgar Allan Poe.

Our children saw more than we did of Japanese life during our stay in the little house. Our first good friend was Koji, whom we had met through the open windows of the inn. He came with

three friends one evening on a formal visit. They presented us with a yellow silk photograph album delicately painted in watercolors. Each boy had signed his name inside the cover in English and Japanese characters.

When we moved into our house, Koji came every day and soon was taking the four older children on sightseeing trips through the city or to the swimming pool in a nearby park. He taught them the train schedules and they learned to move around the city with amazing ease. His English progressed and our speech became sprinkled with new Japanese phrases.

Masaru, who was Koji's age, was another steady visitor. Their competition in creating diversions for the family added to the wonderful experiences for the children. They were treated like visiting royalty at Masaru's uncle's home, where they were fed and entertained with classic Japanese hospitality. Masaru, who was to become a lifelong friend, was learning to play the guitar and soon learned American favorites like "Greensleeves," which suffered only slightly with a Japanese accent. He changed the words of Clementine, singing "Oh, my darling Jennifer," to Jenda who glowed with pleasure.

My favorite song, popular in Japan at the time, was "Love Me or Leave Me," which became "Rub me or reave me or ret me be ronery."

It was easy to laugh at mispronounced English but I often reminded the children that we were guests in Japan and nobody was laughing at our pathetic attempts at Japanese.

Keiko, the sixteen-year-old daughter of a Tokyo University professor, decided I was incompetent and came several evenings to clean my kitchen and amuse the children. One evening when Vernon and I had gone out Andy developed an earache. Keiko took him to her father who painted his ear, swathed it in bandages, and fed him some magic medicine. Penicillin, perhaps, or herbs? When we arrived home Andy was sleeping soundly with an ice pack over his ear. Keiko arrived at 5:30 the following morning with a fresh supply of ice.

I have a tender memory of Andy on a hot summer afternoon sitting on the front step, licking a bean ice cream bar. (The Japanese apparently can make anything from soybeans and Andy would

eat anything called ice cream. His brothers and sisters were pickier about their foods.) Three small girls squatted on their haunches, solemnly watching Andy. Occasionally he would give each a lick and they would return to their observations.

After the scarcity of food in the Soviet Union, I delighted in the many small shops in our neighborhood and the variety of foods. We tried them all—beef sliced thinner than bacon, enormous white peaches, pear apples, and tiny yellow-fleshed watermelon. There were radishes as long as my arm, tiny fish, soy-glazed crackers, and strange pickled things. The clerks were patient with my newly learned words and often chortled wildly at some of my attempts. There are different ways of counting in Japanese. It has something to do with flat things, square things, or maybe live things. I never quite sorted it out but I was proud to have touched on even one method and it usually produced the right amount of whatever I needed.

We were still officially lost in Tokyo when the bus arrived from Nahodka. The red tape of visas couldn't begin to compare to the problems of bringing a bus into the country. It began with the fact that tourists were not allowed to drive and moved briskly on to such details as an import license for the bus. There were no rules for private buses and we were led to believe it would take a special session of the Diet to determine the solution. Laws also called for foreigners to register with the local police department after arrival but we were considered unregisterable without visas. We were in a state of limbo.

The bus arrived in good shape, shrouded in a thick film of grease and soot from its exposure to train smoke and dust for many weeks. This had also filtered into the bus through closed windows, and layers of dirt lay over the seats and counters.

Most astounding, however, beside the driver's seat, by a miracle of Soviet bureaucracy or friendly cooperation, was the cane Vernon had left in Irkutsk, even though the wired seal was still in place on the door.

Christie and Jill spent two days on the Yokohama docks scrubbing the bus inside and out with strong suds. They didn't object to the work but they bitterly resented the film taken by

CBS before they had a chance to clean the bus. It was scheduled for stateside showing and their friends might see it. We said the dirt proved we had really traveled but the girls wouldn't let us drive through Tokyo until they had finished their work.

The bus was finally released from customs and our papers were in order after a week, during which Vernon spent entire days running from official to official pleading for stamps, seals, and signatures. The officials who had been in charge of arranging the documents were as pleased with their performance as if they had put a man on the moon (something that hadn't been done at the time). As they presented the documents to Vernon one of them noticed the number on the temporary license—000-13. He snatched it back and said, "Americans do not like number thirteen. They think it is bad luck. We must change number." As politely as possible, Vernon retrieved the long-awaited permit and reassured them *this* number thirteen was the luckiest number he could hope for.

He and Jill went to retrieve the bus in Yokohama. It took them the better part of the day to return to our house, but it hadn't been boring. Only a man with Vernon's positive outlook would have dared to get behind the wheel of a large bus and drive on the left-hand side of unfamiliar, narrow, crowded streets amid drivers worthy of a demolition derby.

With the receipt of our visas, we were ready to head for home. We had arranged passage on a military transport for the end of October, traveling "space available" thanks to Vernon's eligibility from the military. All we had to pay was a modest amount for meals. It matched our budget perfectly and the lure of home was growing.

Meanwhile, our getting lost in Tokyo had given us an extra month in Japan and we still had the usual two-month visa for traveling. We packed up our camping gear, loaded the bus, and headed for Hiroshima.

# Chapter Forty-One

OUR GENERAL PLANS WERE to follow the main highway southeast as far as Hiroshima.

Before leaving Tokyo we had inquired about the best route through the rugged mountains that form a solid barrier between the two sections of the island. We soon discovered there was only one way, over the Hakone Pass—on the ancient Tokaido Road. It had served foot traffic since the twelfth century but, even with improvements, was incredibly narrow for twentieth-century requirements.

Our first day went well with only a few thrills thrown in. There was really nothing wrong with the highway surface but it could have benefited from a smidgen of extra width. Vernon adapted quickly to driving on the left of a road that was wide enough for two cars but barely wide enough for two buses. The narrow road did not intimidate other drivers, even with the abrupt drop-offs on either side that formed drainage for both road and adjoining rice fields. Vernon was grateful for the steering wheel on the left and became adept at balancing the left wheel on the very edge of the road.

At least in theory driving was to the left. On the level stretches no one paid this theory much heed. Oncoming cars, trucks, and buses barreled down the center of the highway. Vernon at first responded by pulling as far as possible to the left but eventually discovered other drivers regarded such a defensive action as

"chicken." After testing the oncoming driver's mettle, they took advantage of every spare inch. Vernon, too, learned to drive in the center, swerving only at the last minute.

We spent our first night in a tiny park near Kamakura, where we visited the great Buddha and the small dreamlike island of Enoshima. In late afternoon we approached Hakone Pass at the base of the Fuji mountain chain. The road became even narrower as we ascended the incredibly steep climb toward the top. Having no compound low gear tested Vernon's driving skill to the limit, even though we had the advantage of the inside lane with a maximum drop of only two feet into the drainage ditch. To the right the precipice was several thousand feet above granite-lined canyons. Only a few guardrails blocked the edge and the broken remains of some of those evoked a grim picture. Clearance between our bus and others narrowed to a scant few inches and we shuddered when the rear-view mirror of one of those buses hit and shattered our right-hand rear-view mirror. The enthusiastic skill of the more experienced drivers failed to cut their speeds and they added to the excitement by passing on curves. The *kamikaze* syndrome was at full throttle. It was a quiet ride to the crest, even the children sensing the adults' concern.

We found a magnificent place to park the bus in a large empty parking lot at Hakone. That night, after the children had gone to sleep, we talked about the trip up the mountain.

"Nothing's going to get me to drive that road again," I said. "I'd rather walk back to Tokyo." I remembered the scorn I had always felt for friends who showed fear on mountain roads.

"Don't worry about it," said Vernon. "We don't have to think about it for a month."

Believing as I do in preventive worrying, I did think about it throughout the month, often and in depth, as we toured the ancient cities of Kyoto and Nara on our way to Hiroshima. My imagination was stimulated by an occasional horror story of the most recent bus or car to plunge off the Hakone Pass.

The word Hakone still sends chills along my spine and I have scant memory of the magnificent rocky gorges, rushing rivers, and lush undergrowth. The knowledge that on the return trip we would be riding on the outer edge did little to cheer us.

While backpack camping is popular in Japan, there is little land surface available for a camping vehicle. Finding a real campground was as likely as finding apple pie in a sushi shop. We set up our home in strange places during those weeks of travel. At Hakone we had sweeping views of beautiful Lake Ashi with a crimson *torii* gate in the clear water near shore and the sacred mountain of Fuji rising in the distance, framed by the twisted arms of ancient pines.

As we headed south we stayed on a baseball field, swarming with mosquitoes, adjoining the home of Swedish missionaries who offered us the convenience of their home. They brewed rich Swedish Gevalia coffee and regaled us with tales of missionary life in war-torn China and ordered the children's new favorite—soba noodles—to be delivered to the bus. When I complained about the road over the Hakone Pass they said, "It is a horror, isn't it? We saw three vehicles drop into the gorge one day."

The changing scene outside our bus windows was a never-ending wonder. Women in dark shirts, baggy trousers, and broad-brimmed hats tended rice paddies where the slender stalks drooped under the heavy grains at harvest time. They cut the ripe stalks by hand and tossed them into deep baskets tied to their shoulders. Rounded hedges of tea plants nestled at the base of craggy hills that were covered with a blend of giant bamboo and blue-green evergreens. The sweeping, up-tilted, blue-tiled roofs of farmhouses must have looked the same in the days of the samurai. Graveyards were crowded with tall, gray stones. Small temples capped little hills and there were occasional sturdy white castles high above deep moats. Something in the Japanese air recreated the misty, dreamy quality one sees in their paintings.

I hated the practical side that made it necessary for us to spend much of each day in the search for a semi-private place to sleep and for water with which to wash clothes that were quickly soiled in the steamy climate. If we found water there was the problem of a space in which to hang laundry to dry. Shopping for food was a treat for me but tested the patience of the family, who waited for me in the bus.

By the time we arrived in beautiful Kyoto, we were fed up

with Japan and with each other yet were faced with a three-week wait until our ship would sail for San Francisco.

While I could lose myself in day-to-day details during those months of travel, Vernon had stayed positive. By the day we arrived in Kyoto I had not only lost the big picture, I was looking through the wrong end of the telescope at a husband who didn't understand me and at children who were unappreciative, uncooperative, and unwashed. After nineteen months of it, I just wanted to go home.

We finally found a park outside of Kyoto, not a real campground but big enough for us to spread out a bit. It even had running water—the broad Katsura River. The children immediately tumbled out, freed from crowded quarters and excited by the sight of the running water. Suddenly to the rear of the bus we heard the roar of a motorcycle, screams, a sliding crash, and more screams. I lived a lifetime in those seconds. A Japanese motorcyclist had run into Andy and was holding our little boy, bowing, and apologizing with a repeated, *"Gomenasai."* I grabbed Andy, who was conscious and crying but not bleeding. He had a bump on his head, a tiny cut on one arm, and very wet pants. His arm was tender but didn't appear to be broken. We breathed sighs of relief and Andy spent the evening basking in our tender ministrations.

I have a copy of a letter I wrote that night. I never mailed it. I didn't want friends at home to think I didn't appreciate this great opportunity to see the world. I tried to begin with the bright side of life but it lasted for only a paragraph. After describing Andy's accident I continued:

It seemed a perfectly logical ending to a gruesome day. The combination of dirty clothes, dirty children, hot muggy weather, mosquitoes, and nothing to do about any of it is so damned discouraging.

Japan is a tourist's dream with wonderful hotels, great restaurants, cheap trains. Of course, ours may make a more amusing story but when I'm an old lady I hope I get a chance to really see Japan.

Vernon suggests that I have the wrong attitude. "We

should have brought more clothes," he says. "Dirt is a mental outlook," he teases me.

I must have a dirty mind, I decide. More clothes certainly are no answer. We barely have room for the ones we use. Vernon's consistent good nature irritates the hell out of me at times. Sometimes I see the trip differently. Meals should be prepared tastefully, efficiently, and quietly. Shopping should be done in the same way. Walk quietly to the store, buy several hundred pounds of food, bring it back to the bus, find a place to put it, and cook the damned stuff before it spoils without ice. If there is no place to dump garbage, see that it is stored discreetly in a space the size of a matchbox. Keep the camp stoves filled with some sort of fuel and when one explodes, maybe throw myself over it, extinguishing the fire with little fuss.

If a child has to go potty in the middle of the street, middle of the night, middle of the city, and there's absolutely no place to go, convince him he really doesn't have to go. And then clean it up. Don't let the children wear dirty clothes or shorts or other inappropriate garb. Keep the girls in clean dresses and when the dresses are dirty wash them without water, clothesline, or iron. After hours of travel in this chicken coop on wheels cheerily fix supper and settle a dozen arguments before bedtime. Keep the big picture in mind.

Boy, did I feel better after getting that off my chest!

By the time I'd finished my letter, everyone else was asleep near me in the bus or outside in sleeping bags on the grass beside Vernon. A whisper at the front door caused me to look up from my typewriter. By the glow of the faint light over my portable typewriter, I saw two young Japanese men watching me silently. I was frightened but tried to smile pleasantly and welcomed them to look around. One stared at me with glassy, expressionless eyes. My frozen smile may have convinced the other, who bowed stiffly to me, and took the unfriendly one by the arm, urging him out of the bus and off down the dark, deserted road. Nervously, I slid into my sleeping bag beside Vernon, who snored comfortably.

An hour later I heard footsteps behind a shadowed clump of bushes. I nudged Vernon who whispered, "Pretend you're asleep." The shapes of four men appeared darting from bush to bush. Hearts pounding wildly, but feigning sleep and steady breathing, we watched through squinted eyes as the small group circled the bus and walked slowly around our sleeping bags. Then, their curiosity satisfied, they detached a rear view mirror from the bus and disappeared into the night. We figured it was to replace the mirror broken on the motorcycle that afternoon.

The next morning we bought replacement rear view mirrors and tried to enjoy the beauty of the ponds and gardens at the Golden Pagoda. The children continued to bicker and complaints simmered like boiling oil.

"I have to go potty, Mommy."

"You'll just have to use the bucket in the closet."

"Moth–er," whined a teenager. "I don't have any clean clothes."

"You'll just have to wash them in the river this evening, I guess." My patience had vanished along with the dream of a laundromat. Only that morning a Japanese photographer had taken pictures of us as we washed clothes beside the river.

"Can't you girls work things out quietly?" Vernon said. "I can't drive with all this chatter. We might as well just turn around and go back to Tokyo." He seemed to think that was a threat, as though I could give a good goddamn whether we drove another mile or not.

The next day we decided it was foolish to continue on to Hiroshima. Unstated was the opinion that it was foolish to continue to share the same roof. Even Vernon was disgruntled and decided we would return to Tokyo and our little house and apply for immediate passage back to the States. I promptly felt guilty for being unable to take a few inconveniences in my stride in exchange for a once-in-a-lifetime experience.

It was then, as we came to a stoplight, that a man on a bicycle pulled up beside Vernon's window and handed him a white card with golden edges. Then he peddled off down the street. One side bore beautiful Japanese calligraphy; the other side in awkwardly printed English read, "Time is Spirit."

We returned to our campsite and Vernon sat quietly reading and rereading those three words. "That's it," he said. He sounded as though he had received a message from on high. "That really says it all. We'll keep going and everything will be all right."

I'll never understand ancient Oriental wisdom but my husband, who admired Taoist thought and the I Ching, knew better. Life was never quite as hectic again. The weather cooled, we found places to camp, we met hospitable people, and we found the true beauty of a timeless country. Today that inscrutable blessing, "Time is Spirit," is reproduced on a plaque over my kitchen door.

# Chapter Forty-Two

WE ARRIVED IN HIROSHIMA sixteen years after the American B-29 *Enola Gay* dropped the first atomic bomb on a warm summer morning in August of 1945. We had planned the trip to Hiroshima with the deep sense of responsibility many Americans feel about our use of the atom bomb, the greatest man-made disaster in history. Vernon had been severely wounded in that same war. He, too, had dropped bombs on cities. Yet, like many Americans, we felt the horror of Hiroshima must never be repeated. We wanted our children to bear witness to the devastation of atomic weapons.

It was to be expected that bitterness and hatred would have lingered over the intervening years, yet, wherever we turned, we found hospitality and friendliness from the people of Hiroshima.

We parked near the Memorial Peace Park and climbed hesitantly from our bus. As at other stops, curious friendly people surrounded us. Our old bus still bore California plates, a bear flag across the front, and a small American flag in the rear window. The destination sign over the front window read "Around the World" in Japanese. Teenage autograph hounds, who had seen stories of our trip in Japanese papers, were anxious to test their English and gave us paper and even pocket handkerchiefs to sign. Andy cried because he was not asked for his autograph. He couldn't write, but he wanted to be asked.

With several young boys and girls accompanying us we

walked through the park, passing the arched tomb of the unknown dead, with its perpetual flame and sprays of fresh flowers. A fragile old woman in a dark blue kimono stood in front of it with hands clasped together, bowing slowly. Japanese schoolchildren in navy blue uniforms came in groups, bringing colorful garlands of folded paper cranes to hang on the children's memorial, a bomb-shaped sculpture with figures of children.

Unexpected beauty lay before the skeletal ruins of the former Industry Promotion Hall—a rose garden in full bloom, blossoms of every imaginable color bursting with life, flamed hopefully in stark contrast to the gutted shell and twisted steel which testified to the destruction of that August morning.

We returned to the Peace Museum, known by local peace activists as the "Chamber of Horrors," and walked in silence among the displays in those haunted rooms. Even our children's usual questions were few as we passed cabinets showing the charred and melted remains of houses and buildings, pieces of shoes and clothing. There were photographs of survivors, of the dead, of people's silhouettes burned into cement paving, of a woman with the flower print of her kimono emblazoned on her naked back, of fires and destruction.

As I walked around a large diorama of old Hiroshima, a small Japanese woman moved slowly beside me. She pointed to the tiny model of the Industry Promotion Hall and touched my arm as she began to speak with urgency, first in normal tones and then with vivid pantomime to describe her words. Even though I knew only a few Japanese words her story was appallingly clear.

She had been in the city on that August morning in 1945. She had been witness to the blinding burst in the sky and following nightmare weeks. In mute testimony her arms rocked a missing baby and her right hand measured the height of a toddler. Her two children were killed. She pointed to a spot on the map where her house had been before she had gone to hide in the hills. There were no visible scars on her face or body, but the scars in her eyes were indelible.

Tears ran down my face as I turned to look at my own healthy children. When I put my arm around the little woman's shoulder, she looked up at me and smiled with eyes glazed by the madness

of eternal pain, still rocking the missing baby in her arms. Then she bowed formally to me and left the hall. But she has never left me. That nameless woman is my Hiroshima.

# Chapter Forty-Three

WITH THE KNOWLEDGE that the end of the trip was in sight, we could only gear ourselves for the joy of seeing familiar sights and faces. We headed back toward Tokyo. We spent one night in Nara, parking our bus among the tame deer in the royal park. Another night was spent in the baseball park, partly out of sympathy for the Swedish missionaries who welcomed the companionship of western visitors.

Vernon had become very good at asking directions in Japanese. It's easy enough to ask a question in a foreign language but understanding the response is another cup of tea. He would lean out of the window with a confident, "Which way is the road to...." Then he listened carefully while a volunteer guide answered in a volley of Japanese. Then we would turn and drive in whatever direction they pointed. Enough stops and we would find our way.

At a repair shop in Kyoto mechanics worked diligently on bus repairs, supplied a few spare parts, refused to charge us, and sent us on our way with the bus behaving better than ever. The weather had cooled and we were again able to enjoy new experiences.

North of Toyohashi we found an inviting strip of beach with an open space in which to park. The only sign of habitation was a cluster of small houses beyond broad fields of green topped with nodding heads of ripening rice. Along the beach were racks on which hung golden-bearded clusters. A few women in faded

clothing and broad straw hats threshed the grain in a hand-driven wooden machine before tossing it in the air on large rice mats to clear it of chaff. The women were of all ages, many with the rickets-bowed legs from poor diet and years of stooping work. An empty rice rack stood near the bus and our children, freed from hours of driving, instantly climbed it, hanging from their knees on the top bars. I looked to the Japanese women for their permission and they smiled and nodded their approval. As if by a silent signal other children appeared, joining ours on the racks, and wandering into the bus to stare openly at the tall, pale-eyed invaders.

Clean white sand spread down to the water where long rolling waves curled slowly. Tiring of the rice rack the children headed for the inviting water. The teenagers swam out past the waves; the little ones paddled in the shallows and built drip castles amid tiny scurrying crabs. The Japanese children watched with serious expressions. "Maybe they don't know how to swim," said Vernon.

In late afternoon long open fishing boats with carved and painted dragon prows appeared offshore. The fishermen rowed skillfully through the waves and beached their boats. Some folded their nets and others hauled their catches up the beach in large wicker baskets hung from yokes across their bare shoulders.

Donning a faded blue shirt, one of the fishermen approached Vernon and me as we watched the children in the water. He pointed to them and shook a warning finger. We were puzzled. He picked up a driftwood stick and began to draw in the sand the full-length figure of a large shark. The motion of many fingers showed us a multitude of sharks lived in those waters. It was the end of the water play.

The fisherman then motioned to Vernon to wait and he went to his boat, returning with two fishing lines. Like two old friends, he and Vernon fished companionably but unsuccessfully from shore as I fixed dinner in the bus. With both hands folded against his cheek, Vernon asked if we could sleep there that night and his host responded with smiling nods and deep bows.

Our young visitors returned that evening after dark as we sat in the bus while Christie and her father played the guitar and accordion. The beach was deserted and only a firefly glimmer of light shown from the distant houses. At first our visitors stood

around outside the bus, listening to the music and watching us. Christie played a couple of Japanese tunes she had learned and they were greeted with much giggling, hands clasped over mouths. In formal Japanese fashion for a first visit to new friends, one young man produced gifts. Christie received a little book of Japanese songs and the donor hummed hopefully as he tried to teach her the melody. He handed me a small tin of mandarin oranges and gave Vernon a tiny stone figure of a Japanese shrine.

When I began to plan dinner the second afternoon, I found I needed an onion. The thought of searching for a little shop in the village on the far side of the rice paddies was intriguing. I finally had a vocabulary of common polite phrases and the words for various foods which helped me with my shopping when pointing did not suffice. In the dictionary I found the word for onion, *tamanegi*.

I set off alone on the narrow footpath that cut through the rice fields. On that autumn afternoon I felt at one with my surroundings, forgetting my foreign looks, as I came to the single unpaved street of the village.

Turning to the right I walked the length of that dusty street. The only vehicle was a small wooden cart. Houses crouched together on either side, saving as much land as possible for crops. I glanced through open *shoji* screens into the interior darkness, looking for a shop. Small girls wore faded, often outgrown kimonos. Little boys wore turquoise *hapi* coats printed with Japanese characters. Some wore short pants, and a few bare bottoms could be seen beneath the coats. Many of the children had red spots on their arms but otherwise were healthy and laughing. The thought of a measles epidemic sent a small shiver through me. The youngsters gathered around an improvised platform on which stood two large drums and a yoke of gongs the size of serving trays. The boys took turns thumping the instruments with long padded sticks. It made a cheerful cacophony.

A boy of about twelve was first to acknowledge my presence. He turned to a friend and whispered. I smiled and said hello. *"Ohio gozaimasu."* My accent sent them into paroxysms of laughter, the girls covering their shy giggles with their hands. I pictured myself as I appeared to them, a giantess with light hair and pale eyes, possibly the first Caucasian some had seen. Then one brave

boy looked at me and made a circle of thumb and forefinger around his eyes to copy my round eyes in the same way our children might have pulled at the corners of their eyes to create the Asian slant. I laughed and turned to walk to the other end of the street.

A smaller boy, one with the reddest spots, decided to follow me. I could hear the slap of his bare feet on the dust. Finally, he mustered the bravery to reach out and tweak my skirt. The others giggled wildly. I hoped to make a gesture of friendship with the children as I turned to him. "Boo," I said. It was a spontaneous response to tease and encourage his playfulness. I'll never know what boo means in Japanese but the child was terrified and beat a fast retreat to his buddies, not in the least assured by my smile.

I continued toward the other end of the village, asking a couple of women where I could buy an onion. They only shrugged. Possibly my request sounded as though I was begging but I held out coins in one hand to show I was willing to pay. In one darkened doorway stood a middle-aged woman in a faded navy blue work kimono. I repeated my request, *"Tamanegi, kudasai?"*

The woman nodded and motioned me to wait by the door. She returned with a large onion and offered it to me. I was sure this was from her personal supply but I held out a handful of coins, urging her to take what was right. She shook her head. I tried to put the coins in her hand but she waved her hand in a gesture of giving, murmured a gentle, *"Dozo,"* and bowed deeply. Even in poverty the graciousness of the country reigned.

I bowed and thanked her. *"Arigato."* Then I returned to my other world at the end of the narrow path through the rice paddies.

We stayed there on the beach for three days. Only an exhausted food and water supply and the imminent arrival of our ship in Yokohama urged us to leave our almost-private seaside resort.

After four weeks of driving Japan's narrow highways Vernon had become daring enough to pass another bus on a road obviously wide enough for only one bus. He drove with ease on narrow streets jammed with bicycles, pedestrians, trucks, and buses. He had figured down to a hair the precise width of the bus and could

squeeze through impossible places at a respectable speed, losing only two more rear-view mirrors.

We had moments of dread when we thought of the return trip over the Hakone Pass but there was no way to avoid it. It had been bad enough the first time when we had the advantage of the inside lane. Somewhere along the way we heard there was another road from the Hakone crest down the eastern side of the mountains. Nothing could be as horrifying as the main road and Vernon decided to try the alternate. The ride to the crest from the south was not as hair-raising as on the other side and we made good time on a sunny morning.

We followed a tourist bus up the slope, stopping when the other bus did at a site with a spectacular view of Mount Fuji. All the men on the Japanese bus promptly lined up at the protective railing, admiring the view and relieving themselves in a manner worthy of the fountains of Versailles. The women remained discreetly in the bus, enjoying the view from the windows. A half-mile down the road was an official rest stop, at which point all of the women dismounted and visited the public toilets.

We took a right turn on the road that was to take us down the mountain. Not wanting to show my nervousness to the children, I had taken a tranquilizer that morning and, feigning sleepiness, retired to the back of the bus to lie down. That kept me from transferring my anxiety to Vernon; besides, I figured I might as well be comfortable when I went to meet my maker.

When we reached the bottom about an hour later Vernon reported his perspective of the downhill journey. "That road made the old Tokaido road look like a walk in the park," he said. "There I was proceeding in low gear, hand on the emergency brake, headed down the steepest road I've ever seen, and suddenly I see a sign—in English—STEEP ROAD AHEAD. PLEASE TO USE ENGINE BRAKE. But there was no turning back at that point."

# Chapter Forty-Four

OUR RETURN TO THE SMALL HOUSE in Nerima-ku was like a homecoming, with neighborhood children shouting greetings. Koji had left a welcome note beneath the door. "I love you permanently," it read.

Our Nisei neighbors (born and raised in California before working for the U.S. Army in Japan) introduced us to their best friend, who worked in the Tokyo immigration office. He and Vernon managed the "deportation" of the bus and us in slightly under one week of eight-hour days. "Japanese government, paper government," said the official to Vernon as he waded through high stacks of papers in quadruplicate.

I went to the American Embassy one morning to wind up a few last-minute details. I had gained some confidence in the suicide troops who maneuver Japanese taxis but that morning my faith was tested. I left the Embassy with a young driver en route to Tokyo Station for the ride back to Nerima-ku. Halfway there he plowed into the rear of a parked truck. After much bowing to and from the truck driver, we proceeded. Two blocks later a policeman who objected to our position on the wrong side of the street stopped him. (I hadn't thought anyone cared.) I rejected the urge to change taxis as I felt it would be the final blow to my driver's morale. I grinned sickly at him and murmured, "Whew!" This apparently gave him the confidence he needed to continue and we whirled into the station parking lot,

where he clipped a motorbike. I left him ministering to the startled driver.

At last the bus was delivered to the docks for shipment. We spent the night in a comfortable hotel nursing Andy who had a raging fever brought on by the number of vaccinations that had been demanded at the last minute for us to board an American military ship. The rest of us had sore arms from the mixture of typhoid, DPT, polio, and smallpox booster shots—all given at one time. "We've been around the world and suddenly we need shots to protect us in the United States. Doesn't sound like a healthy place," Vernon said.

A dozen Japanese and American friends made the trip to Yokohama to see us off. With a typhoon bearing down on the coast, there was some question as to the hour of departure. Hours were spent in repeated farewells before it was announced that we would not be able to up-anchor until the following morning. The only person waiting to say goodbye to us was Mr. Sakamoto, the stern-faced immigration officer who had told us to return to Moscow for a proper visa. He obligingly repeated his original austere words into Vernon's tape recorder but he smiled as he did so.

The term Military Transport transmits an image of gray metal, narrow stacks of bunks, and miserable food. Not so the U.S.S. *General Barrett*, which had been converted from a Matson Line ship that had once carried vacationers around the Pacific. It had all the comforts of a cruise ship. In addition, this time our portholes were above the water.

It was interesting to be surrounded by our compatriots, to have familiar meals, and to speak English at a normal clip. For the better part of the twelve-day crossing we were tossed by the typhoon and everything on the ship was lashed with ropes. Trips to the dispensary for seasick remedies were the order of the day. It was a rough crossing but we soon adapted.

At night as we lay in our berths, which were set port to starboard rather than lengthwise, our skin became raw as we slid back and forth on the sheets. Through the bedside porthole we could watch the tilt of the ship as we went slowly, slowly down to skim

the waves' tips and then the long roll back with nothing but the dark sky in sight.

The sea had calmed by the morning we were due in San Francisco. After almost two years away from home, our only American connection had been at military bases all around Europe, where we had always stopped for peanut butter and hamburgers. It even explained Andy's frequent answer when someone asked his name. Although his birth certificate listed him as Anders Merrick Johnson, he told anyone who asked, "My name is Andy American Johnson."

The sun was just rising as we passed the Farallon Islands and approached the Golden Gate Bridge. That beautiful bridge is a symbol as powerful as the Statue of Liberty.

The feeling of home and country and pride brought me to tears. We all stood on deck as we approached the docks of Fort Mason. It was six-year-old Kara who broke the emotional silence. It was easy to understand her reaction when she saw the Stars and Stripes flying over the military post. "Look, Mommy," she shrilled. "There's an American base!"

# Chapter Forty-Five

THE THOUGHT OF AN IMMEDIATE return to Santa
Barbara was out of the question. Plans for our "triumphal entry"
had been part of the excitement throughout the trip. We had to
stay in San Francisco until the bus arrived on a separate vessel. We
only needed to find a place to stay.

As tugs slowly pulled our ship up to the docks a military band
played rousing marches. Newspapermen came aboard before we
could reach the gangplank and amid the flurry of interviews in-
formed us that we were to be the guests of a brand new hotel in
the heart of the city—next to Fishermen's Wharf. The *San Fran-
cisco Chronicle* and the *Examiner* had banner headlines of our trip—
AROUND THE WORLD WITH EIGHT CHILDREN. A carload of
friends had driven the three hundred miles from Santa Barbara to
meet us. Friends and relatives streamed through the hotel.

We enjoyed the glamour of San Francisco but the excitement
we longed for was the reunion with the bus and the drive home.
When it finally arrived four days later, we all went to the docks to
supervise its unloading. Within the hour we were heading south.

The bus, as always, had a mind of its own. It behaved well as
we drove down the Peninsula, but by the time we reached San
Jose its prima donna temperament came to the fore. We ignored
the first few times it slipped out of high gear. After all, we hadn't
expected that last transmission to last forever.

I had resorted to our old trick of holding a rope around the

gearshift to keep it from popping out of third gear. "Do you think it'll get us home?"

"We still have a perfectly good low gear as well as second and reverse," said Vernon. "We'll get home this evening if we have to run in reverse."

"That's what you said with the other two transmissions."

"You have to admit," he said, "it made for interesting experiences. You should write a travel guide of garages we have stayed in—a new approach to the Michelin guides. Four wrenches could be the highest accolade."

"Sure," I said. "A limited edition of two to meet popular demand."

I couldn't remember a single day's travel during the past twenty months without some mechanical problem, but Vernon had made it all an adventure. "This is a beautiful spot for lunch. You and the girls make a picnic while Court and Jeff help me work on the engine." We had enjoyed picnics in valleys and on mountaintops, in country lanes and parked on city streets during our frequent emergency roadside stops.

We were still in high spirits when we stopped long enough to buy hamburgers in Paso Robles. When the bus wouldn't start friendly onlookers helped us push it out onto the road and down the street until the motor turned over. It was growing dark but we were on our last lap—two hours we figured. The welcome home party might have to begin without us.

The Cuesta Grade, south of Paso Robles, is steep but second gear was no problem and we climbed easily, enjoying the breadth and smoothness of California freeways. We were less than one hundred feet from the crest when an ominous clank signaled the loss of a fan belt. Vernon installed a new one and then called to me to turn the motor a couple of times while he checked the tension on the belt.

The resulting noise sounded as though the rear end of the bus had blown loose. I quickly turned off the key and ran to the rear expecting to see Vernon and the motor spread across the landscape.

"Well that's the end of this motor," he said. "We've thrown another rod."

Then we began to laugh, until even the youngest children joined in, not knowing what was so funny but enjoying the sight of their mother and father who were hanging onto each other as they guffawed. It was *so* suitable, *so* right, the only appropriate finale for our globe-circling escapade.

We didn't think to flag down other cars to send for help. It only meant another night in the bus. We rolled out the sleeping bags, climbed in, and went to sleep.

We were awakened after midnight by a knock on the bus door. I tiptoed around the sleeping children and looked out into the faces of two highway patrolmen.

"Are you the Johnsons?" one asked. "You've been reported missing on an all-points state bulletin."

"We're not missing," I said. "We're right here and quite comfortable."

"But you can't sleep beside the road," he said firmly. "It's dangerous. You'd better lock your doors."

Vernon joined me in fresh gales of laughter. Dangerous? If they only knew where we'd been sleeping. Lock the doors? Not for the last twenty months.

The officers offered to send for a tow truck but we told them we would be quite all right until morning. They asked if we wanted to send a message home and we thanked them and wrote a short note.

An hour later they returned, wakened us again, and reported that friends were on their way to meet us. The officers left us two gallon jugs of water and two dozen eggs.

Another hour passed and there were fresh knocks at the door. The brother of a friend had driven from his home in San Luis Obispo to take us to the shelter and warmth of his home. A giant rig tow truck accompanied him. I opted for the warmth of his station wagon and have since been reminded of that bit of disloyalty on my part. The children refused to abandon ship. Vernon insisted on staying at the wheel of the bus. The tow truck driver attached chains and lines to the bus and prepared to haul it away.

Vernon described the ensuing moments. "The children had climbed back into their sleeping bags. We felt the first tug of the truck. Then suddenly the front end of the bus rose high in the air.

I hung on to the steering wheel but the children slid into an enormous heap in the rear seat." The driver had inadvertently touched an automatic winch with his foot.

"You missed all the fun, Mommy," said Court.

I returned to the bus after a coffee break in San Luis Obispo and, with an escort of friends (who had interrupted the welcome home party long enough to join us), we were towed the last one hundred miles back to Santa Barbara. The bus had never traveled at such speeds as it did that morning. Our triumphal entry down State Street was lacking, however, as we were towed through side streets and up Hot Springs Road to our house. The bus was back in the driveway where it could rest as long as it chose. The children ran through the house and yard to inspect all their favorite hideouts. I was back in the yellow and gray kitchen I had designed, checking the refrigerator, turning faucets on and off, running my hands over the surface of my old stove, vowing to be contented forever.